Surrealism in Belgium

The Discreet Charm of the Bourgeoisie

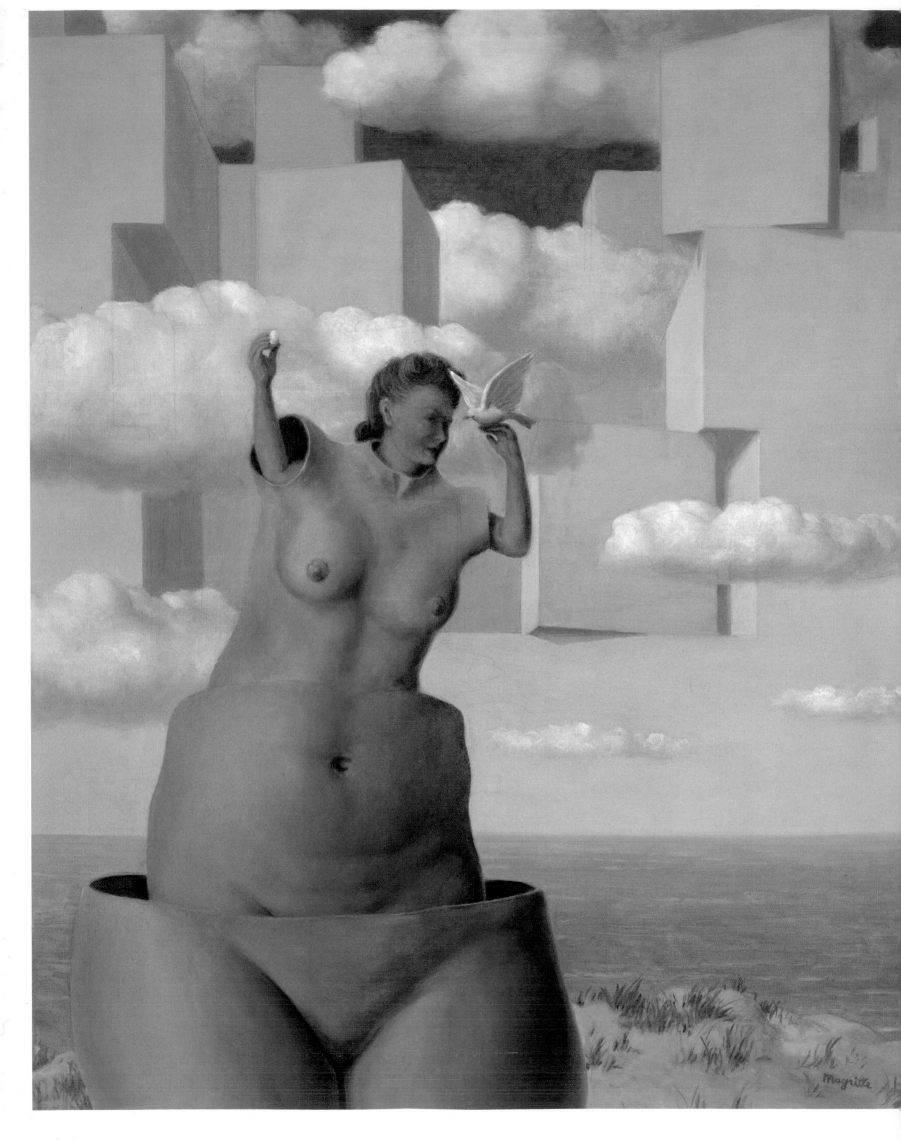

Xavier Canonne

Surrealism in Belgium
The Discreet Charm of the Bourgeoisie

René Magritte
The Object Lesson
(La Leçon de choses), 1947
Oil on canvas
Private collection

Artis—Naples
Home of The Baker Museum
and the Naples Philharmonic

BERKLET

Mt
MAROT

Organized by and presented at Artis—Naples, The Baker Museum,
from 31 January to 3 May 2015

Colophon

Published in conjunction with the exhibition *Surrealism in Belgium: The Discreet Charm of the Bourgeoisie*, organized by and presented at Artis—Naples, The Baker Museum from 31 January to 3 May 2015.

Editorial Director
Jan Martens

Translated from French
Patrick Lennon

Design
Juliette de Patoul
Joël Van Audenhaege, Collin Hotermans (Dojo Design)

Printed and bound by
New Goff – Graphius Group Ghent
On paper Perigord by Condat. 150 gsm

Published by
Marot S.A. (17 rue J. B. Meunier – 1050 Brussels – Belgium),
Berklet Editions (88 Chemin du Halage – 6530 Thuin – Belgium) and The Baker Museum in January 2015

ISBN: 978-2-93011-743-0
D/2015/9044/2

Printed and bound in Belgium

Photo Credits

A.P. Alexander Photography
95

G. Braeckman
10 – 17 (right) – 19 – 87 – 106 (right) – 109 (right) – 114 (top right)

A. Breyer
62 (left) – 153 (top)

G. Castellano
83 – 101

C. Galand
28 – 57 – 58 – 59 – 62 (left) – 63

D. Gilson
13 – 15 (right) – 17 (left) – 25 – 44 – 45 – 49 – 50 (bottom) – 52 (bottom) – 53 – 54 (left) – 64 (bottom) – 66 – 68 (bottom) – 77 – 78 – 80 – 81 – 86 – 89 – 93 – 113 – 121 (top) – 122 – 123 – 136 – 137 – 138 – 139 – 140 – 141 – 142 – 143 – 152 – 153 (bottom) – 154 – 155 – 156 – 157 – 158 (bottom)

M. Lefrancq
36 – 46 (top) – 50 (top) – 56 (top) – 71 – 72 – 74 – 151

Musée de la Photographie, Charleroi
32 – 54 (top – middle – right) – 55 – 68 (top) – 70 – 72 – 73 – 76 (top) – 103 – 104 – 105 – 106 – 108 (right) – 126 – 128 – 129 – 130 – 131 – 133 (top) – 134 – 135 – 143 – 146 (top) – 147 – 148 (top)

R. Saublains
16 – 34 – 43 – 46 (bottom) – 48 (bottom) – 61 (bottom) – 67 – 69 – 72 – 84 – 91 – 108 (left) – 112 – 114 (top left + bottom) – 115 – 125 – 144 – 150 (bottom) – 158 (top) – 159 (bottom)

A. Stas
27 – 146 – 147

Verbeke Foundation
110 (bottom) – 112 (top) – 132 – 133 (bottom)

Wallonia-Brussels Federation
11 – 21 (left) – 24 – 29 – 74 – 75 – 104 – 124

Contents

Thank you

The exhibition comprises works from private, museum, and government collections. Especially the access to the holdings of the Province of Hainaut in Belgium proved to be critical for the success of the exhibition and the development of its complete scope.

I thank Xavier Canonne sincerely for his willingness to make a profound commitment to working with The Baker Museum from the onset to materialize the idea of a well-rounded and insightful survey exhibition, and for the terrific essay he has produced for the handsome accompanying exhibition catalog.

Utmost gratitude goes to Pascal Retelet for partly underwriting the production of this catalog in addition to lending stellar works to the exhibition.

It goes almost without saying that a project of this magnitude cannot take place without significant financial assistance from our enlightened museum benefactors. I want to thank Lety and Stephen Schwartz for their generous support of the exhibition.

I am grateful to Kathleen van Bergen, CEO and President of Artis—Naples, and to the Board of Directors of The Baker Museum – chaired by Jay H. Baker – for their relentless support of our museum program. We are all delighted about the possibility of traveling this exhibition to additional American venues and would be thrilled to be bringing it to new audiences.

Finally, I want to express my sincere appreciation for the devotion to this project of our entire museum team: Gisela Carbonell, Curator of Special Collections; Silvia Perea, Curatorial Research Associate; Jackie Zorn, Registrar; Carla McCambridge, Assistant Registrar; Shannon Gallagher, Executive Assistant; Steve Kravec, Preparator; Chris Smith, Art Handler.

Acknowledgments

The organization of this first exhibition devoted to the surrealist movement in Belgium has involved the assistance and collaboration of many lenders. Our deepest gratitude goes to the various lenders:

Archives et Musée de la Littérature, Brussels, Belgium, Mr. Marc Quaghebeur and Mr. Luc Wanlin
Banque CPH, Tournai, Belgium, Mr. Alain Declercq
Ministry of the Wallonia-Brussels Federation, Brussels, Belgium, Mrs. Nathalie Nyst
Musée de l'Art Wallon, Liège, Belgium, Mrs. Ann Chevalier
Musée Ianchelevici, La Louvière, Belgium, Mrs. Valérie Formery and Mrs. Nancy Nechelput
Mu.ZEE, Ostend, Belgium, Mr. Phillip Van den Bossche
Province of Hainaut, Charleroi, Belgium, Mr. Pierre-Olivier Rollin and Mrs. Marie-France Desaintes
Verbeke Foundation, Kemzeke, Belgium, Mr. Geert Verbeke and Mrs. Marie Verboven
Verdec Collection, Belgium

Mrs. and Mr. Anelga and Raffi Arslanian, Lier, Belgium
Mrs. and Mr. Patty and Jay Baker, Naples, Florida
Mr. Gregory Berkowitsch, Brussels, Belgium
Mrs. Monique Bréhier, Brussels, Belgium
Mr. Xavier Canonne, Morlanwelz, Belgium
Mr. and Mrs. Chris and Lieven Declerck, Roeselare, Belgium
Mrs. Mireille Dohmen, Berchem, Belgium
Mr. Claude Galand, La Louvière, Belgium
Mr. Paul Gonze, Brussels, Belgium
Mrs. and Mr. Freddy Huyghe, Veurne, Belgium
Mrs. Claudine Jamagne, Brussels, Belgium
Mr. Michel Lefrancq, Mons, Belgium
Mr. Robert Leuwenkroon, Antwerp, Belgium
Mrs. Anouck and Nathalie Leuwenkroon, Antwerp, Belgium
Mr. Luc Remy, Brussels, Belgium
Mr. Pascal Retelet, Principality of Monaco
Mrs. and Mr. Wilbur Ross, Palm Beach, Florida
Mr. André Stas, Spa, Belgium
Mrs. and Mr. Jessy and Ronny Van de Velde, Antwerp, Belgium
Mr. Jean Wallenborn, Furfooz, Belgium

And all those who wished to remain anonymous.

The author and the publisher of the catalog would like to thank Mr. Charly Herscovici from the Magritte Estate for his special support.

Foreword

Frank Verpoorten
Director & Chief Curator of The Baker Museum

It is nothing short of exceptional that Artis—Naples, The Baker Museum has taken it upon itself to organize an engrossing exhibition such as *Surrealism in Belgium: The Discreet Charm of the Bourgeoisie* precisely at a time when works by one of its protagonists, René Magritte, are in high demand because they are included in major exhibitions devoted to the artist both in the US and abroad. In addition to the unique challenge this posed I am particularly proud that we have produced the first major exhibition in the US to offer a concentrated perspective on surrealism in Belgium, an art movement that was largely marginalized by most Anglo-American explorations of the genre until recently.[1]

Organized together with Xavier Canonne, one of the foremost experts on the subject, this exhibition has been conceived to offer an inaugural platform for the study and appreciation of different phases and aspects of the surrealist movement in Belgium by bringing together a diverse group of more than 250 paintings, drawings, photographs, prints and books by the inspired minds and imaginations of artists such as René Magritte, Paul Nougé, Marcel Mariën, Jane Graverol, Rachel Baes, Edouard Mesens, Armand Simon and Paul Delvaux.

Surrealism as an artistic movement developed in France where its existence was officially proclaimed with the publication in 1924 of André Breton's *Surrealist Manifesto,* in which the author bravely repositioned the goals of painting "in the future resolution of these two states – outwardly so contradictory – which are dream and reality, into a sort of absolute reality, a surreality, so to speak."[2]

Emerging about the same time (1924), the Belgian surrealist movement was the second largest after the French movement, its two main hotbeds being Brussels and the province of Hainaut, in the southern part of Belgium. Of all artists, Magritte was the most collegiate, making a solid niche for himself while hugging close the Belgian group of which he was a member right until the end of his life in 1967. A master of the absurd, his unique temperament, probing intellect and rich creative resources manifested themselves early and supported a consistently distinguished artistic production throughout his life. If paradox was the fundament of the surrealist movement in Belgium, Magritte was the most paradoxical of all its proponents. He presented an entirely respectable bourgeois front, happily married, living in the more salubrious parts of Brussels and painting not in a studio but a corner of the living or dining room. Yet his whole life was spent subverting the bourgeois and their values.

After 1945, Magritte's success and the insistence of his wife Georgette made him opt for a career as an internationally renowned artist. With the help of Harry Torczyner, a well-known international lawyer with Belgian roots based in New York

Endnotes

1 Patricia Allmer and Hilde Van Gelder,
 "The Forgotten Surrealists: Belgian Surrealism
 Since 1924" (*Image & Narrative* 13).
2 André Breton, *Manifestoes of Surrealism* (Ann
 Arbor, University of Michigan Press, 1972), 14.
3 Sam Hunter (intro.), *Magritte/Torczyner:
 Letters Between Friends* (New York, Harry
 N. Abrams, 1994), 11.

who generously acted as an ambassador for his work in the US, Magritte moved from the relative obscurity of a cult figure in the 1950s to his public discovery across the Atlantic and long overdue promotion to the category of distinguished modern master.[3]

Today Magritte's compositions are iconic and immediately recognizable because of their dissociated images, contrasts of objects and unrelated verbal inscriptions that pose existential philosophical questions of meaning and relationship between painting and real objects. They underscore especially the problem of realizing new forms of identity as part of the creative process.

As Xavier Canonne aptly discusses in his essay, despite the fact that the personality and international renown of René Magritte, the movement's principal representative, long overshadowed that of the other members and despite the absence of a Belgian surrealist manifesto, this artist collective developed a rich alternative to the surrealist movement in France that thrived for at least three quarters of a century, the proof of which is for viewers to discover in *Surrealism in Belgium: The Discreet Charm of the Bourgeoisie*. The works and documents in this exhibition testify to the diversity, the components and the complexity of the surrealist movement in Belgium and affirm its continued existence. They also demonstrate the relevance of a surrealist milieu in Belgium, which distanced itself from its French counterpart, concerning itself more with everyday life, the objects it consists of and the words that describe it, with the goal of a radical transformation of the world, while rejecting art and literature as a goal in itself.

About The Baker Museum

One of the foremost fine arts museums in Southwest Florida, Artis—Naples, The Baker Museum is a reflection of the unique spirit and generosity of the region's patrons. As part of a multidisciplinary arts organization that creates and presents over 300 events annually in the areas of performing arts, visual arts, and arts education, the Museum hosts several traveling exhibitions annually to complement installations of works from its permanent collections. Our internationally recognized holdings of American modern and contemporary art include nearly 3,000 objects and continue to grow. We strive continuously to expand the range of cultural experiences we offer, and to provide as many ways as possible to make the art meaningful and accessible for our community.

Surrealism in Belgium

Xavier Canonne

The Brussels group

In 1924, at the very moment when André Breton was publishing his *Surrealist Manifesto* in Paris, strange coloured leaflets were being sent out to carefully selected address-ees in Belgium and France. These tracts, if such we can call these pages written in a restrained style, are reminiscent of printers' sample pages: preceding each title and facing their publication date, the name of a colour appears in capital letters, followed by the number of the tract. From *Bleu 1,* dated 22 November 1924, to *Nankin 22,* dated 10 June 1925, a total of twenty-two numbered leaflets printed in an edition of less than a hundred copies were dispatched by a small group of men, a trio unknown at the time to the general public and artistic circles: Paul Nougé was a chemist, Camille Goemans was a law student (soon to be a merchant of paintings), and Marcel Lecomte would become a high-school supervisor – three men who shared the fact that they had not yet published anything, or so little.

The method underlying the *Correspondance* tracts was as original as it was clandestine: their tone is allusive, abstruse without being incomprehensible, and more so than the general public, they targeted an addressee who, it was hoped, would recog-nize himself, his disciples or circle of admirers, perhaps some literary critics. Replete with insinuations, detours, references and allusions, the undertaking compelled the addressee to read it, sometimes even to reread his own work. Although the trio's close attention to literary style could sometimes make it seem a form of homage, even going so far as to pastiche that style, their undertaking nevertheless acted as a sort of warn-ing to the men of letters, warning them of certain literary temptations to which they could succumb. Paul Eluard, Jean Paulhan, Philippe Soupault, André Gide, André Breton and Paul Valéry were some of the authors concerned or mentioned in these tracts dispatched from Brussels. The trio also asserted its wariness of modernism and the avant-garde movements of the day. "The advent of an *art nouveau* is hardly our concern. Art has been demobilized, and besides, it is a question of living," we can read in the first *Correspondance* tract.

If *Correspondance* can be considered the first act of the "Brussels group" – it is under this name that they cosigned various tracts and collective declarations with the Paris surrealist group in 1925 – we must already observe the difference in attitude and form that distinguishes the Brussels group from its Parisian counterpart: acting in the shadows rather than under the chandeliers of the literary salons, Paul Nougé and his accomplices relied on their own cunning and anonymity.

At the same time, two figures made their appearance in the Belgian avant-garde circles, Edouard-Léon-Théodore Mesens and René Magritte, the authors of the sole issue of the Dadaist-inflected review *Œsophage,* published in March 1925. Born in Brussels in 1903, Mesens devoted himself in 1919 already to the study of music, becoming a friend of Erik Satie's and frequenting Dadaist circles in Paris. For his part, Magritte gradually rid himself at this period of the futurist and modernist influence that had so far permeated his painting to reveal Giorgio de Chirico's influence on his new output. Mesens and Magritte had known each other since 1920, they too seeking to distance themselves from the artistic questions raised by the promoters of modernism in Belgium, representatives of abstract art then called *plastique pure. Œsophage*'s attempts to provoke Breton's group would push the *Correspondance* trio and the *Œsophage* duo to join forces in *Marie,* a review published by Mesens in 1926 and 1927, and in particular in its ultimate issue, entitled *Adieu à Marie.* Paul Nougé's influence permeated this January 1927 number, contrasting radically with the Dadaist tone of the earlier publications. Foreign collaborations were banned; the review only featured the names of Nougé, Magritte, Goemans, the avant-garde musician Souris, and Mesens, whose photograph of a hand gripping a knuckle-duster is reproduced in the centre pages.

René Magritte
Drawing for *Œsophage,* 1924
Collection of Ronny and Jessy
Van de Velde, Antwerp

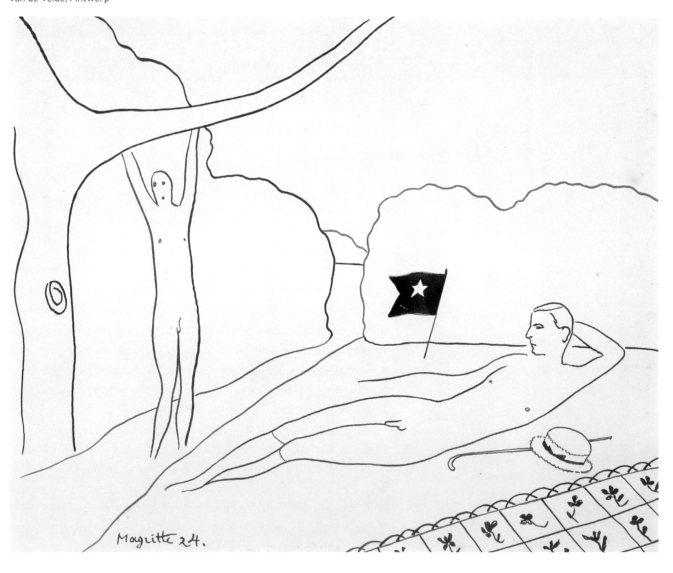

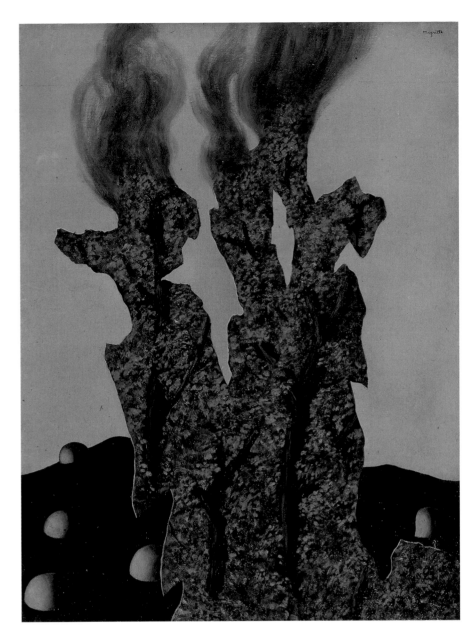

René Magritte
Countryside III (Campagne III), 1927
Oil on canvas
Collection of the Wallonia-Brussels Federation

The year 1927 turned out to be a crucial one for the Brussels group, which still had not decided to label itself "surrealist": besides various scandal-generating interventions seeking to prevent stage performances – including Jean Cocteau's *The Wedding Party on the Eiffel Tower* – it was the year of René Magritte's first great exhibition at Galerie Le Centaure in Brussels, prefaced among others by Paul Nougé, with who Magritte embarked on a fruitful collaboration lasting almost thirty years. Magritte here revealed his first surrealist works influenced by Giorgio de Chirico and metaphysical painting, bearing witness to the search for a personal style as with *The Lost Jockey* (1926) or *The Face of Genius* (1926). The year 1927 also saw the group joined by the poet Louis Scutenaire – whose first name was still Jean – whose friendship with René Magritte lasted forty years and whose collection of paintings, donated to the Modern Art Museum of Brussels, later formed the basis of the Magritte Museum in that city. The review *Distances* featured the group in its entirety over three issues, between February and April 1928. Published from Paris, it bore witness to the time spent by Camille Goemans and René Magritte in the French capital, Magritte remaining there for three years, from August 1927 to July 1930. Although he attended the meetings

Portrait of Paul Nougé, c. 1925
Private collection

of Breton's group, with whom the Brussels group had grown closer, and although he participated in some of their activities – his painting *The Hidden Woman* (1929) is reproduced in the twelfth and last issue of the review *La Révolution surréaliste* (15 December 1929) surrounded by photographs of the French and Brussels surrealists with their eyes shut –, Magritte could but observe the persistence of certain divergences as regards the methods of action envisaged by both groups. The incident of the cross – during which Breton demanded that Magritte's wife Georgette take off the crucifix around her neck, the couple refusing and leaving the gathering all of a sudden – is but one of the signs of the mutual mistrust. It is at Perreux-sur Marne, in the Paris suburbs where he resided, that René Magritte, joined by his younger brother Paul, made his first word-paintings, including the famous painting known as "This is not a pipe," entitled *The Treachery of Images* (1929). Paul Nougé, who had stayed in Brussels, would respond to it that same year with the extraordinary photographic series published as *Subversion of Images,* consisting of nineteen photographs made with simple means, staging his partners in compositions that explore the theme of the object, visible or hidden, and more broadly, the theme of representation. It is also in January 1929 in the Salle de la Bourse of Charleroi that Paul Nougé delivered a lecture on music, an exceptionally perceptive analysis of the music world, a genre generally neglected by the surrealists, published in 1946 under the title *The Charleroi Lecture.*

Emerging as the dominant figure of the Brussels group, its "brains," Paul Nougé once more stood out during the "Aragon Affair": threatened with legal action and imprisonment following the publication of his poem "Front rouge" (Red front), which contained several passages calling for disobedience and inciting the murder of the police prefect and soldiers, Louis Aragon saw his comrades from the Paris group come to his defense, comrades who issued a tract to protest the sanctions he faced. Nougé would add his name to the tract's 300 signatories but would also publish the tract *La Poésie transfigurée* in which, with René Magritte, André Souris and E.L.T. Mesens, he lauded this inculpation for restoring to the poem "its intrinsic value as a human provocation, its immediate virtue of demands resulting, after the fashion of the challenge, the insult, in a sensibly adequate response." For Nougé and his partners, there could then be no literary practice or indulgence with regard to the artist, but a genuinely revolutionary commitment must be demanded of the latter.

Other actions brought the Paris and Brussels groups in close contact, however, such as the publication in December 1933 in Brussels of the small volume *Violette Nozières,* a homage to a young patricide who they elevated as a model against bourgeois hypocrisy and order, defending her and organizing various events in her favor. It is on the occasion of the *Minotaur* exhibition at the Centre for Fine Arts in Brussels, which welcomed an important representation of surrealist artists, that André Breton pronounced on 1 June 1934 a lecture entitled *What Is Surrealism?,* during which he saluted his "surrealist comrades from Belgium" present in the assembly, an adjective which Nougé would accept "for the sake of the conversation." It is in that same year that the poet Paul Colinet joined the Brussels group, before the photographer Raoul Ubac in 1935 and, two years later, the youngest of the group, Marcel Mariën, aged seventeen. Although the Brussels group did not express itself at the time in collective undertakings, its members nevertheless pursued their own activities. For instance, René Magritte exhibited in Belgium, in the Netherlands in 1936 and 1939, at the Julian Levy Gallery in New York, before his first solo exhibition at the London Gallery in London, run by his partner Mesens. During this period, Magritte also illustrated Louis Scutenaire's *Les Haches de la vie* (1937) and *Frappez au miroir* (1939).

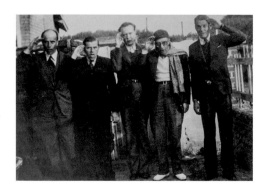

The surrealist group in Koksijde, 1935
Left to right: Paul Colinet, René Magritte,
Louis Scutenaire, Paul Nougé and Paul Magritte
Private collection

Marcel Mariën
Talking Collage (Collage parlant), 1939
Private collection

The Rupture group in Hainaut

Meeting on 29 March 1934 at Haine-Saint-Paul, in a suburb of La Louvière, an industrial town in the province of Hainaut, the lawyer Achille Chavée, the chemist Albert Ludé, the librarian André Lorent and the teacher Marcel Parfondry founded the Rupture group. Marked by the general strikes that had hit the south of Belgium in 1932, these young intellectuals chose this name to underline their condemnation of capitalist society and to distinguish themselves from the traditional leftist parties which they believed had become too bourgeois. The statutes of the Rupture group assert their desire to "strengthen revolutionary consciences" and to "contribute to the elaboration of a proletarian moral." It is only one year later, on 13 April 1935, that, spurred on by the poet Fernand Dumont who joined this group on this occasion, the Rupture group officially adhered to surrealism and that its members signed with the Brussels group in August 1935, under the name "surrealist group of Belgium," the third *Bulletin international du Surréalisme* (International bulletin of surrealism).

Helped by E.L.T. Mesens, whose work as a gallerist facilitated contacts – and who in 1931 bought an impressive number of paintings, including 150 works by Magritte, from the bankrupt Galerie Le Centaure –, the Rupture group organized a *Surrealist Exhibition* running from 13 to 27 October 1935 in La Louvière, the first in the world to be so clearly labelled. Although the exhibition was held in the general indifference of the inhabitants of this small industrial town that had become, despite itself, the hub of international surrealism, and while the press only gave the event little coverage, the exhibition legitimized Rupture in both Brussels and Paris. The young group's doings enthused André Breton, who, writing on 1 November 1935, praised the collective journal *Mauvais temps* – another significant title, meaning "Bad time" – which appeared just after the exhibition:

> *Mauvais temps:* annual journal … You absolutely must speak out more often. You must do so all the more violently and more consistently than ever because, politically in particular, I think that for us the moment has come to speak up loudly and to make ourselves heard by all.

On 21 January 1936, acting with the Brussels group under the name "the Surrealist group of Belgium," the members of Rupture signed the tract *Le Domestique zélé* excluding the musician André Souris, accused of having conducted a mass in memory of one of the founders of the Centre for Fine Arts in Brussels. The Spanish Civil War and Achille Chavée's enlistment in the International Brigades in November 1936 delayed the publication of a new issue of *Mauvais temps*.

Upon Chavée's return in October 1937, the group was split between a "political" wing represented by André Lorent and Albert Ludé, and a more literary wing embodied by Fernand Dumont. Besides these differences of opinion as to what the group should be, there were also divergences between Trotskyists and Stalinists. The friendship between the members could only postpone the inevitable divide: taking with them the newcomers, the draftsman Armand Simon, the photographer Marcel Lefrancq and the painter Louis Van de Spiegele, Chavée and Dumont founded the Hainaut surrealist group on 1 July 1939 in Mons. Although Marcel Lefrancq drafted a cover for *Mauvais temps 1939,* the issue was never published, no more than *Mauvais temps 1940,* the members of the Hainaut surrealist group failing to impose in a single collective publication the existence of a group that soon faced military mobilization,

Max Servais
The Ambassador (L'Ambassadeur), 1935
Collage
Private collection

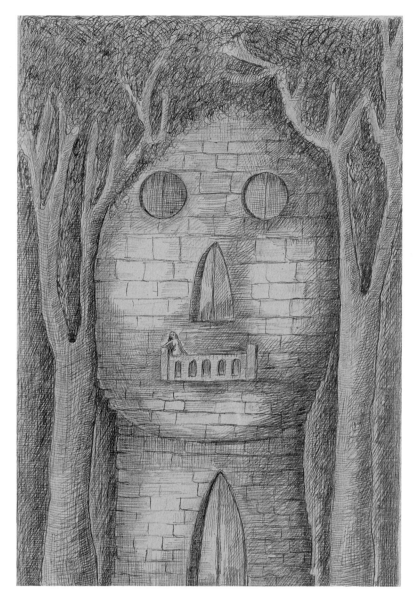

Armand Simon
The Mysterious House (La Maison mystérieuse), 1939
Drawing
Private collection

the outbreak of war and the ensuing dispersal. Two years after *Le Domestique zélé*, the Hainaut group and the Brussels group came together on two issues of *L'Invention collective* published in February and April 1940, organized by René Magritte and Raoul Ubac, which would include the only instance of the presence, through the reproduction of two paintings, of the painter Paul Delvaux in the Belgian surrealist group. Appearing just before Belgium entered the war, these two issues also featured many Parisian surrealists.

Born in 1910 at Malmedy in the east of Belgium, Raoul Ubac entered surrealism about 1932. It is at this time, during a voyage in Dalmatia, that he took his first photographs of stones, a theme he would develop over the next decade, before distancing himself from surrealism and developing his work as an abstract painter and sculptor. His encounter with Man Ray in 1933 and with the Dadaist Raoul Hausmann would incite him to pursue further his photographic experiments by using various

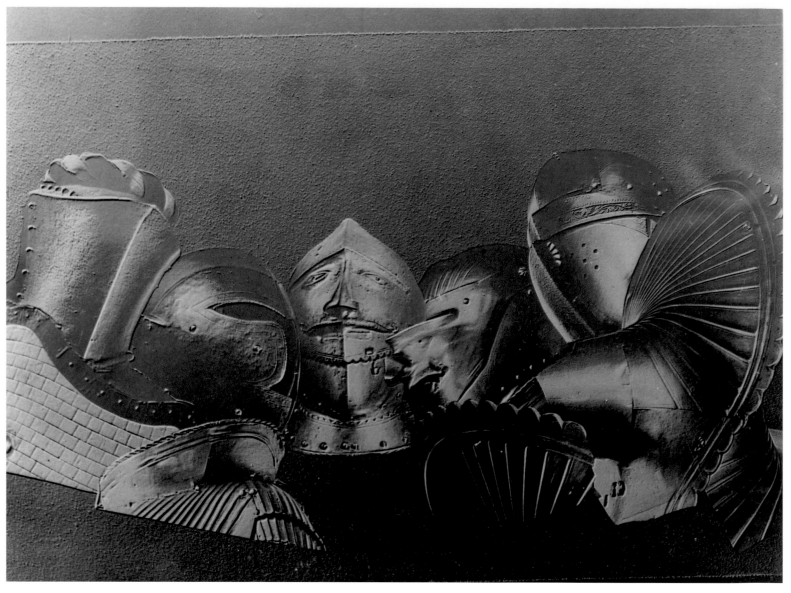

Raoul Ubac
Armor Helmets (Casques d'armures), 1938
Solarized photograph. Print dating from the late 1930s
Collection of the Province of Hainaut
on loan to BPS22, Charleroi

techniques: solarization, blowing, double exposure and photomontage. In 1936 already, Ubac began work on the *Penthesilea* series, an homage to Heinrich von Kleist, consisting of pictures of his wife's body replicated in striking compositions evocative of a petrified world of fighting Amazons.

A new recruit in the Brussels group, Marcel Mariën would immediately stand out through his multifaceted activity as a poet, writer, collagist, assemblagist and photographer, and also publisher, prolonging for half a century the activity of his elders. He would create in that same year one of his most emblematic works, *Nowhere To Be Found,* two temples assembled around a single lens, an object that would be displayed in *Surrealist Objects and Poems* in December 1937 at the London Gallery. The following year he delivered his first text devoted to the painting of René Magritte, *La Charpente des mirages,* before the first monograph devoted to the painter, in 1943.

The war

Although the war complicated the least of their undertakings and forced some surrealists into exile or underground, it had not the slightest impact on surrealism's objectives. It was in its second generation – embodied in Belgium by the young Raoul Ubac, Marcel Mariën and the poet Christian Dotremont – that surrealism would find a way to live on, the Belgians associating, despite the trouble communicating, with the French group La Main à plume led by Noël Arnaud. The exhibition of photographs by Raoul Ubac at Galerie Dietrich in May 1941 in Brussels that was prefaced by Paul Nougé was the first public event of the Brussels group since the German invasion of Belgium. The exhibition was shut down by the occupiers, however, after being denounced by Nazi collaborators. In Hainaut, Achille Chavée was forced underground for four years; Fernand Dumont, arrested in 1942, would not return from the camps where he was held by the Germans. Mesens spent the war in London under the bombs, and acted as a speaker in the Belgian section of the BBC. As for René Magritte, his rare exhibitions were brought to the attention of the Nazis by their lackeys.

At the liberation of the country, various attempts were made to bring together the Belgian surrealists, but it is the *International Surrealism Exhibition* at Galerie des Editions La Boétie in Brussels organized by Magritte in December 1945 that would mark the revival of any collective activity. Considered a scandal in the postwar years, this exhibition brought together the surrealists from Brussels and from Hainaut, but also some elements of the Paris group, future dissidents of André Breton still in exile in the United States.

Robert Willems
Drawing for *Le Ciel Bleu*, c. 1945
Ink on paper
Private collection

René Magritte
Vertigo (Le Vertige), 1943
Pencil on paper
Collection of Ronny and Jessy Van de Velde, Antwerp

In his inaugural talk, Paul Nougé specified:

> The attitude of the mind – an attitude termed, for the sake of the conversation, surrealist – carries the investigation and the longing for experience into the most threatened and the most futile areas of the human personality. Scandal for the sake of scandal, humor for the sake of humor, have to be relinquished for good. And it is less a matter of erecting a doctrine than establishing a discipline, a method which, to our mind, is far from having yielded all its fruits.[1]

In 1946, René Magritte launched himself into a new way of painting, pursuing his pictorial experience "in the sunlight," producing paintings with fruity tones:[2]

> We must not fear sunlight on the pretext that it has almost always served to light up a miserable world. Under the new and charming traits, the sirens, the doors, the ghosts, the gods, the trees, all these objects of the mind will be brought back to the intense life of the bright lights in the isolation of the mental universe.

Revolutionary surrealism

This longing for alternatives to surrealism also made itself felt in the political sphere. The young Belgian and French surrealists, who for the most part had remained in Europe during the war, wanted to resume relations with a Communist Party more powerful than ever since the hope generated by the victory at Stalingrad against the German army and the important participation of the communists in the Resistance. In the ultimate issue of the review *Les Deux Sœurs,* the young Christian Dotremont developed the notion of "revolutionary surrealism," a new attempt to synthetize poetry and politics. Although the initiative was at first welcomed by André Breton, who had returned from his American exile, the latter rapidly dissociated himself from it, to the extent that the "revolutionary surrealists" can seem from a distance as dissidents of the surrealism embodied by Breton. In October 1947 Dotremont organized in Brussels the International Conference of Revolutionary Surrealism – soon before the Congress of Communist Artists in Antwerp – and in early 1948 he published the *Bulletin international du surréalisme révolutionnaire,* condemning surrealism "as it is more or less identified with Breton," and reasserting the need for the class struggle. Although Magritte, Mariën, Nougé and Scutenaire attended both conferences, they did not play a role of any importance in either of them and would in fact distance themselves from them. The failure of "revolutionary surrealism" and its takeover by the French Communist Party that was eager to avoid any "deviance" led Dotremont to undertake the CoBrA adventure, an international movement bringing together Danes, Belgians and Dutchmen, founded in November 1948 in Paris.

René Magritte
Ways and Means (Les Voies et les Moyens), 1948
Oil on canvas
Private collection, courtesy of Ronny Van de Velde

Haute Nuit

In late 1946, Achille Chavée pronounced the dissolution of the Hainaut surrealist group and attempted to bring together the members of the prewar groups. On 19 February 1947 he founded in Mons the Haute Nuit group, of which Marcel Lefrancq became the secretary. The group published *Liberté,* the poems written in captivity by Fernand Dumont, who died in 1945, and organized a collective exhibition in Mons in March 1947. Although the group wanted to take part in the exhibition *Surrealism* in 1947 at Galerie Maeght in Paris, in order to distinguish itself from the Brussels group, no work by its members would figure in the show despite André Breton's written agreement, an absence that remains unexplained. The activities of the Haute Nuit group would remain very local, the group declining Dotremont's invitation to join CoBrA, so that its main activities after 1949 involved publishing.

The "vache" (cow) period

In Brussels, Magritte, Mariën and Nougé expressed their desire to get closer to the Communist Party and their incomprehension in the face of André Breton's "drift towards esotericism." Paul Nougé wrote the following in January 1948 in the catalog accompanying the René Magritte exhibition at Galerie Dietrich in Brussels:

> Behold the tarots, the horoscopes, the premonitions, the hysteria, the objective chance, the black masses, the conspiracy, the voodoo rites, the ossified folk-lore, the ceremonial magic. Quoting André Breton is now out of the question, Breton being rejected.[3]

That same year, René Magritte painted in six weeks about forty gouaches and oil paintings in garish tones, the opposite of his usual painting method: figures with huge noses like comic-strip characters evolving against squared backgrounds, next to wrestlers, naked girls and one-legged figures under green and blue suns.

Magritte would refer to them as his "fauve" or "vache" (cow) period. These paintings were produced in great secret, and none of his friends were aware of their existence, with the exception of Scutenaire, Mariën and Wergifosse. Exhibited in May and June 1948, at Galerie du Faubourg in Paris to the great surprise of its owner who had hoped for more traditional works, they met with the incomprehension of the Paris public and that of Magritte's admirers. With this genuine "surrealist act," Magritte not only put his reputation at stake, but also his living conditions, still unenviable at the time. But by thumbing his nose at the public and at critics in this way, he wanted to demonstrate surrealism's insurrectionary capacity. It would take a few more years for his popularity to grow in the United States, working with the New York gallerist Alexander Iolas, and for him to be gradually recognized in Belgium.

At the same time, at Paul Colinet's request, Magritte and his friends collaborated regularly via texts and drawings on a strange review of which only a single issue was published, *Vendredi,* in an edition of a hundred copies composed between November 1949 and October 1951, sent by Colinet to his nephew the draftsman Robert Willems, residing at the time in the Belgian Congo.

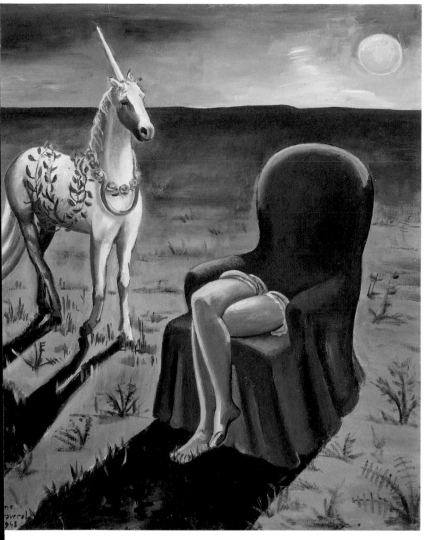

Jane Graverol
The Procession of Orpheus (Le Cortège d'Orphée), 1948
Oil on canvas
Collection of the Wallonia-Brussels Federation

Jane Graverol
Portrait of Paul Nougé (Portrait de Paul Nougé), 1968
Oil on canvas
Private collection

In October 1952, with the help of Paul Colinet, Magritte launched *La Carte d'après nature,* "the smallest review in the world" in the words of Jean Paulhan. Although it brought together the members of his circle, it was not a collective review, since Magritte alone defined the contents and the subject of the two studies. It did not receive Mariën's full support, and even less Nougé's, who, for private reasons, was at odds with Magritte, believing it to be a bit confused and "demobilized." Growing closer to Colinet, Magritte expressed less and less interest in political commitment, considering this phase of surrealism to be "historical" and therefore past. Mariën, eager to publish the entirety of Paul Nougé's texts, most of which were unpublished, then founded a new review, *Les Lèvres nues.*

Les Lèvres nues

Facing particularly precarious living conditions and living off small temporary jobs, Mariën joined merchant marine cargos from 1951 to 1953, cherishing on board the project of a review. Upon his return, he met during a conference in Verviers the painter Jane Graverol, an admirer of Magritte's who organized in this small town of the east of Belgium an exhibition of the latter's work.

With Paul Nougé, whom she took in after his divorce, Graverol founded with Mariën in April 1954 the review *Les Lèvres nues,* which would also act as a publishing house. Besides Nougé, no member of the surrealist group featured in the contents of the first issue, the review's more political tone irritating Magritte who, like Paul Colinet, would refuse to take part. Over time, André Souris and Louis Scutenaire gradually appeared in the review, which appeared until 1958. New names also surfaced, such as Gilbert Senecaut and Leo Dohmen, two friends from Antwerp, Paul Bourgoignie, a writer close to Jane Graverol, and, increasingly, Guy Debord and the members of the Lettrist International, soon to be the Situationist International. The review revealed in particular Paul Nougé's early texts and reproduced for the first time his photographic series *Subversion of Images,* created in 1929. Besides a concurrence of opinion on their methods of action, Mariën shared with Debord and the Lettrists an interest in a new cinema, an experimental cinema at the antipodes of the film industry. In 1956 both men jointly took part in various events, including a protest entitled "The oil industry seen by artists" against an exhibition organized by the Shell oil company as well as an invitation to a conference issued via an anonymous tract – a reception organized on the occasion of André Breton's sixtieth birthday, tricking various figures from the press and the literary world.

L'Imitation du cinéma

In 1959, with the complicity of Leo Dohmen, Jane Graverol and Gilbert Senecaut, and with a very small budget, Mariën undertook the shooting of his only film, and the only film that can unreservedly be called "surrealist" in Belgium, *L'Imitation du cinéma.* This medium-length film tells the story of a young man caught by a priest as he exchanges the erotic magazine he was reading for *Of the Imitation of Christ.* Fascinated by Christ's tragic end, the young man decides to die on the cross and sets off in search of a cross his size. His journey is a long hard battle: a prostitute gives herself to him for free; a carpenter gets his measurements wrong; broken glass punctures the wheels on his bicycle, forcing him to finish his journey home on foot, where he chases away the priest who turns out to be a crook; unable to crucify himself by himself, he chooses to gas himself and to die sitting down, with his arms spread. The film caused a scandal upon its release in March 1960 and charges were brought against it. The (mostly French-speaking) progressive press defended the film and invoked the freedom of expression, while the Flemish-speaking press cried blasphemy. Cinema owners refused to screen it and the film was banned in France in 1961 by a decision of the Ministry of Information: it could only be shown in private screenings and upon invitation.

The role of the young man in *L'Imitation du cinéma* was given to a newcomer, an eighteen-year-old poet, Tom Gutt, who would soon occupy a key place in surrealist circles, of which he embodied the third generation in Belgium.

Leo Dohmen
Tom Gutt in *L'Imitation du cinéma,* 1959
Black and white photograph
Private collection

Leo Dohmen
L'Imitation du cinéma, 1959
Black and white photograph
Private collection

Rhétorique

In the early 1960s, the work of René Magritte was at last recognized and, both in Belgium and abroad, several important exhibitions were devoted to his work. A first documentary was devoted to him in July 1960, *René Magritte ou la leçon de choses* (René Magritte or the object lesson) directed by Luc de Heusch and commissioned by the Ministry of Education, and in which appeared some of his friends, Louis Scutenaire, Irène Hamoir, Marcel Lecomte and Camille Goemans. Since the end of *La Carte d'après nature,* Magritte had felt the need for a review which would offer him the possibility of developing, outside his paintings or his correspondence, his theses on his painting. This would be *Rhétorique,* a review that was entirely devoted to him, organized with the active collaboration of a young admirer, André Bosmans. The review, of which thirteen issues appeared between August 1961 and February 1966, featured contributors such as Achille Chavée, Louis Scutenaire, Pierre Demarne, André Pieyre de Mandiargues, Harry Torczyner (a collector and Magritte's New York lawyer), Marcel Lecomte and Jacques Wergifosse. Neither Paul Nougé nor Jane Graverol or Marcel Mariën appeared in the contents of *Rhétorique,* which therefore officialized the split that had taken place, since *Les Lèvres nues,* in the as yet rectilinear stream of surrealism in Belgium.

Devoted entirely to the work of Magritte, who organized its contents with André Bosmans, the well-titled *Rhétorique* shows an increased interest in philosophy and attempts to approach Magritte's work from that perspective. As a result, Mariën would parody this style to fool the painter and his admirers in a joke that would put him at odds once and for all with Magritte.

Grande baisse

René MAGRITTE — Les Travaux forcés.

GRANDE BAISSE

La pensée est le mystère, et ma peinture, ma véritable peinture, est l'image de la ressemblance du mystère avec son reflet ressemblant dans la pensée. Ainsi, le mystère et sa ressemblance ressemblant à l'inspiration de la pensée qui évoque la ressemblance du monde dont le mystère est susceptible d'apparaître visiblement.

De mystère en mystère, ma peinture est en train de ressembler à une marchandise livrée à la plus sordide spéculation. On achète maintenant ma peinture comme on achète du terrain, un manteau de fourrure ou des bijoux.

J'ai décidé de mettre fin à cette exploitation indigne du mystère en le mettant à la portée de toutes les bourses.

On trouvera ci-dessous les éclaircissements nécessaires qui réconcilieront, je l'espère, le pauvre et le riche au pied du mystère authentique. (Le cadre n'est pas compris dans le prix).

J'attire l'attention sur le fait que je ne suis pas une usine et que mes jours sont comptés. L'amateur est invité à passer commande immédiatement. Qu'on se le dise : il n'y aura pas du mystère pour tout le monde.

René MAGRITTE

Quelques suggestions (en format standard) :

	Belgique Fr.	France N.F.	U.S.A. Dollars
LA MÉMOIRE			
tête de plâtre tournée vers la gauche	7.500,—	750,—	150,—
tête de plâtre tournée vers la droite	8.500,—	850,—	170,—
LA MAGIE NOIRE			
Offre spéciale : pour toute commande ferme de douze exemplaires, une 13ᵐᵉ Magie noire gratuite	6.000,—	600,—	120,—
LA CONDITION HUMAINE			
avec vue sur la mer	5.000,—	500,—	100,—
avec vue sur la campagne	4.500,—	450,—	90,—
avec vue sur la forêt	4.000,—	400,—	80,—
LA FOLIE DES GRANDEURS (ex-IMPORTANCE DES MERVEILLES)			
avec emballage supplémentaire	4.000,—	400,—	80,—
avec double emballage supplémentaire	4.500,—	450,—	90,—
PORTRAITS EN BUSTE (supplément de 10 % pour les portraits en pied)			
adultes masculin au-dessus de 40 ans	8.000,—	800,—	160,—
adultes masculin au-dessous de 40 ans	6.000,—	600,—	120,—
adultes féminins — jolies	500,—	50,—	18,—
adultes féminins — passables	4.000,—	400,—	80,—
adultes féminins — défavorisées	10.000,—	1.000,—	200,—
— Prix à convenir —			
GOUACHES TOUS SUJETS à partir de	1.000,—	100,—	20,—
DESSINS à partir de	50,—	5,—	1,—

ET LA FÊTE CONTINUE !

Tract *Grande baisse*, 1962
Collection of the Province of Hainaut
on loan to BPS22, Charleroi

On 29 June 1962, on the eve of the Magritte retrospective at the casino of Knokke-le-Zoute, Mariën dispatched, in an envelope bearing the address of *Rhétorique,* an apocryphal tract, *Grande baisse,* presented to the public as coming from Magritte himself. A photomontage showed Leo Dohmen's *Les Travaux forcés (Hard Labor)* presenting on a banknote Magritte's photograph instead of that of King Leopold I. Magritte appears to revolt againt the financial speculation surrounding his painting and therefore proposes to sell his paintings at a discount: buy twelve and get a thirteenth painting free, for example. Magritte learned of the tract during the exhibition's vernissage, irritated at hearing the first addressees congratulating him for something done at his expense.

André Breton himself praised this action in the journal *Combat,* welcoming this attitude against the art market, an appreciation that was not shared by gallerists and collectors, not least in the US, who Magritte would have to reassure. Although Magritte had no doubt as to the source of the tract – he said so in writing to Mariën who denied being the author – the Belgian police conducted an investigation following the complaint lodged at the Bank of Belgium, the reproduction of banknotes being illegal. Discovered, Mariën let a certain doubt hang over the paternity of the tract for a long time, and Magritte would only know for certain long afterwards, when playing chess with the printer of the tract. Mariën chose this moment to leave Belgium, undertaking a three-year journey across the US, Japan and China, where he would work as a proofreader in a propaganda newspaper before returning in early 1965, with no illusions about life under Mao.

Leo Dohmen
Hard Labor (Les Travaux forcés), 1962
Collection of the Wallonia-Brussels Federation
on load to the Museum of Photography, Charleroi

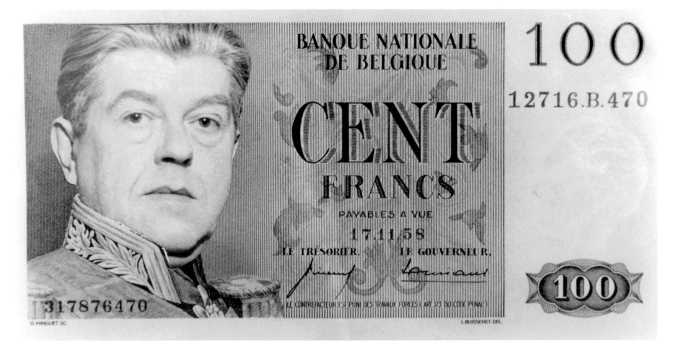

Vendonah

In the summer of 1964, two fake issues of *La Carte d'après nature* reached Magritte and other addressees, leading the painter to deny being the author, condemning the actions of a "so-called surrealist Brussels group." The group to which Magritte was alluding was led by Tom Gutt, the young man of *L'Imitation du cinéma* who, with his partners Jean Wallenborn, Claudine Jamagne (his spouse) and Michel Thyrion, collaborated on the review *Vendonah*, published on colored mimeographed pages. Released in 1963 already, *Vendonah* gradually brought together Irène Hamoir and Louis Scutenaire, defending the work of Roger Van de Wouwer, whose exhibition was censored at the time in Brussels, and saluting Mariën during his stay abroad. Admiring of Paul Nougé, who was then walled up in an unshakeable silence, the group gradually imposed itself as the next generation of surrealism with the tract *Vous voyez avec votre nombril* dated 22 November 1964 which implicitly constituted the rebirth certificate of the Belgian surrealist group, associating Tom Gutt and his partners to the very first surrealists. Tom Gutt's group then clashed with the Belgian wing of the Phases movement, the artists gathered around the review *Edda*.

Edda

In the summer of 1958 the review *Edda* was published in Brussels at the initiative of the painter Jacques Lacomblez, with an editorial signed by Edouard Jaguer, the driving force in Paris behind the review and the Phases movement, of which *Edda* became the Belgian branch. Lacomblez met Jaguer in 1956 and the next year adhered to the Phases movement, created in 1952. In the mid 1950s, Lacomblez made up with

Jacques Lacomblez
Let's Go Home
(Revenons chez nous), 1985
Oil on canvas
Private collection

Jacques Zimmermann and Marie Carlier a small group of painters practicing non-figurative painting in the tradition of Max Ernst, Lacomblez wanting to synthetize various forms of expression. On the occasion of the publication of the first issue of *Edda,* the first Phases exhibition in Belgium was organized in Brussels. Five issues of *Edda* were published between 1958 and 1964, its desire to gather "the highest common denominator" seeming from the start to distinguish it from the other component of surrealism in Belgium. Refusing, without rejecting it entirely, the Magrittean side of surrealism, turning towards pictorial and poetic experimentation, the members of *Edda* seemed to turn more gladly towards France, towards André Breton.

Tom Gutt's group would use different tracts to vehemently oppose the activity of the members of *Edda,* the two wings of surrealism diverging on the methods of action and their legitimacy in the eyes of André Breton.

Les Lèvres nues (second series)

Upon his return from Maoist China, Mariën wanted to revive his publishing house and his review, and to take up his activities again. In April 1967 he held his first solo exhibition since joining the surrealist group. Entitled *Rétrospective et nouveauté 1937-1967* (Retrospective and novelty 1937-1967), it presented thirty years of work in the fields of publishing, collage, words and objects. Indeed, although Mariën collaborated on many group exhibitions, his living conditions and his traveling prevented him from devoting himself with any regularity to his own creative activity.

Like Tom Gutt's group, the series of works made since his return from China reveals the perennity of a surrealist state of mind that had not grown weaker.

Mariën also revived his review *Les Lèvres nues* in April 1968, inaugurating a collection of documents that appeared until 1975, interspersed with more recent texts and collaborations. It is in one of these publications that appeared a young collagist from Liège, André Stas, who is still active today, who would join Tom Gutt's group around Galerie La Marée and the review *Le Vocatif,* of which more than 300 numbers were issued between October 1972 and May 2002.

In the gallery and the accompanying exhibition catalogs we find the following: Max Servais, an extraordinary collagist and long-time friend of the surrealists; Rachel Baes, who painted the torments of childhood; Robert Willems, the nephew of Paul Colinet, an inventive draftsman and painter; Paul Magritte, René's younger brother, a great dilettante who was the author of collages, texts and songs; Armand Simon, a former member of the Rupture group, the creator of prodigious drawings of a tumultuous universe; Marcel Mariën; Gilles Brenta, of which Tom Gutt introduced many exhibitions and who would make a series of portraits of the group's members; and lastly Claude Galand, a meticulous draftmasn, close to Armand Simon whose graphic work he prolonged in his own way.

Both collectively and individually, surrealists would remain active in Belgium at the initiative of Tom Gutt and Marcel Mariën, the latter provoking a scandal with the publication of his "souvenirs" in 1983, *Le Radeau de la mémoire.* The revelation of intimate details about the group's existence and of René Magritte's activities as a counterfeiter and forger led the latter's wife to ask for the work to be seized, but her case was dismissed.

André Stas
Nostalgia
(La Nostalgie), 1986
Collage
Private collection

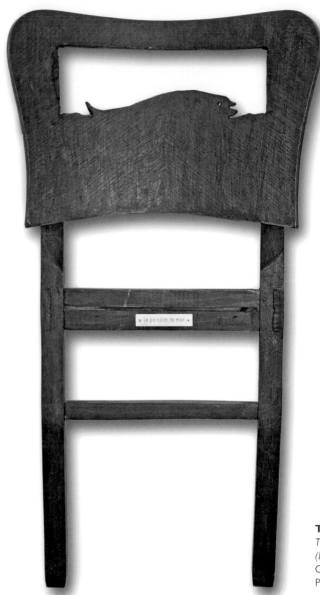

Tom Gutt
The Sea Fish
(Le Poisson de mer), 2000
Object
Private collection, Brussels

Endnotes

1 Paul Nougé, *Histoire de ne pas rire*
 (Brussels, Les Lèvres nues, 1956), 152.
2 René Magritte, repr. in *Marcel Mariën,
 L'activité surréaliste en Belgique* (Brussels,
 Lebeer-Hossman, 1979), 393.
3 Paul Nougé, "Les points sur les signes" in the
 exhibition catalog *L'Exposition Magritte* (Brussels,
 Galerie Dietrich, 1948).
4 Paul Nougé, "La solution de continuité"
 in *Histoire de ne pas rire* (Brussels,
 Les Lèvres nues, 1956), 106.

Mariën would continue publishing, undertaking the release of a third series of *Les Lèvres nues* which appeared between 1987 and 1993, each issue bearing a different name.

The death of Marcel Mariën in September 1993 and that of Tom Gutt in May 2002 deprived Belgian surrealism of the legitimacy inherited from Paul Nougé's first group.

Although we shall certainly not deliver its death certificate in conclusion to this text, surrealism in Belgium having no baptism certificate, we must recognize the end of any collective activity, although this in no way prevented the permanence of a state of mind, the continuation of individual activity. So that if the historical phase of surrealism is now over, its revolutionary and insurrectionary components live on since, as Paul Nougé wrote about the surrealists, "The external world is our condition." [4]

Jane Graverol
The Drop of Water (La Goutte d'eau), 1964
Oil on canvas
Collection of the Belgian State on loan
to the Musée d'art wallon, Liège

Chronology

1895 Birth of Paul Nougé

1898 Birth of René Magritte and Paul Colinet

1899 Birth of André Souris

1900 Birth of Camille Goemans and Marcel Lecomte

1901 Birth of André Lorent

1902 Birth of Paul Magritte

1903 Birth of E.L.T. Mesens

1904 Birth of Max Servais

1905 Birth of Louis Scutenaire and Jane Graverol

1906 Birth of Achille Chavée, Fernand Dumont, Marcel Parfondry, Armand Simon and Irène Hamoir

1910 Birth of Raoul Ubac

1912 Birth of Marcel Havrenne, Albert Ludé, Louis Van de Spiegele and Rachel Baes

1916 Birth of Marcel Lefrancq

1919 In Paris, André Breton and Philippe Soupault publish *The Magnetic Fields*

1920 Birth of Marcel Mariën

1922 Birth of Leo Dohmen and Pol Bury

1923 Armand Simon discovers *Les Chants de Maldoror* by the Comte de Lautréamont

1924 In Paris, André Breton publishes the *Surrealist Manifesto*
Publication of the *Correspondance* tracts (Lecomte, Goemans, Nougé)
First stirrings of surrealism in Belgium

1925 Birth of Gilbert Senecaut

1926 Birth of Robert Willems
Publication of the review *Marie* (Nougé, Mesens…)

1927 First solo exhibition of René Magritte
Camille Goemans and René Magritte move to Paris, where they remain until 1930

1928 Birth of Jacques Wergifosse
In Paris, André Breton publishes *Nadja*

1929 Publication of *Surrealism in 1929,* a special issue of *Variétés*
Paul Nougé delivers *The Charleroi Lecture* and shoots the photographic series published in 1968 by Mariën as *Subversion of Images*
In Paris, André Breton publishes the *Second Surrealist Manifesto*
Birth of Jacques Zimmermann

1931 The Aragon Affair begins

1933 Publication of the collective volume *Violette Nozières*
Birth of Roger Van de Wouwer

1934 Foundation at Haine-Saint-Paul near La Louvière of the Rupture group (Chavée, Lorent, Ludé, Parfondry)
Birth of Jacques Lacomblez
Minotaur exhibition at the Centre for Fine Arts in Brussels
André Breton delivers the lecture *What Is Surrealism?* in Brussels

1935 The Rupture group joins surrealism
In October, *Surrealist Exhibition* in La Louvière and publication of the collective journal *Mauvais temps*
Birth of Urbain Herregodts

1936 André Souris is excluded from the surrealist group via the tract *Le Domestique zélé*

Achille Chavée joins the International Brigades and enters the Spanish Civil War

1937 In London, André Breton publishes *Mad Love*

1938 In Paris, *International Surrealism Exhibition*
Pol Bury joins the Rupture group

1939 Foundation in Mons of the Hainaut surrealist group (Dumont, Chavée, Lefrancq, Simon …)
Birth of Jacques Matton

1940 Publication of the review *L'Invention collective*

1941 Birth of Tom Gutt and Jean Wallenborn

1942 The Nazis arrest Fernand Dumont, and Achille Chavée goes underground

1943 Birth of Claudine Jamagne

1945 Death of Fernand Dumont at the Bergen-Belsen camp in Germany
Surrealism, international exhibition in Brussels

1946 Birth of Claude Galand

1947 Foundation of the Haute Nuit group at Mons
International exhibition *Surrealism in 1947*
Foundation of Revolutionary surrealism (Dotremont, Arnaud …)

1948 René Magritte's "vache" (cow) period
CoBrA founded by Christian Dotremont

1949 Birth of André Stas

1952 The review *La Carte d'après nature* (Magritte, Colinet) begins publication

1953 The review *Les Lèvres nues* (Mariën, Nougé, Graverol) begins publication

1957 Death of Marcel Havrenne and Paul Colinet

1958 The review *Edda* (Lacomblez) begins publication

1959 Marcel Mariën directs *L'Imitation du cinéma*
In Paris, *International Surrealism Exhibition*

1960 The review *Rhétorique* (Magritte, Bosmans) begins publication
Death of Camille Goemans

1962 Publication of the tract *Grande baisse* (Mariën, Dohmen) that tricked René Magritte

1963 The review *Vendonah* (Gutt) begins publication

1966 Death of André Breton and Marcel Lecomte
Publication of Paul Nougé's *L'Expérience continue*

1967 Death of René Magritte and Paul Nougé

1969 Death of Achille Chavée and Jacques Matton

1970 Death of André Souris

1971 Death of E.L.T Mesens

1972 Death of Louis Van de Spiegele

1975 Death of Paul Magritte

1981 Death of André Lorent and Armand Simon

1983 Death of Rachel Baes

1984 Death of Jane Graverol

1985 Death of Raoul Ubac

1986 Death of Urbain Herregodts

1987 Death of Louis Scutenaire

1990 Death of Max Servais

1993 Death of Marcel Mariën

1994 Death of Irène Hamoir

1997 Death of Gilbert Senecaut and Albert Ludé

1999 Death of Leo Dohmen

2002 Death of Tom Gutt

2005 Death of Roger Van de Wouwer and Pol Bury

2006 Death of Jacques Wergifosse

2011 Death of Robert Willems

Reviews
and Documents

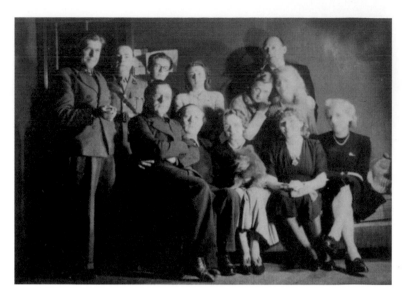

Raoul Ubac
The Brussels group, Feb. 1940
Standing: René Magritte, Camille Goemans,
Marcel Mariën, Jacqueline Nonkels, Irène Hamoir,
Jean Bastien, Agui Ubac
Seated: Georges Mariën, Louis Scutenaire, Georgette
Magritte, Sacha Goemans, Antonina Grégoire
Collection of the Museum of Photography, Charleroi

Carte d'après nature (La)

Considered by Jean Paulhan to be "the smallest review in the world," *La Carte d'après nature* was launched in 1952 at the initiative of René Magritte. Ten issues were published, eight in the form of postcards and two in the form of small books that included the conclusions of two surveys: "What do you understand by poetry?" and "Does thought enlighten us and our acts with the same indifference as the sun, or what hope do we have and what is its value?" However, *La Carte d'après nature* was not a collective venture since Magritte alone was responsible for the contents, and the review was in fact based in his home.

Charleroi Lecture (The)

At 3 o'clock on Sunday 20 January 1929, in the Salle de la Bourse in Charleroi, Paul Nougé delivered an introductory lecture to a chamber-music concert by André Souris held in conjunction with an exhibition of works by René Magritte. Announced in the program as "commentaries," the talk was published as *The Charleroi Lecture*. Nougé's perceptive analysis of the music sector – a genre generally dismissed by the surrealists – seems to have puzzled the audience, little used to such an eloquent speaker.

LA CARTE D'APRES NATURE
Nº 1 · OCTOBRE 1952

RÉDACTION : MAGRITTE, JETTE-BRUXELLES
135, RUE ESSEGHEM

CHIEN
DANGEREUX
CLAIR
DE
LUNE
Rosier

P.C.

Dessin de Paul COLINET

Review *La Carte d'après nature*,
no. 1, Oct. 1952
Private collection

Correspondance

Ranging from *Bleu 1,* dated 22 November 1924, to *Nankin 22,* dated 10 June 1925, *Correspondance* comprises a series of 22 tracts, numbered and printed in less than a hundred copies on color paper. At the bottom of each tract we find the title *Correspondance,* under which they appeared at the initiative of three men who were until then unknown in the Belgian avant-garde circles: Paul Nougé, Marcel Lecomte and Camille Goemans. Often drafted collectively, they aimed to travesty the style of the targeted authors. Although sometimes signed with initials, they were neither for sale nor available through a subscription, but sent to carefully selected figures. Distributed outside Belgium, they drew the attention of André Breton, Paul Eluard and Louis Aragon, among others. Contemporaneous with the publication of Breton's *Surrealist Manifesto, Correspondance* marked the beginning of the Brussels group and already bears witness to a difference in attitude and form compared to the Paris group, the Brussels group preferring strategic thinking and anonymity.

Bibliog.
Paul Aron (pref.), *Correspondance*
(Brussels, Didier Devillez, 1993)

Distances

Published in Paris at the address of Camille Goemans who was residing there at the same time as René Magritte, *Distances,* although conceived and printed in Brussels, was released over three issues between February and April 1928. The review acted as a Belgian embassy, as it were, since only members of the Brussels group were involved such as Mesens, Scutenaire, Magritte, Souris, Nougé and Lecomte – or their followers, such as Gaston Dehoy and Marc Eemans (who would soon be excluded from the group).

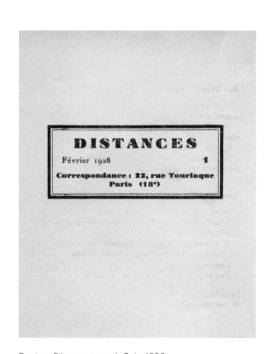

Review *Distances*, no. 1, Feb. 1928
Private collection

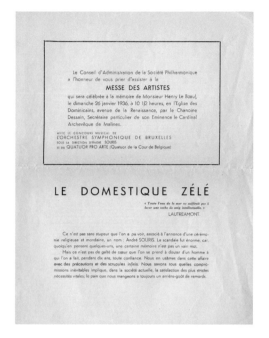

Domestique zélé (Le)

If we ignore the rather brief exclusion of Marcel Lecomte from *Correspondance,* the only exclusion to take place in Belgian surrealism was that of the musician André Souris, accused of having conducted a mass in memory of Henry Le Boeuf, one of the founders of the Centre for Fine Arts in Brussels. His exclusion happened on 21 January 1936 via the tract *Le Domestique zélé* (The zealous servant). Drafted by Paul Nougé – "The bread we eat always leaves an aftertaste of remorse" – it was signed by the members of the Brussels and Hainaut groups, Albert Ludé being the responsible publisher. Only Louis Scutenaire and Paul Colinet refused to add their signatures to the tract, as much as a matter of principle as out of sympathy for Souris. Although the latter was involved in a number of later activities, his exclusion not being definitive, Souris was profoundly marked by it for the rest of his life.

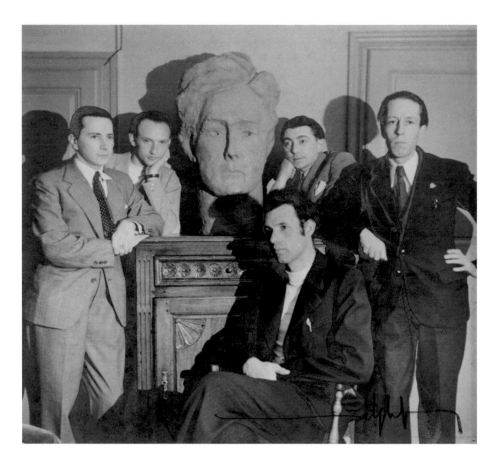

Edda

The first issue of the review *Edda* (subtitled "International documentary journals on the poetry and art of the avant-garde") was published in Brussels in the summer of 1958 at the initiative of Jacques Lacomblez. Its editorial was by Edouard Jaguer, the driving force behind the Phases group in France, of which *Edda* became the Belgian relay. The "Belgian sister of Phases" (in the words of Jacques Lacomblez), five issues of *Edda* were published between 1958 and 1964, and the list of its contributors bears witness to its openness: besides Jacques Zimmermann and Marie Carlier, they included Achille Chavée, Marcel Havrenne, Marcel Broodthaers, E.L.T. Mesens, Pierre Alechinsky, Jacques Matton, Paul Joostens and Marcel Lecomte.

Bibliog.
Phases belgiques: Courant continu
(Mons, Musée des Beaux-Arts, 1990)

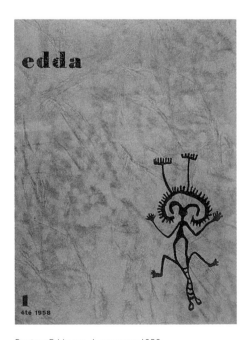

Review *Edda*, no. 1, summer 1958
Collection of the Province of Hainaut
on loan to BPS22, Charleroi

Hainaut surrealist group

After the dissolution of the Rupture group in late 1938, torn between a Stalinist wing (represented by Chavée and Dumont) and a Trotskyist wing (embodied by Lorent, Ludé and Havrenne), the former two founded in Mons on 1 July 1939 the Hainaut surrealist group, which Armand Simon, Louis Van de Spiegele, Marcel Lefrancq and Pol Bury, among others, joined later. All that remains of their plans for the collective journal *Mauvais temps 1939* is the cover designed by Lefrancq: mobilization and the outbreak of war would put a definitive end to the group's activities.

Bibliog.
Surréalisme en Hainaut: 1932-1945 (La Louvière, Institut des Arts et Métiers, 1979; Brussels, Palais des Beaux-Arts, 1980; Paris, Centre Wallonie-Bruxelles, 1980)

Haute Nuit

Officially dissolved in late 1946, the Hainaut surrealist group was succeeded by the Haute Nuit group, founded in Mons on 19 February 1947 by Achille Chavée, Marcel Lefrancq, Armand Simon and Louis Van de Spiegele as well as newcomers such as Jacques d'Hondt, Paul Franck, Michel Holyman and Franz Moreau.

Besides organizing several collective exhibitions, the Haute Nuit group focused on issuing publications, including Fernand Dumont's posthumous work. The group hesitated about openly taking part in Christian Dotremont's Revolutionary surrealism and about committing to CoBrA, struggling to overcome an all too narrow regionalism. No collective activity took place after 1949.

Bibliog.
Le Surréalisme à Mons et les Amis bruxellois
(Mons, Musée des Beaux-Arts, 1986)

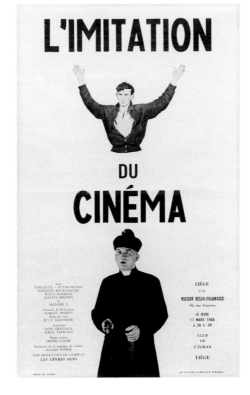

Poster for *L'Imitation du cinéma*, 1959
Collection of the Province of Hainaut
on loan to BPS22, Charleroi

Imitation du cinéma (L')

Made on a shoestring in 1959, Marcel
Mariën's *L'Imitation du cinéma* (The imitation
of cinema) is probably the only authentically
surrealist Belgian film. It is the story of a
young man (played by Tom Gutt) manip-
ulated by a crook posing as a priest who
decides to end his life on the cross but,
for lack of finding one his size, resolves to
gas himself with his arms spread. The film
caused a great scandal and, following a vio-
lent press campaign led by clerical circles –
"Can filmmakers do as they please?" asked
the newspaper *Gazet Van Antwerpen* – and
after several cinema owners abandoned the
idea of showing it, the film was banned from
public screenings in France and could only
be screened privately and upon invitation.
Although it is the work of a closely knit
group – Gilbert Senecaut, Jane Graverol,
Leo Dohmen, André Souris and Paul
Bourgoignie feature in it in varying degrees
– *L'Imitation du cinéma* was nevertheless
directed with seriousness and diligence by
Mariën, whose only film it was. Watching it
today, this medium-length film of 40 min-
utes reveals many qualities and shows some
fine editing.

Bibliog.
Xavier Canonne, Pierre-Olivier Rollin, Nancy Casielles
et al., *L'Imitation du cinéma de Marcel Mariën: Histoire
d'un film ignoble* (Paris, La Maison d'à côté, DVD, 2011)

Invention collective (L')

Only two issues were published of this re-
view founded by René Magritte and Raoul
Ubac, respectively in February and April
1940, just before Belgium entered the war.
The first issue brought together for the last
time the Brussels and Hainaut surrealists,
while the second opened up to members of
the Paris group, André Breton and Pierre
Mabille.

Bibliog.
Pierre Vilar (foreword), *L'Invention collective*
(Brussels, Didier Devillez, 1993)

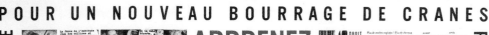

Review *L'Invention collective*, no. 1, Feb. 1940
Collection of the Province of Hainaut
on loan to BPS22, Charleroi

Lèvres nues (Les)

A publishing house as well as a review, *Les
Lèvres nues* saw the light of day in Verviers in
early 1954, where it was founded by Marcel
Mariën, Jane Graverol (who shared his life
at the time) and Paul Nougé (whom she had
taken in during his emotional and financial
collapse). *Les Lèvres nues* published the com-
plete writings of Nougé as well as several
works that were essential in making Belgian
surrealism known as well as recognized.
The review went through three series: a
first series of 12 issues and a special issue
published between 1954 and 1960; a second
series of 12 issues published between 1969
and 1975; and a third series published be-
tween 1987 and 1993, the year of Mariën's
death, the last series comprising 87 issues,
each one bearing a new title. Although all
surrealist authors featured in it (and not
only Belgians), the review mixing historical
documents, photographs, drawings, paint-
ings, collages and original texts, it cannot
really be called a collective review, since
Mariën alone defined the contents.

Bibliog.
Les Lèvres nues 1954-1958 (Paris, Allia, 1995)

Poster announcing the publication of *Les Lèvres nues*, 1955
Collection of the Province of Hainaut on loan to BPS22,
Charleroi

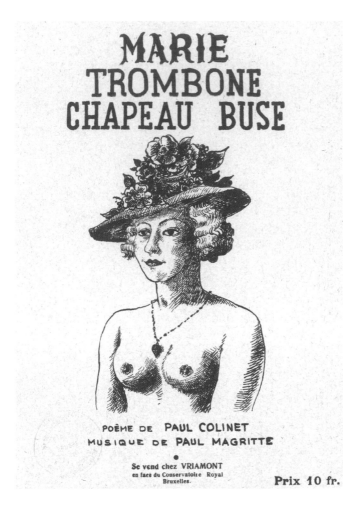

Marie

Three issues of the review *Marie* were published between June and July 1926, including a double issue, and an *Adieu à Marie* was published in early 1927 by E.L.T. Mesens, who had been without a review since *Œsophage*. Subtitled "A bimonthly magazine for the gilded youth," it is the first publication of a small surrealist circle gathered in the wake of *Correspondance* and *Œsophage*, Marcel Lecomte, E.L.T. Mesens, René Magritte, Camille Goemans, André Souris and Paul Nougé featuring among the contributors.

Bibliog.
Pierre-Yves Soucy (pref.), *Marie: Journal bimensuel pour la belle jeunesse* (Brussels, Didier Devillez, 1993)

Marie Trombone Chapeau Buse

This is a poem by Paul Colinet set to music by Paul Magritte, whose score was published in 1936 by Vriamont with a drawing by René Magritte. Although the latter illustrated many scores, the quality of the trio makes this a genuine surrealist piece, like *Garage* by Mesens on a poem by Philippe Soupault (1926).

Mauvais temps

Founded at La Louvière in 1934, *Mauvais temps* was the only collective publication of the Rupture group. It came out in the wake of the *Surrealist Exhibition* of October 1935 and gathered the group's most active members, thereby constituting its "passport" in surrealism. Poetry (by Jean Dieu, Achille Chavée, Fernand Dumont and André Lorent, among others), literary criticism (Marcel Havrenne's "Notes on Lautréamont"), political analysis (Lorent's "Le Chemin de la trahison") or the place given to the proletarian writer Constant Malva set the tone for a group seeking to achieve an alchemy between poetry and politics. The foreword to the journal mentions the need to "strengthen revolutionary consciences" and to "participate in the elaboration of a proletarian moral," while underlining the impossibility of "intellectual collaboration with Christians," the members of Rupture declaring themselves to be "irreducibly opposed to any confusion arising from the ghostly God." In a letter to Dumont dated 1 November 1935, André Breton encouraged the group to manifest itself more: "A review like *Mauvais temps* really satisfies, at all levels, my greatest desire." Not yet counting any visual artists, the Rupture group entrusted the illustration of *Mauvais temps* to René Magritte and Max Servais. Two other issues were planned: *Mauvais temps 1936* (postponed due to Chavée's enlistment in the International Brigades during the Spanish Civil War), and *Mauvais temps 1937* (of which all that remains is a draft table of contents). All that is left of *Mauvais temps 1939* is a draft cover, a collage by Marcel Lefrancq, the Rupture group having been unable to overcome the internal tensions that led to its dissolution.

Bibliog.
Pol Bury (pref.), *Mauvais temps 1935* (Brussels, Didier Devillez, 1993)

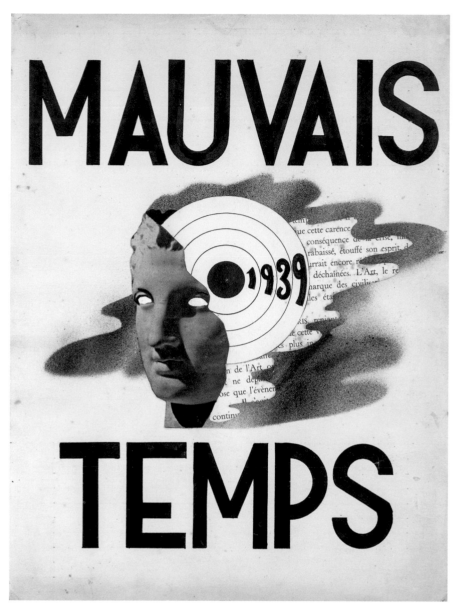

Marcel Lefrancq
Draft cover of *Mauvais temps*, 1939
Collage and drawing
Collection of Michel Lefrancq, Mons

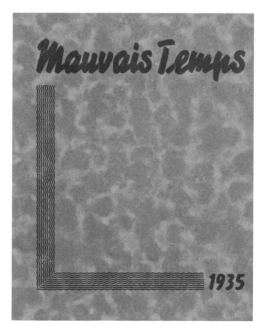

Review *Mauvais temps*, 1935
The Rupture group, La Louvière
Collection of the Province of Hainaut
on loan to BPS22, Charleroi

Cover of the review *Le Surréalisme Révolutionnaire*, March-April 1948
Collection of the Province of Hainaut
on loan to BPS22, Charleroi

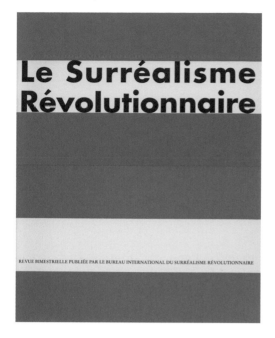

Revolutionary surrealism

Founded in the summer of 1947 by Christian Dotremont and Noël Arnaud, this group sought to distinguish itself from the surrealism of André Breton and his followers and to revive the movement's political commitment. The expression of a second generation of surrealists who spent the war in occupied Belgium or France, it once again attempted the difficult exercise of combining poetry and politics. Although, in Belgium, René Magritte, Paul Nougé, Marcel Mariën, André Chavée, Albert Ludé, Louis Scutenaire and André Lorent joined the movement for a short while, they soon distanced themselves from it. Rejected by the Communist Party and strongly opposed to Breton, the revolutionary surrealists were forced to dissolve after the failure of the international conference organized in Paris in November 1948, in the wake of the October 1947 conference in Brussels that had brought together Belgians, Frenchmen, Danes and Czechs. Out of this collapse emerged that same month CoBrA, of which Dotremont was the driving force and secretary.

Bibliog.
Xavier Canonne (foreword), *Le surréalisme-révolutionnaire* (Brussels, Didier Devillez, 1999)

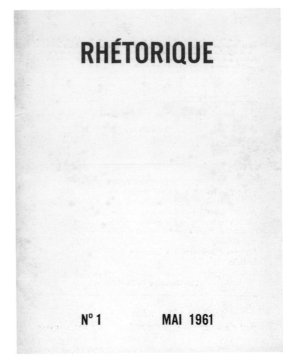

RHÉTORIQUE

N° 1 MAI 1961

Review *Rhétorique,* no. 1, May 1961
Collection of the Province of Hainaut
on loan to BPS22, Charleroi

Rhétorique

The first issue of the review *Rhétorique* came
out in late May 1961 at Tilleur-lez-Liège. It
was the fruit of the encounter between the
painter René Magritte and a young admirer,
André Bosmans, a schoolteacher in the
process of finishing his military service. Both
men had been corresponding since 1958.
Twelve other issues followed until February
1966. Now monographic, now collective,
Rhétorique is devoted entirely to the work
of Magritte, who took all editorial decisions
and financed it entirely.

Marcel Lefrancq
The Rupture group, 1938
From left to right: Max Michotte, Marcel Havrenne,
André Lorent, Bob Deplus, André Bovy, Achille
Chavée, Fernand Dumont, Constant Malva
Collection of Michel Lefrancq, Mons

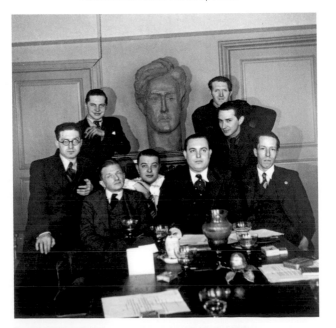

Rupture

The Rupture group was founded on 29 March
1934 at Haine-St-Paul by the lawyer Achille
Chavée, the librarian André Lorent, the
chemist Albert Ludé, and the schoolteacher
Marcel Parfondry, who recorded its statutes
in a school notebook. Besides the obligation
to belong to a left-wing political movement,
the group's aims were: "1) to strengthen rev-
olutionary consciences; 2) to participate in
the elaboration of a proletarian moral." The
group was soon joined by the lawyer André
Bovy, the musician Jean Louthe, and then
Fernand Dumont and Marcel Havrenne,
who were initially seen as "colonial" mem-
bers, i.e. sympathizers. It is only in 1935 that
the Rupture group explicitly rallied surreal-
ism during a gathering attended by Dumont
and E.L.T. Mesens. The year 1935 was in fact
the group's most productive time: it orga-
nized the *Surrealist Exhibition* in La Louvière
and published the collective journal *Mau-
vais temps,* which received an enthusiastic
response from André Breton. Plans for a
second issue, *Mauvais temps 1936,* were
postponed, Chavée having enlisted in the
International Brigades in Spain. The group
then limited its activities to publishing, the
Cahiers de Rupture bringing out *Borins* by the
proletarian writer Constant Malva, *A Ciel
ouvert* by Dumont, as well as *Le Cendrier
de chair* and *Une Fois pour toutes* by Chavée.
The latter's return from Spain in 1937 and
the divergent political leanings of its mem-
bers led to Rupture's dissolution, leading to
the creation of the Hainaut surrealist group
on 1 July 1939 in Mons.

Bibliog.
Surréalisme en Hainaut, 1932-1945 (La Louvière, Institut
des Arts et Métiers, 1979; Brussels, Palais des Beaux
-Arts, 1980; Paris, Centre Wallonie-Bruxelles, 1980)

Surrealism in 1929

Published in June 1929, the contents of this
special issue of Paul-Gustave Van Hecke's
review *Variétés* was drawn up by André
Breton and Louis Aragon with the help of
E.L.T. Mesens. In order to cover the high
cost of this special issue, the very erotic
1929 was published and sold clandestinely:
it featured four photographs by Man Ray
and texts by Benjamin Péret and Louis
Aragon.

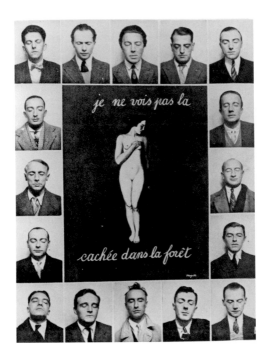

The surrealists with their eyes closed around René
Magritte's painting *The Hidden Woman (La femme
cachée)* in *La Révolution surréaliste,* no. 12, Dec. 1929
Private collection

Catalog of the *Magritte* exhibition,
Paris, Galerie du Faubourg, 1948
Collection of the Province of Hainaut
on loan to BPS22, Charleroi

Surrealist Exhibition

Considered by some to be the first of its
kind in the world, the *Surrealist Exhibition*
of October 1935 in La Louvière took place
one year after the *Minotaur* exhibition of
the Centre for Fine Arts in Brussels (also
organized by E.L.T. Mesens), but preceded
the *International Surrealist Exhibition* at the
New Burlington galleries in London in 1936.
We must also recall the *Surrealist Exhibition*
at Galerie Pierre in 1925 in Paris, whose
catalog was prefaced by André Breton and
Robert Desnos. Nevertheless, the catalog
is striking for the quality of the works as-
sembled for a fortnight in October 1935 in a
rather dilapidated venue. Although the ex-
hibition was not a success, it served to con-
solidate the Rupture group by offering it its
first – and alas only – moment of glory, the
group publishing in the wake of the show
the collective journal *Mauvais temps,* which
drew André Breton's interest.

Program of the *Surrealist Exhibition,*
La Louvière, 1935
Collection of the Province of Hainaut
on loan to BPS22, Charleroi

"Vache" period

In May 1948, René Magritte exhibited at
Galerie du Faubourg in Paris about thirty
paintings and gouaches of the sixty that
make up what is known as the "vache" (cow)
period. Painted in haste, in bright colors and
a flamboyant style, they were for Magritte
not only a means by which to thumb his
nose at the Parisian public and his admir-
ers, but also an exhilarating outburst in his
way of painting, reminiscent of the comics
of his childhood such as Louis Forton's *Les
Pieds nickelés,* and an exploration of new
themes. The exhibition catalog includes a
text by Louis Scutenaire, "Les pieds dans
le plat" (Putting one's foot in it), the same
Scutenaire producing a complicit and equally
exhilarating tract in the face of the public's
incomprehension: "Going on about the Paris
exhibition of works by René Magritte is pre-
mature. Let's visit it!" Contemporary eye-
witnesses – Scutenaire, Mariën and Jacques
Wergifosse – had never seen Magritte
as happy as with these gaudy paintings,
thrilled at having been able to rid himself
of the "chore of painting." Nevertheless, to
please his wife, he took up his old ways. We
are indebted to Scutenaire for saving these
works which long remained in Paris without
too much interest from the painter.

Bibliog.
David Sylvester and Jan Ceuleers, *René Magritte:
Peintures et gouaches* (Antwerp, Ronny Van de Velde,
1994)

Vendonah

Taking its title from the name of a Native
American chief mentioned in Orson Welles's
The Magnificent Ambersons (1942), the review
Vendonah was released at the initiative of
Tom Gutt in May 1963. It was mimeographed
on colored paper and had a print run of 250.
Twenty-nine issues appeared by December
1964. Polemical and violent in tone, it tar-
geted equally Salvador Dali, the painter Paul
Delvaux and Jacques Lacomblez's group, and
constitutes one of the first collective manifes-
tations of, in Scutenaire's term, the "gang" of
Gutt and his followers, who wanted to revive
surrealism in Belgium.

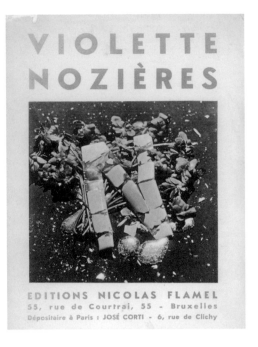

Collective publication *Violette Nozières*,
Dec. 1933
Collection of the Province of Hainaut
on loan to BPS22, Charleroi

Violette Nozières

In August 1933 in Paris, an eighteen-year-old student was arrested for the murder of her father, her mother having narrowly escaped death. Suspected of being easy, Violette, the "poisoner" whose guilt everything seemed to underline, was condemned to death, but the sentence was commuted to a life sentence of hard labor in 1935. The trial showed that she had been abused by her father, a railway employee, since the age of twelve. The surrealists grew very interested in the young patricide: Paul Eluard and André Breton gathered the contributions and asked E.L.T. Mesens to publish in his Editions Nicolas Flamel a small volume with a cover photograph by Man Ray. Salvador Dali, Yves Tanguy, Max Ernst, René Magritte and Alberto Giacometti were among the contributors to this volume, of which a number of copies were seized at the French border. "Violette dreamed of undoing / has undone / the horrible snake-like coils of blood ties," wrote Eluard. The one to whom Breton would send a bouquet of red roses upon her release would see, in 1943, before her "resurrection," her sentence commuted into twelve years of imprisonment by Marshal Pétain and would leave prison, General de Gaulle annulling at the Liberation her ban on visiting specific places. Married to the son of the steward of the prison of Rennes, she would go on to have five children, opening a roadside café in Normandy and dying with her name cleared in 1966, having even taken in her elderly mother.

Vocatif (Le)

A simple sheet folded in four, a cover generally free from any illustration, irregular and unpredictable publication dates: such are the characteristics of the review *Le Vocatif*, launched in October 1972 by Tom Gutt and of which about 300 issues were released by 2002. Generally devoted to a single author, the review presents texts and documents concerning the main actors of the surrealist movement in Belgium and abroad. It was occasionally a collective effort. Like Marcel Mariën's *Les Lèvres nues*, this publication bears witness to the endurance of the surrealist spirit and to Gutt's mobilizing role.

What Is Surrealism?

Title of a lecture given by André Breton on 1 June 1934 in Brussels, at La Maison des Huit Heures, the seat of the socialist trade unions, of which the text was reproduced in the eponymous book published by Henriquez, its cover featuring René Magritte's painting *The Rape*. The talk was delivered during the *Minotaur* exhibition at the Centre for Fine Arts in Brussels, in front of Paul Nougé and his followers. Breton addressed the latter as "surrealist comrades from Belgium," which Nougé would then consent to accept "for the sake of the conversation."

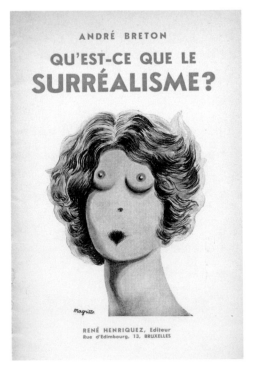

André Breton
Cover of *Qu'est-ce que le Surréalisme?*
Collection of the Province of Hainaut
on loan to BPS22, Charleroi

CATALOG

Rachel Baes (Ixelles, 1912 – Bruges, 1983)

Painter, draftswoman

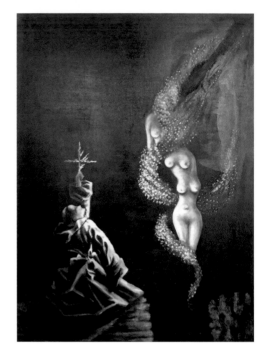

Rachel Baes
*The Temptation of Saint Anthony
(La Tentation de saint Antoine),* 1973
Oil on canvas
Private collection

It is in 1945, after having tragically lost her beloved some years earlier, that Rachel Baes met Paul Eluard (who would preface her first Paris exhibition) and that she turned to surrealism. René Magritte painted her "portrait," *Sheherazade,* in 1947, the year in which Marcel Lecomte devoted a first study to her.

Living in Paris, she was in contact with figures as diverse as Pablo Picasso, Paul Léautaud and Jean Cocteau, and in 1953 she held an exhibition at Galerie L'Etoile with the backing of André Breton. Upon her return to Bruges in Belgium in 1963, Baes pursued her oeuvre, an introspective body of work that relies on an uncompromising technique and in which young girls reenact childhood dramas. Although she refrained from participating in any collective activity, her work drew the attention and esteem of both the Belgian and French surrealists.

Rachel Baes
*The Altarpiece
(Le Retable),* 1960
Oil on canvas
Private collection

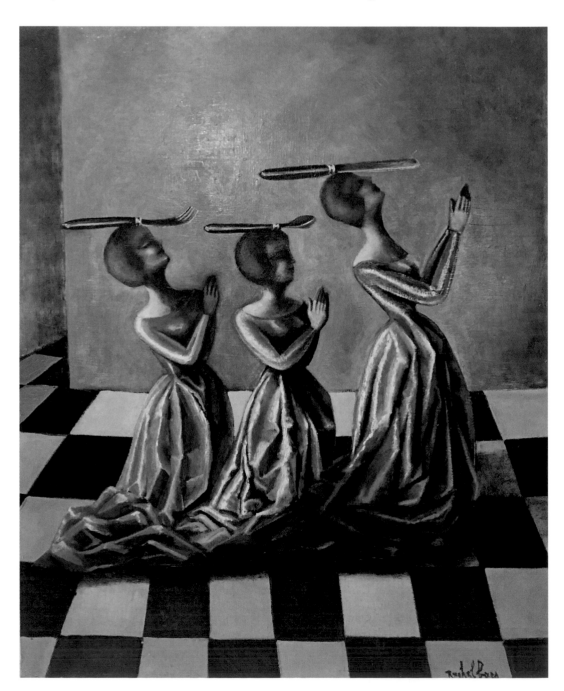

Bibliog.
Marianne Janssens, Patrick Spriet, Sofie Van Loo, Xavier Canonne et al., *Gekooid verlangen: Jane Graverol, Rachel Baes en het surrealisme* (Antwerp, Ludion, 2002)

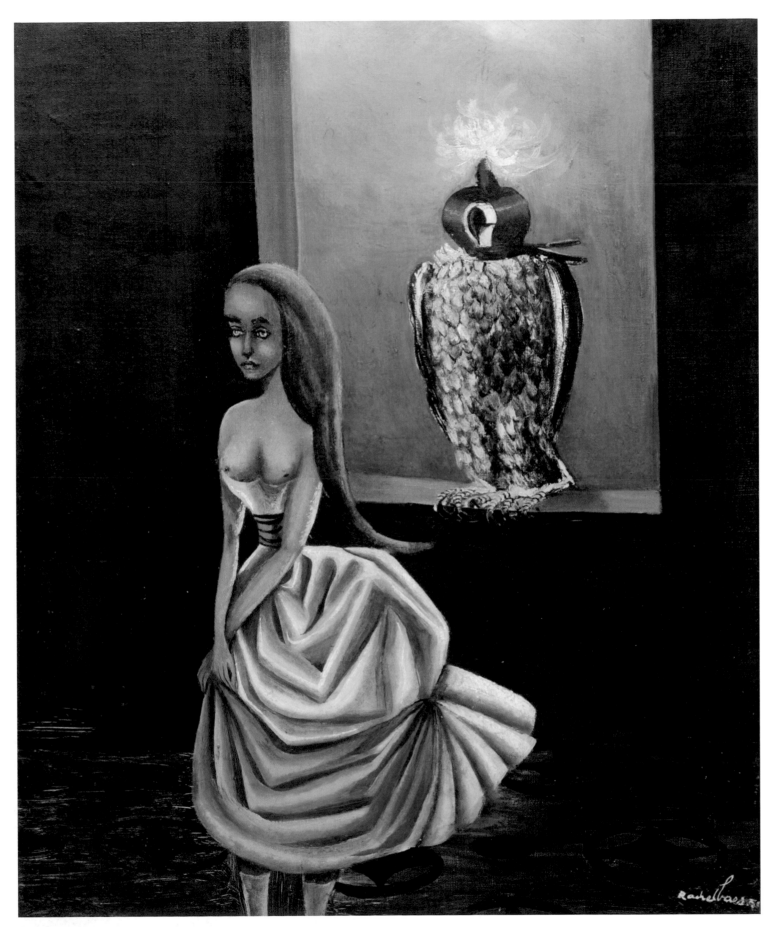

Rachel Baes
Oh! (Ah !), 1954
Oil on canvas
Collection of the Province of Hainaut
on loan to BPS22, Charleroi

Gilles Brenta (Brussels, 1943)

Painter, collagist

A props man and decorator by profession, Gilles Brenta met Louis Scutenaire (who would preface his first exhibition) at Tom Gutt's Galerie La Marée in 1976. A friend of Gutt and Claudine Jamagne's, he illustrated several of their books and was closely involved in their activities. He also collaborated on Marcel Mariën's review *Les Lèvres nues*. Although uninterested in painting itself, Brenta was technically skilled and sought to trick the spectator's gaze and representation itself in paintings replete with pitfalls, sometimes revisiting earlier work. Brenta, who rarely exhibits his work, has lived in the southeast of France for the past decade.

Gilles Brenta
Untitled (Sans titre), 1978
Oil on canvas
Private collection

Gilles Brenta
Untitled (Sans titre), 1982
Oil on canvas
Private collection

Bibliog.
Xavier Canonne, *Le Surréalisme en Belgique: 1924-2000* (Brussels, Fonds Mercator, 2007)

Gilles Brenta
Untitled (Sans titre), 1982
Oil on canvas
Private collection

Pol Bury (Haine-Saint-Pierre, 1922 – Paris, 2005)

Painter, sculptor, writer

Georges Thiry
Pol Bury, c. 1960
Museum of Photography, Charleroi –
Yellow-Now Editeur

Upon graduating from the Fine Arts Academy of Mons in 1938, Pol Bury met Achille Chavée (whose book *D'ombre et de sang* he would illustrate) and took part in the activities of the Hainaut surrealist group. He collaborated on the review *L'Invention collective* and subsequently produced works inspired by Magritte. Gradually freeing himself from this influence, he moved towards abstraction and, after a brief passage in CoBrA, he abandoned painting in 1953 for "mobile planes," introducing movement into his compositions. It is this kinetic component that appears in his wood and metal sculptures and in his fountains, works in praise of slowness. It is also present in his "kinetizations," works on paper or photographs that displace the subject by making it move and undulate.

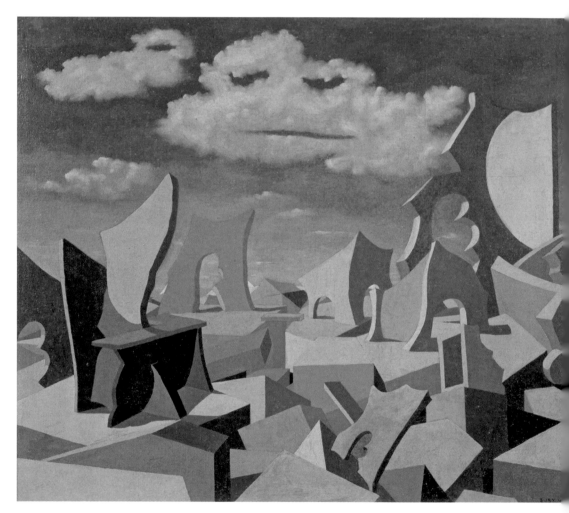

Pol Bury
*The Old Age of Copper
(Vieillesse du cuivre)*, 1944
Oil on canvas
Collection of the Province of Hainaut
on loan to BPS22, Charleroi

Bibliog.
Pierre Descargues, *Les fontaines de Pol Bury*
(La Louvière, Le Daily-Bûl, 1986);
Eugène Ionesco and André Balthazar,
Pol Bury (Brussels, Cosmos, 1976);
Pol Bury: Rencontres et connivences
(La Louvière, Musée Ianchelevici, 2002)

Achille Chavée (Charleroi, 1906 – La Hestre, 1969)

Poet

Portrait of Achille Chavée, n.d.
Private collection

Politically active as the cofounder in 1927 of the Walloon Federalist Union, which advocated the cultural and economic autonomy of Wallonia, the southern region of Belgium, it is as a matter of course that Achille Chavée, a lawyer, took part in the 1932 strikes and discovered, through the librarian André Lorent, the works of André Breton. Together with Albert Ludé, André Lorent and Marcel Parfondry, Chavée founded, on 29 March 1934, at Haine-Saint-Paul near La Louvière, the Rupture group, which would only explicitly adhere to surrealism in 1935, when Fernand Dumont and Marcel Havrenne joined. It was at the initiative of the Rupture group, and with the help of E.L.T. Mesens, that the *Surrealist Exhibition* was organized at La Louvière in October 1935, on which occasion the group published its only collective journal, *Mauvais temps*.

Chavée's enlistment in the International Brigades in 1936 led the group to relocate to Mons, complicating any efforts to act collectively. Upon the dissolution of the Rupture group, Chavée and Dumont founded the Hainaut surrealist group in 1939. Forced underground during the German occupation, Chavée was unable to take up a leading role after the war, despite the formation of the Haute Nuit group in February 1947 at Mons, whose main activity would be publishing. Throughout his life Chavée remained loyal to a certain form of automatic writing, even though today his aphorisms (*Laetare 59,* 1959) and dialogues (*L'Éléphant blanc,* 1961) dominate an abundant body of work. His role as a mobilizer of young artists in the Centre region in the province of Hainaut and his silhouette moving from café to café turned him into a legendary figure in La Louvière.

Bibliog.
André Miguel, *Achille Chavée* (Paris, Seghers, 1968); *Autour d'Achille Chavée* (La Louvière, Musée Ianchelevici, 1999)

Achille Chavée
The Palace (Le Palais),
6 Sept. 1939
Ink on paper
Collection of the City
of La Louvière

Paul Colinet (Arquennes, 1898 – Brussels, 1957)

Poet, draftsman

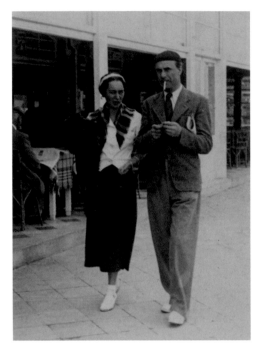

Georgette Magritte and Paul Colinet, De Panne, 1937
Private collection

Although a native of the province of Hainaut and close to the Brussels surrealists since 1933, it is only starting from 1936, after the *Surrealist Exhibition* of La Louvière, that his name began to feature next to theirs, so to speak. Indeed, his signature never in fact appeared at the bottom of a tract or a collective declaration, the political side of surrealism and its revolutionary commitment having failed to motivate the poet of *Les histoires de la lampe* (1942). He preferred to focus on language, inventing words, transforming expressions to produce falsely naïve fabliaux reminiscent of childhood. Opening up the field of surrealism, he revealed to his friends figures as remarkable as his nephew Robert Willems or the painter and poet Armand Permantier as well as other "irregulars" whom he had a genius for detecting, like the poet Robert Desmeth or the Piqueray brothers.

Paul Colinet
*The Labors of Hercules
(Les Travaux d'Hercule),* 1942
Ink on paper
Collection of the Province of Hainaut
on loan to BPS22, Charleroi

Paul Colinet
*Fog Effect and a Crisis of Enthusiasm
(Effet de brouillard etcrise d'enthousiasme),* c. 1950
*Passer-By, Amphibians and Amateurs of Lashes
(Passant, amphibies et amateurs de cils),* c. 1950
*Mountain and Useful Objects
(Haute-Montagne et objets utiles),* c. 1950
*Skyline Overcoming Its Difficulties
(Ligne d'horizon surmontant ses difficultés),* c. 1950
Pencil on paper
Private collection

Bibliog.
Paul Colinet 1898-1957 (La Louvière, Direction générale des Affaires culturelles du Hainaut, 1997); *Œuvres,* 4 vols. (Brussels, Lebeer-Hosmann, 1980-89)

Effet de brouillard et
crise d'enthousiasme

Haute-Montagne et objets utiles

Passant, amphibies et
amateurs de cils

Ligne d'horizon surmontant
ses difficultés

Paul Delvaux (Antheit, 1897 – Veurne, 1994)

Painter, draftsman

Charles Leirens
Paul Delvaux, c. 1950
Museum of Photography, Charleroi

A student of the symbolist painter Jean Delville, Paul Delvaux enrolled in 1920 at the Fine Arts Academy of Brussels where René Magritte was a fellow student. He met E.L.T. Mesens in 1930 and discovered the work of Giorgio de Chirico in 1934 at the *Minotaur* exhibition held at the Centre for Fine Arts in Brussels. His painting then took on a somewhat surrealist aspect, depicting cities at nighttime, antique buildings, and rural train stations peopled with naked ladies. Although André Breton and Paul Eluard showed an interest in his work, inviting him to participate in the *International Surrealism Exhibition* in Paris in 1938 and in Mexico in 1940, the Belgian surrealists were more reserved towards him.

Delvaux, who participated with the surrealists in the review *L'Invention collective* in 1940, was criticized by Magritte and Mariën for the overly dreamlike and symbolic aspect of his work. As a result he refrained from participating in any collective activity of the Brussels group, wary of surrealism's political component.

Paul Delvaux
Untitled (Sans titre), 1949
Ink on paper
Private collection

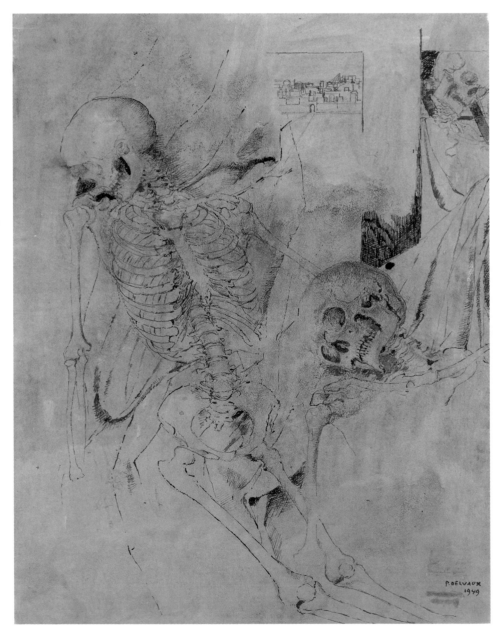

Bibliog.
Michel Butor, Jean Clair and Suzanne Houbart-Wilkin, *Delvaux: Catalogue de l'œuvre peint* (Brussels, Cosmos, 1975);
Barbara Emerson, *Delvaux* (Antwerp, Fonds Mercator, 1985)

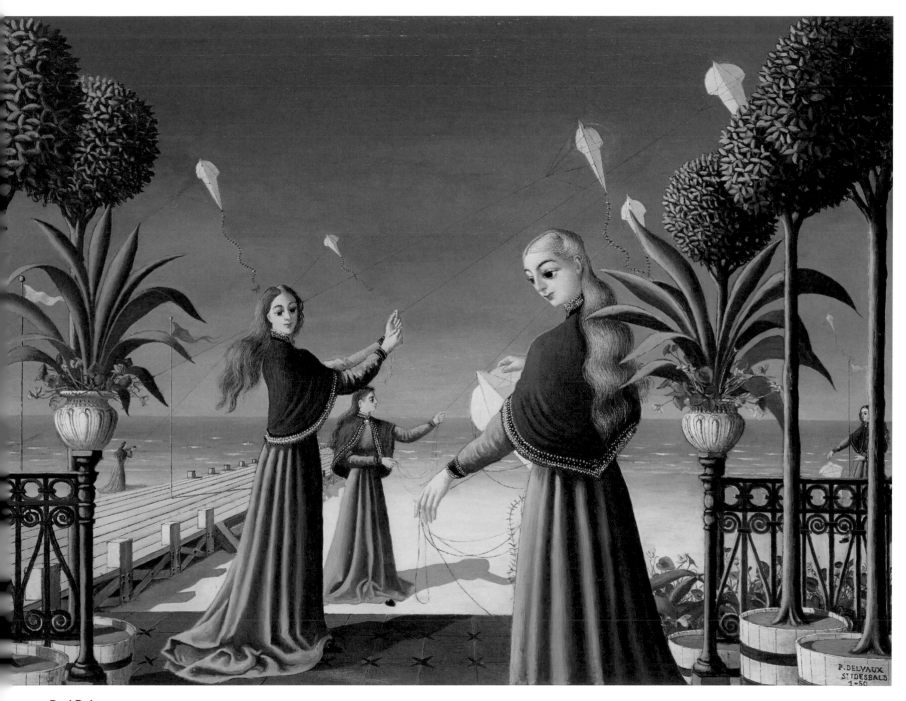

Paul Delvaux
The Kites (Les Cerfs-volants), 1950
Oil on canvas
Private collection

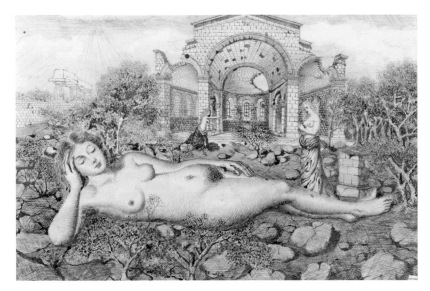

Paul Delvaux
Nude in a Forest (Nu dans un bois), 1938
Ink on paper
B.K.W. Gallery, Brussels

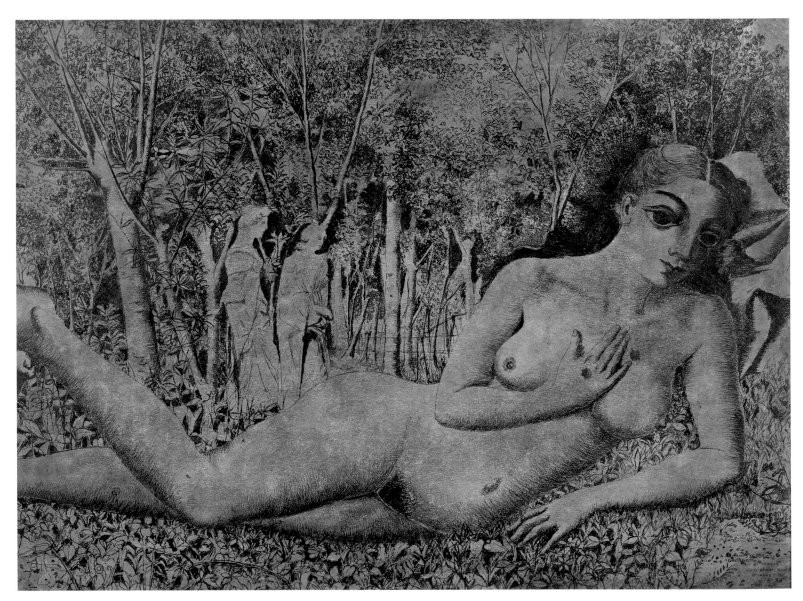

Paul Delvaux
*The Garden of the Caryatids
(Le Jardin des Cariatides)*, 1948
Ink on paper
Private collection

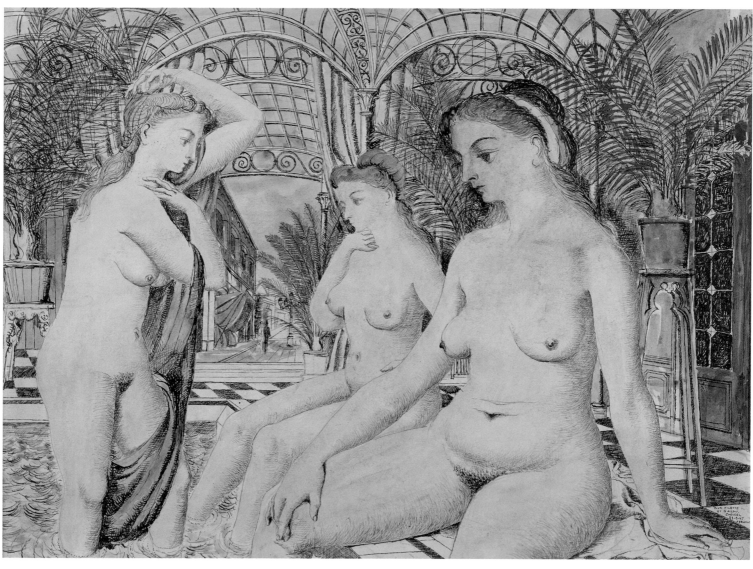

Paul Delvaux
The Swimmers (Les Baigneuses), 1947
Ink on paper
Private collection

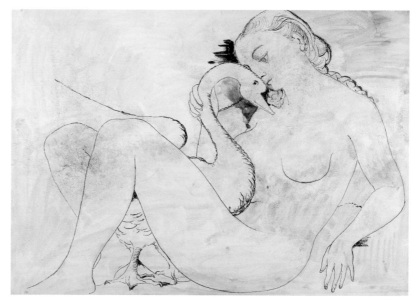

Paul Delvaux
The Swinging Chair
(La Balancelle), 1947
Watercolor and ink on paper
Private collection

Leo Dohmen (Antwerp, 1929 – 1999)

Photographer, collagist, assemblagist

Leo Dohmen
Self-Portrait, 1955
Collection of Mireille Dohmen

A young chemical engineer, Leo Dohmen met Gilbert Senecaut and Marcel Mariën in the 1950s. This was the start of a longlasting friendship that would see Dohmen assist Mariën on the set of the film *L'Imitation du cinéma* in 1959 and create the photomontage illustrating the apocryphal tract *Grande baisse* in 1962 that tricked René Magritte and his admirers. Dohmen gave up photography towards 1965 , having been charged with the sale of erotic photographs, but not, however, without having produced some of the icons of Belgian surrealism, such as *L'Ambitieuse* (1958) and *L'Ebéniste* (1955).

Dohmen was a legendary figure in Antwerp, where he ran various galleries before returning to the creation of assemblages and collages, perpetuating in that city, with Senecaut and Roger Van de Wouwer, a small surrealist group which he called the "Scheldt group" after the river of the same name that runs through the city.

Leo Dohmen
Berenice, 1956
Black and white photograph
Private collection

Leo Dohmen
Seasickness (Le Mal de mer), 1958
Black and white photograph
Museum of Photography, Charleroi

Leo Dohmen
The Cabinetmaker (L'Ébéniste), 1958
Black and white photograph
Collection of Mireille Dohmen

Bibliog.
Jan Ceuleers, Leo Dohmen, *1929-1999: Regardez! Réfléchissez! Gagnez!* (Antwerp, Ronny Van de Velde, 1999);
Xavier Canonne, Jan Ceuleers and Mireille Dohmen, *Copyright Leo Dohmen* (Charleroi, Musée de la Photographie, 2009)

Leo Dohmen
*The Ambitious One
(L'Ambitieuse)*, 1958
Black and white photograph
Museum of Photography, Charleroi

Fernand Dumont (Mons, 1906 – Bergen-Belsen, 1945)

Poet, writer; real name: Fernand Demoustier

Marcel Lefrancq
Fernand Dumont, 1938
Collection of Michel Lefrancq, Mons

It is in 1925 in high school at Mons that Fernand Demoustier – who, out of love for his native city, would use the pseudonym Dumont – met Armand Simon and Achille Chavée, meeting up again with the latter at the University of Brussels where they both studied law. His discovery of André Breton's writings incited him to visit the latter in Paris in 1933 and then to join the Rupture group, eager to offer the movement a broader poetic component. He helped bring about the *Surrealist Exhibition* of October 1935 in La Louvière and published his first text, "L'influence du soleil," in the journal *Mauvais temps.* Fascinated by Breton, he was in close contact with the Paris group and showed its members the drawings of Armand Simon. The cofounder of the Watchfulness Committtee of Anti-fascist Intellectuals, he was arrested by the Nazis in April 1942 and held in various locations in the Netherlands and Germany before dying in captivity in March 1945 at the Bergen-Belsen camp.

Fernand Dumont
Untitled (Sans titre), 1940
Ink on paper
Private collection

Fernand Dumont
Untitled (Sans titre), 1940
Ink on paper
Private collection

Bibliog.
Fernand Dumont, *La région du cœur et autres textes* (Brussels, Labor, 1985);
Xavier Canonne, *Fernand Dumont 1906-1945: Aux cailloux des chemins* (Brussels, Labor, 2006).

Claude Galand (Trivières, 1946)

Painter, draftsman, collagist

Initially close to Achille Chavée, who he encountered in the 1960s, and to Armand Simon, who he also knew, Claude Galand then grew close to the group of Tom Gutt, with who he collaborated intensely, producing various illustrations and collages, and taking part in various collective publications and exhibitions. His meticulous work rests on the close observation of everyday life, whose objects transform and move themselves, like his female bodies, Galand's eroticism often coupled with darkly funny humor.

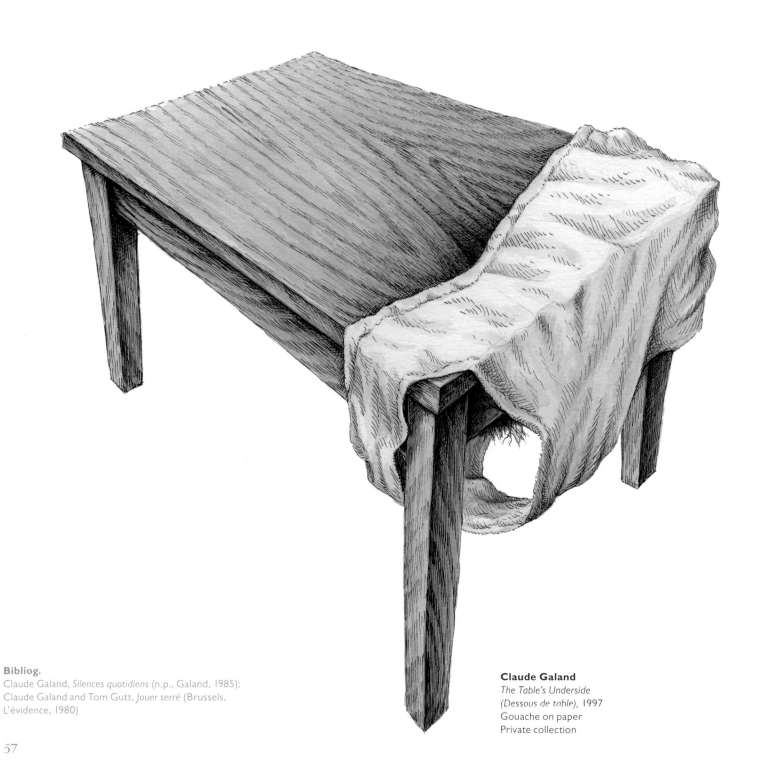

Bibliog.
Claude Galand, *Silences quotidiens* (n.p., Galand, 1985);
Claude Galand and Tom Gutt, *Jouer serré* (Brussels,
L'évidence, 1980)

Claude Galand
*The Table's Underside
(Dessous de table)*, 1997
Gouache on paper
Private collection

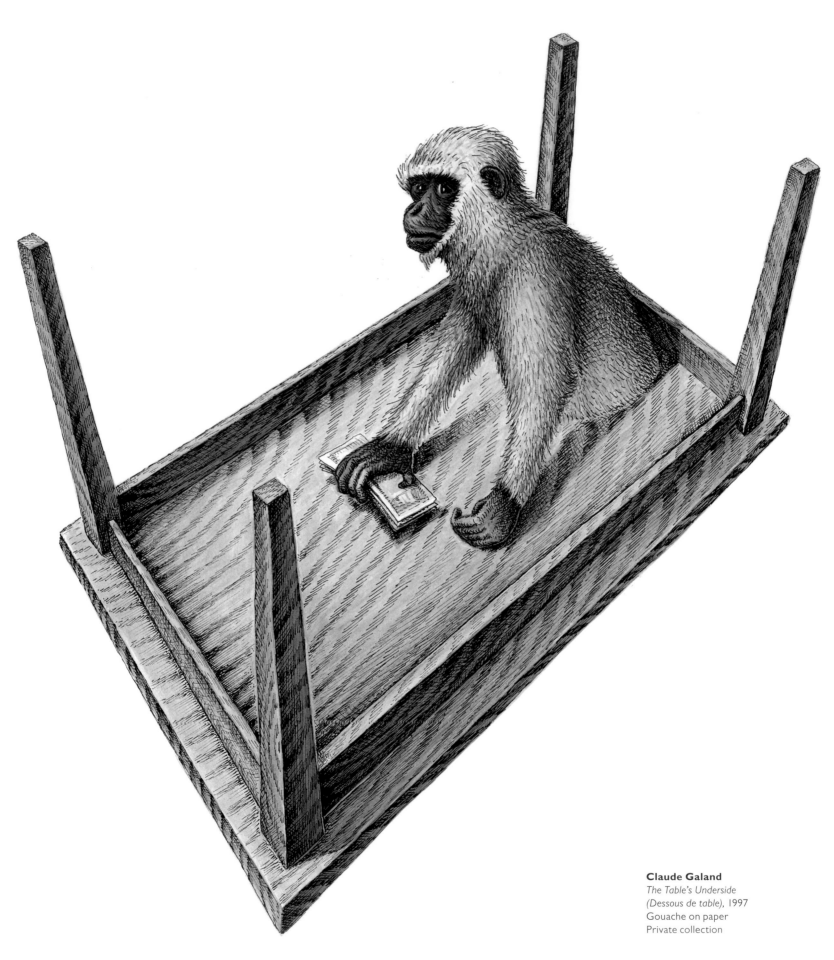

Claude Galand
*The Table's Underside
(Dessous de table)*, 1997
Gouache on paper
Private collection

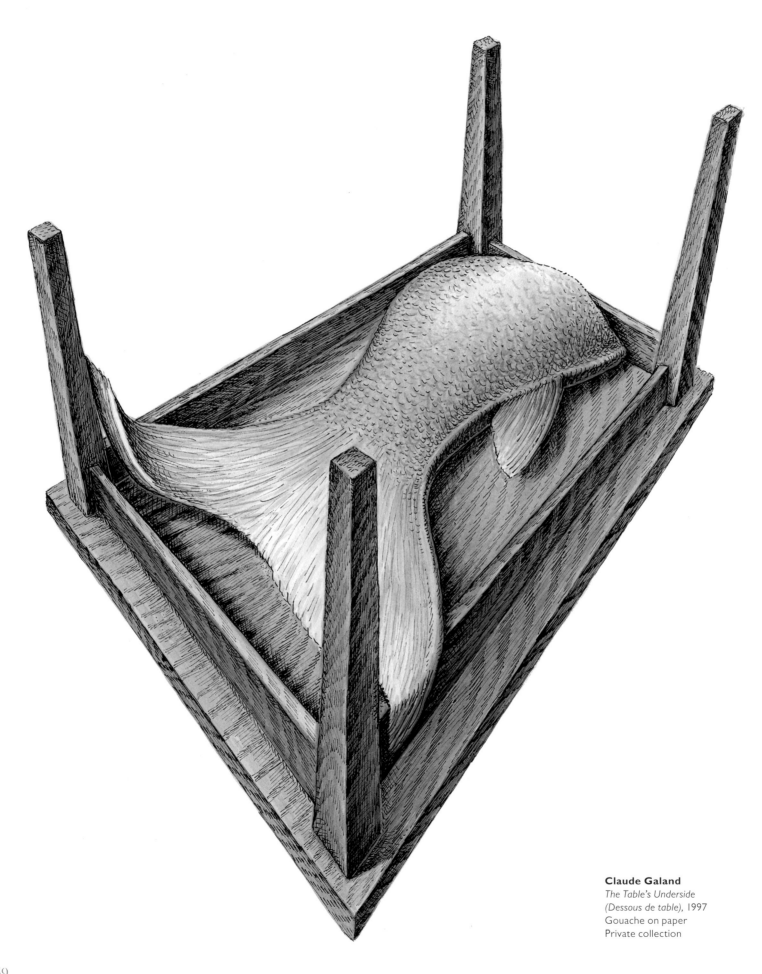

Claude Galand
*The Table's Underside
(Dessous de table)*, 1997
Gouache on paper
Private collection

Camille Goemans (Leuven, 1900 – Brussels, 1960)

Poet

Portrait of Camille Goemans (right), 1928
Private collection

A schoolmate of Henri Michaux's at Collège Saint-Michel in Brussels, Camille Goemans soon came into contact with Paul Nougé and Marcel Lecomte, with who he published in 1924 the *Correspondance* tracts, marking the beginning of surrealism in Belgium. That same year saw the release of his book *Périples,* the only work published in his lifetime. He moved to Paris in 1926, opening a gallery that showed the collages of Max Ernst in 1929 and the first Paris exhibition of Magritte and Dali in 1930. Following the failure of his gallery Goemans progressively distanced himself from any collective activity, even though he retained close ties with the group.

Bibliog.
Camille Goemans, *Œuvre 1922-1957*
(Brussels, André de Rache, 1970)

Camille Goemans
Périples (Voyages), 1924
Private collection

Jane Graverol (Ixelles, 1905 – Fontainebleau, 1984)

Painter, draftswoman

Jane Graverol, c. 1925
Private collection

The daughter of the symbolist painter Alexandre Graverol (a friend of Verlaine's), Jane Graverol met René Magritte in 1949, an encounter that would alter her painting. In 1953 she organized in Verviers, where she lived, an exhibition of works by Magritte, thereby coming into contact with the Brussels group and Marcel Mariën, whose life she would share for the next decade. The cofounder with André Blavier of the review *Temps mêlés,* she was also behind the review *Les Lèvres nues,* set up with Mariën and Paul Nougé, whom she took in at Verviers after his moral and emotional collapse. She worked closely on *L'Imitation du cinéma,* directed by Mariën in 1959. She met André Breton in Paris and later Marcel Duchamp in New York before returning to settle in France, where she married Dr. Ferdière, Antonin Artaud's former physician. She nevertheless retained close ties with the Brussels group.

Jane Graverol
*Natural Harmonies
(Les Harmonies naturelles),* 1956
Oil on canvas
Collection of the Province of Hainaut
on loan to BPS22, Charleroi

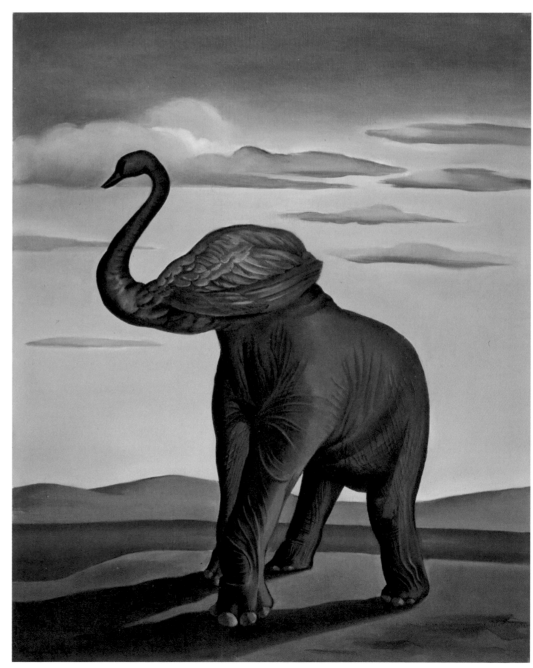

Bibliog.
Jane Graverol (Brussels, Crédit Communal, 1990); Marianne Janssens, Patrick Spriet, Sofie Van Loo, Xavier Canonne et al., *Gekooid verlangen: Jane Graverol, Rachel Baes en het surrealisme* (Antwerp, Ludion, 2002)

Tom Gutt (Woking, 1941 – Brussels, 2002)

Poet, writer, publisher, collagist, assemblagist

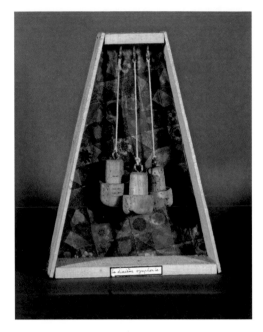

Tom Gutt
*The Tenth Symphony
(La Dixième symphonie)*, 1976
Assemblage
Private collection

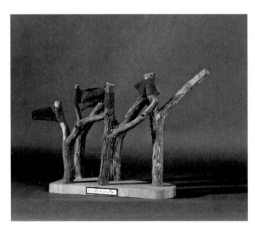

Tom Gutt
*October Forest
(Forêt d'octobre)*, 1987
Assemblage
Private collection

Bibliog.
Xavier Canonne, *Le Surréalisme en Belgique:
1924-2000* (Brussels, Fonds Mercator, 2007)

Tom Gutt made his appearance on the Belgian surrealist scene at the age of nineteen when he played the main role in Marcel Mariën's 1959 *L'Imitation du cinéma.* An admirer of Paul Nougé's, in 1961 he founded the publishing house and review *Après Dieu,* which would be followed by the mimeographed pages of the review *Vendonah* (1963). He mobilized a group of young artists that make up the third generation of Belgian surrealists, while maintaining contact with members of the older generations such as Louis Scutenaire and Irène Hamoir (whose publisher and executor he later became), but also André Souris, Max Servais and Mariën. In May 1963, after Roger Van de Wouwer's painting *Galathée* was censored, Gutt launched the tract *Le Vent se lève,* followed in 1964 by *Vous voyez avec votre nombril,* initiating the revival of surrealist collective activity in Belgium. Besides being the author of some poetry of rare beauty although little known, Gutt founded Galerie La Marée with his spouse Claudine Jamagne, where they exhibited those who he called "comrades." He continued his publishing activities, as with the series *Une Passerelle en papier* and the review *Le Vocatif.* He was also the author of *Cette mémoire du cœur: Fragments pour un Monte-Cristo,* a magisterial reinterpretation of Dumas' work. His death, almost ten years after Mariën's, deprived Belgian surrealism of its leader and put an end to any group activity.

Tom Gutt
*The Fruits of the Earth
(Les Nourritures terrestres),* 2000
Object
Private collection

Tom Gutt
Spring (Le Printemps), 2000
Object
Private collection

Tom Gutt
*The Dearest
(La Très-chère)*, 2000
Object
Private collection

Irène Hamoir (Saint-Gilles, 1906 – Brussels, 1994)

Poet, writer

Raoul Ubac
Portrait of Irène Hamoir, 1942
Private collection

It is at the home of the poet Marcel Lecomte that Irène Hamoir – in literature, Irine – met the man she married in 1930, Louis Scutenaire. Her closeness to the surrealist group made her one of the few women to be active in it, taking part in several major events such as the *Surrealist Exhibition* of 1935 in La Louvière.

In 1944 she published *La Cuve infernale,* short stories written with Scutenaire, and in 1953 *Boulevard Jacqmain,* a parody of detective stories whose main characters are the members of the Brussels surrealist group.

First published in 1944, her *Œuvre poétique* was reissued in 1976. In the early 1960s, Hamoir and Scutenaire took part in the activities of Tom Gutt's group. Upon her death, the couple's collection of works by René Magritte, the most important private collection in the world, was left to the Brussels Museum of Modern Art, forming the core of the future Magritte Museum.

Irène Hamoir
Untitled (Sans titre), 1928
Collage
Private collection

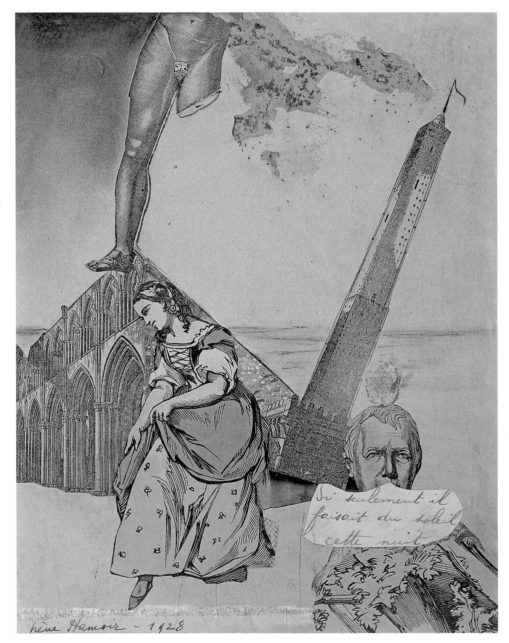

Bibliog.
Xavier Canonne, *Le Surréalisme en Belgique: 1924-2000* (Brussels, Fonds Mercator, 2007)

Marcel Havrenne (Jumet, 1912 – Etterbeek, 1957)

Poet, writer. Pseudonyms: Désiré Viardot, Nicolas Mélotte

Portrait of Marcel Havrenne, c. 1950
Private collection

It is in high school at Morlanwelz that Marcel Havrenne met Albert Ludé and Jean Dieu, future members of the Rupture group, which Ludé introduced him into. It is in *Mauvais temps,* the group's only collective book, that he published his first text, "Notes sur Lautréamont," which was warmly received by André Breton. Having spent the war in captivity, he participated in the attempts made to revive surrealism in Belgium and settled in Brussels. His first collection, *La Main heureuse,* proposed variations on the same texts and was illustrated by Pol Bury. Together with Joseph Noiret and Théodore Koenig, Havrenne founded the review *Phantomas* in 1953, at the same time as he published *Pour une physique de l'écriture* and, in 1956, *Ripopées,* under the pseudonym Désiré Viardot. Jean Paulhan prefaced *Du pain noir et des roses* in 1957, the year of Havrenne's death. He was considered the best writer of the Rupture group by his friend André Lorent.

Bibliog.
Marcel Havrenne (Brussels, A l'Improviste, 1998)

Urbain Herregodts (Edegem, 1935 – La Louvière, 1986)

Painter, draftsman, sculptor

Self-taught, in 1962 Urbain Herregodts met Achille Chavée (whose 1968 book *L'Agenda d'émeraude* he illustrated) and the painter Jacques Matton. About 1964 he joined the Phases movement and took part with Jacques Lacomblez in the activities of the review *Edda.* An adept of the strictest pictorial automatism, Herregodts' work resembles that of an explorer of both the human soul and space, his drawings and paintings bearing witness to an innate sense of composition and color.

Urbain Herregodts
*From One World to the Other
(D'un monde à l'autre),* 1971
Oil on canvas
Collection of the City
of La Louvière

Bibliog.
Urbain Herregodts: Résurgences (La Louvière, Musée Ianchelevici, April 1999)

Claudine Jamagne (Boitsfort, 1943)

Painter, draftswoman, assemblagist

Claudine Jamagne
The Tender Age (L'Âge tendre), 1997
Object
Private collection

Claudine Jamagne
Triumphal Arch
(L'Arc de triomphe), 1997
Object
Private collection

The spouse of Tom Gutt, from the early 1960s she was associated with the activities of the Boitsfort group, of which Louis Scutenaire wrote that it was "by far the best there is in the wake of the surrealist ship" (letter to José Vovelle, April 1968). She illustrated various works by Louis Scutenaire (who in 1972 dedicated *Onze poésies courtes* to her), Tom Gutt, Jacques Wergifosse and Irène Hamoir, and played a considerable part in the publications or exhibitions of Galerie La Marée. Using everyday objects which she transformed through her drawings and assemblages, she gave them a poetic dimension that was not lacking in humor.

Bibliog.
Xavier Canonne, *Le Surréalisme en Belgique: 1924-2000* (Brussels, Fonds Mercator, 2007)

LA
FORTUNE

Claudine Jamagne
Fortune (La Fortune), 1997
Assemblage
Collection of the Province of Hainaut
on loan to BPS22, Charleroi

Jacques Lacomblez (Ixelles, 1934)

Painter, poet, draftsman

Georges Thiry
Jacques Lacomblez, 1953
Museum of Photography, Charleroi –
Yellow-Now Editeur

Jacques Lacomblez
*The Cliff Is Watchful
(La Falaise veille),* 2008
Oil on canvas
Private collection

Jacques Lacomblez joined the Phases movement in 1956 after having had his first solo exhibition at the age of 17. He adopted a form of non-representation inherited from Victor Servranckx and Max Ernst.

His review *Edda* (1958-65) acted as the relay of the Phases movement in Belgium. In 1958 he met André Breton and became involved in various collective exhibitions and publications with his friends Jacques Zimmerman and Marie Carlier. Lacomblez used a meticulous technique to paint and draw a world in which, like in a score, the vegetable and mineral worlds blend, music remaining an important source of inspiration for this music lover. His work combines his interest in sacred texts, primitive art, poetry and ethnology, worlds he explores in fragments. With his review and his collaborators, he made up the other wing of surrealism in Belgium, closer to the Paris group than to the spirit of Magritte.

Bibliog.
Phases belgiques: Courant continu (Mons, Musée des Beaux-Arts, 1990);
Jacques Lacomblez (Paris, L'Ecart absolu, 2002);
Jacques Lacomblez: Chemins 1953-1983 et œuvres récentes (Courcelles, La Posterie, 1988)

Jacques Lacomblez
The Garden with the Two Rooms
(Le Jardin des deux chambres), 1987
Oil on canvas
Collection of the Province of Hainaut
on loan to BPS22, Charleroi

Marcel Lecomte (Saint-Gilles, 1900 – Brussels, 1966)

Poet, writer

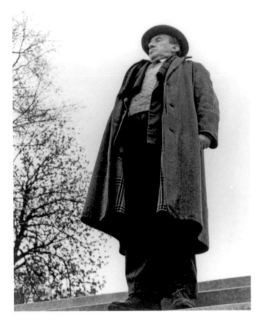

Georges Thiry
Marcel Lecomte, c. 1965
Museum of Photography, Charleroi –
Yellow-Now Editeur

In 1924, together with Paul Nougé and Camille Goemans, Marcel Lecomte formed the trio behind *Correspondance*, from which he was excluded in 1926, however, because seen as too preoccupied with literature. Magritte illustrated his book *Applications* in 1925 and would represent him in several paintings as a hieratic figure. Although Lecomte distanced himself from the surrealist group, he would occasionally take up with the group again on the occasion of collective publications, among others with *La Carte d'après nature*. Writing in an elegant and at times precious style, he authored *L'homme au complet gris clair* (1931), *Les minutes insolites* (1936) and *La servante au miroir* (1941), illustrated by Léon Spilliaert. He also penned studies of Rachel Baes and Jane Graverol.

Marcel Lecomte
Applications, 1925
Private collection

Bibliog.
Marie-Thérèse Bodart, *Marcel Lecomte*
(Paris, Seghers, 1970);
Marcel Lecomte, *Les voies de la littérature*
(Brussels, Labor, 1988)

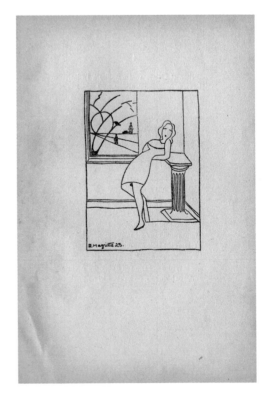

Marcel Lefrancq (Mons, 1916 – Vaudignies, 1974)

Photographer, collagist

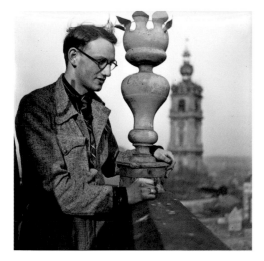

Fernand Dumont
Marcel Lefrancq, Mons 1938
Collection of Michel Lefrancq, Mons

Marcel Lefrancq participated in the activities of the Rupture group in 1938 before joining his friends Achille Chavée, Fernand Dumont and Armand Simon in the Hainaut surrealist group in 1939, becoming the group's regular photographer. Drawn to the bizarre, he walked the streets of Mons at night with Dumont, seeking out secondhand dealers selling mysterious objects which he used to decorate the window of his photography shop *La Lanterne magique* (The magic lantern). His work was experimental by nature (burning, solarizing and sometimes intervening directly on the film). He took part in *L'Invention collective* in 1940 and in Revolutionary surrealism. During the early years of the war, he developed a passion for prehistory and popular art. He took part in 1945 in the *Surrealism Exhibition* at Galerie des Editions La Boétie and was briefly involved, at the invitation of Christian Dotremont, in the CoBrA movement, while an active member of the Haute Nuit group.

A multifaceted and singular character, Lefrancq practiced photography by distancing himself from the influence of Man Ray and Raoul Ubac, as can be seen from his main work *Aux Mains de la lumière* (1948), composed of original photographs.

Marcel Lefrancq
The Holy Spirit (Le Saint-Esprit), 1938
Collage
Collection of Michel Lefrancq, Mons

Bibliog.
Marcel G. Lefrancq (Charleroi, Palais des Beaux-Arts; Brussels, Palais des Beaux-Arts; Mons, Salle St-Georges, Jan.-May 1982);
Xavier Canonne and Michel Lefrancq, *Marcel G. Lefrancq: Aux Mains de la lumière* (Charleroi, Musée de la Photographie, 2003)

Marcel Lefrancq
Dialectics (La Dialectique), 1945
Photographed collage
Collection of Michel Lefrancq, Mons

Marcel Lefrancq
The Law of Coincidences
(La Loi des coïncidences), 1938
Black and white photograph
Museum of Photography, Charleroi

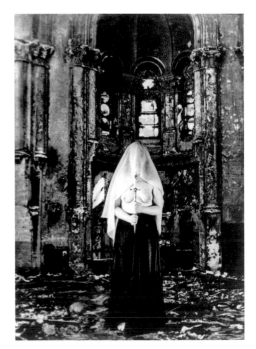

Marcel Lefrancq
The Fall of the Eastern Empire
(La Chute de l'Empire d'Orient), 1947
Collage
Collection of the Province of Hainaut
on loan to BPS22, Charleroi

Marcel Lefrancq
Park of Mons, at Night
(Parc de Mons, la nuit), 1938
Black and white photograph
Museum of Photography, Charleroi

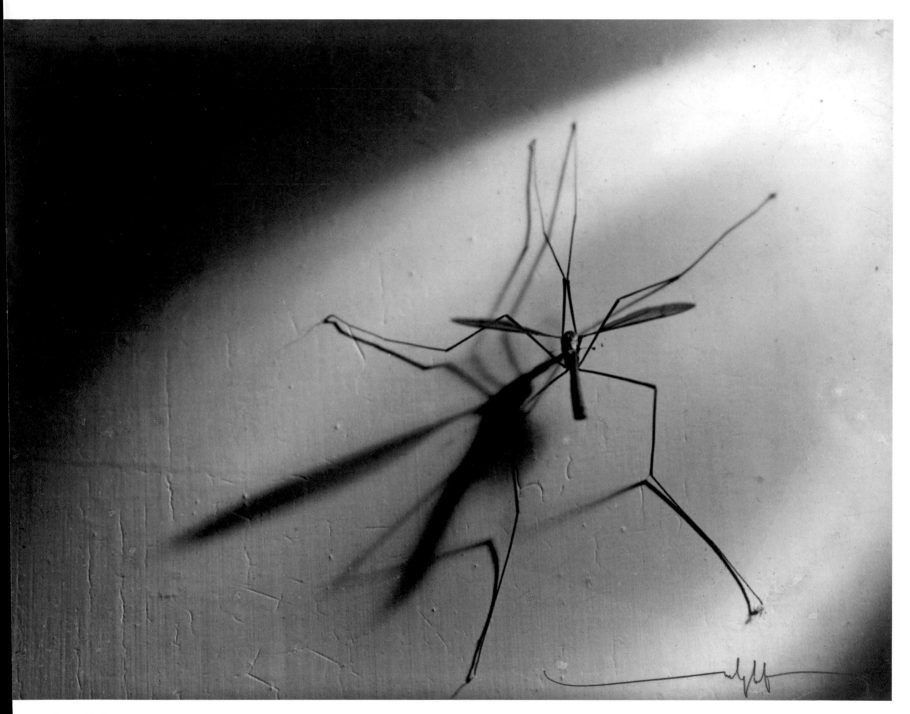

Marcel Lefrancq
The Enemy (L'Ennemi), 1935
Black and white photograph
Museum of Photography, Charleroi

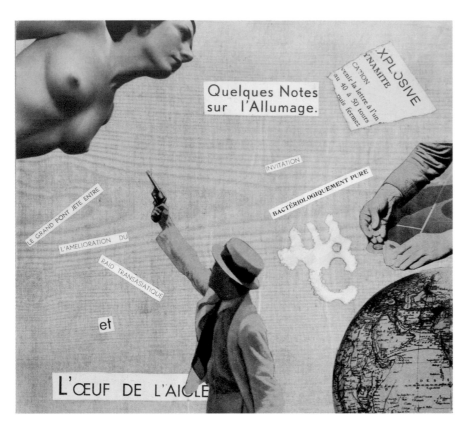

Marcel Lefrancq
The Eagle's Egg (L'Œuf de l'aigle), 1939
Collage
Collection of the Wallonia-Brussels Federation

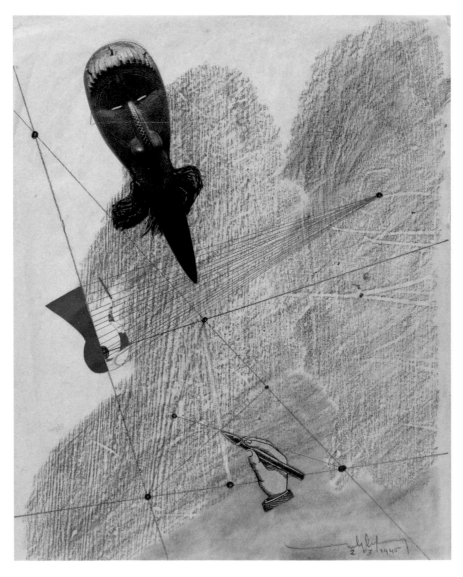

Marcel Lefrancq
*The Problems of Archimedes
(Les Problèmes d'Archimède)*, 1945
Collage and drawing
Collection of Michel Lefrancq, Mons

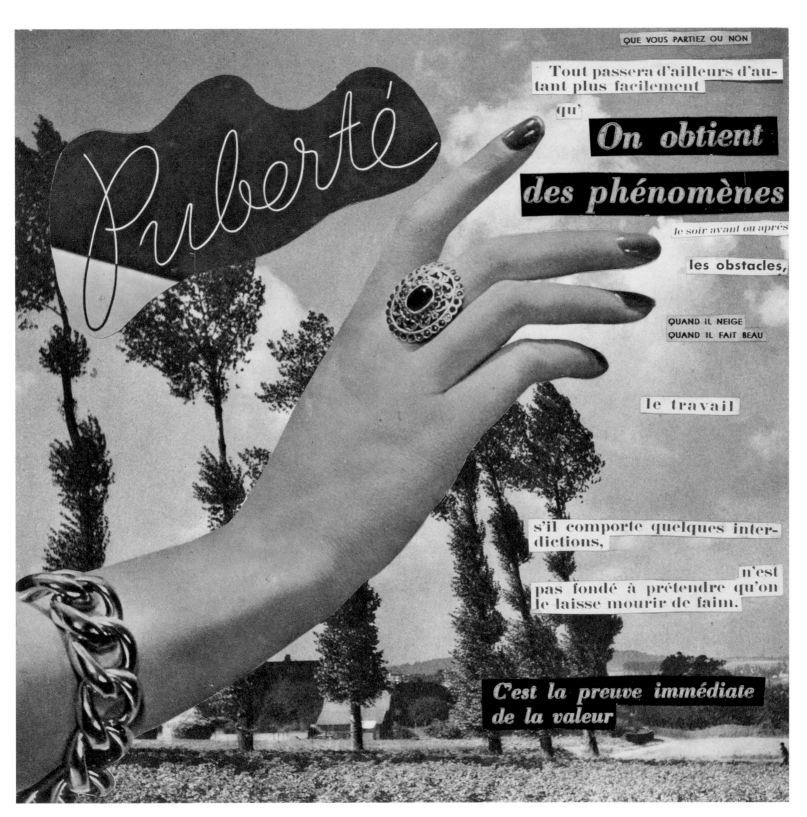

Marcel Lefrancq
Puberty (Puberté), 1939
Collage
Collection of the Wallonia-Brussels Federation

André Lorent (Heusy, 1901 – Ixelles, 1981)

Poet, writer

Georges Thiry
André Lorent, c. 1960
Museum of Photography, Charleroi –
Yellow-Now Editeur

A librarian in La Louvière, André Lorent discovered about 1929 the writings of André Breton, who he revealed to Achille Chavée, Albert Ludé and Marcel Parfondry. Together they founded the Rupture group in March 1934. The "colonel," as his friends called him, was actively involved in the organization of the *Surrealist Exhibition* of October 1935 in La Louvière and in the publication of the journal *Mauvais temps,* which published his first texts, including *Le Chemin de la trahison* (a condemnation welcomed by Breton of the *embourgeoisement* of left-wing parties). His Trotskyist leanings set him at odds with Chavée and Fernand Dumont, leading to the dissolution of the Rupture group. He left the province of Hainaut after the war and settled in Brussels, where he worked in a library, avoiding any group activity. A discreet and endearing personality, he was one of the thinkers of the Hainaut surrealist group, like his friend Ludé.

Bibliog.
Le Pied de la lettre: Lettre à Albert Ludé
(Morlanwelz, Les Marées de la nuit, 1990);
André Lorent and Xavier Canonne (pref.),
Le Chemin de la trahison (Paris, Syllepse, 1997)

Albert Ludé (Haine-Saint-Paul, 1912 – Vellereille-les-Brayeux, 1997)

Writer

Portrait of Albert Ludé, c. 1935
Private collection

Few writings remain of the one who, with Achille Chavée, André Lorent and Marcel Parfondry, was one of the founders, in his own home at Haine-Saint-Paul near La Louvière, of the Rupture group in March 1934. And yet he was one of the intellectual consciences of the Hainaut group and was close to Magritte and Nougé. He long abstained from making any declarations on surrealism or from collaborating on historical exhibitions, preferring to confide himself in intimate conversations or in writings he left after his death.

Bibliog.
Albert Ludé and Xavier Canonne (foreword),
Notes pour une histoire de Rupture suivi d'une lettre à un ami à propos d'Achille Chavée et de Fernand Dumont (Morlanwelz, Les Marées de la nuit, 2001)

Paul Magritte (Gilly, 1902 – Blankenberghe, 1975)

Musician, poet, collagist

Portrait of Paul Magritte, 1938
Private collection

The youngest of three brothers, Paul Magritte was one of the most unusual figures of surrealism in Belgium. The "marquis," as his friends nicknamed him, did not sign any collective declarations and only took part in a small number of surrealist reviews but was, in Rachel Baes's term, that "wonderful lazybones" admired by Louis Scutenaire, Marcel Mariën and Paul Colinet. He accompanied his brother René during his stay at Perreux-sur-Marne, founded with him upon their return the advertising agency Studio Dongo, and took part in various undertakings, both licit and illicit, such as the sale of fake paintings and banknotes.

Besides musical compositions like *Rosa, Le Boudin* and *Marie Trombone Chapeau Buse* (based on a poem by Colinet), he left writings and collages that were published posthumously by Tom Gutt.

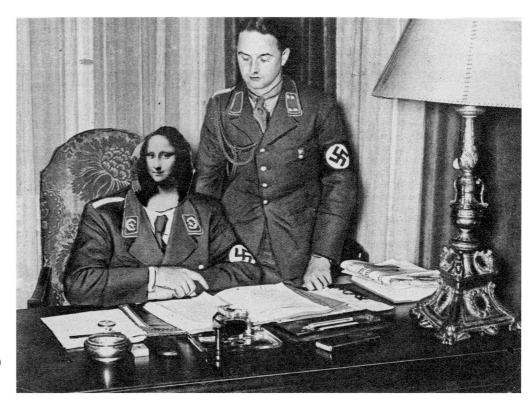

Paul Magritte
Untitled (Sans titre), 1940
Collage
Private collection

Bibliog.
Paul Magritte, *Les Travaux poétiques*
(Brussels, n.p., 1974);
Paul Magritte and Paul Colinet, *Le Coup d'épaule*
(Brussels, n.p., 1974)

Paul Magritte
Untitled (Sans titre), 1940
Collage
Private collection

Paul Magritte
Untitled (Sans titre), 1940
Collage
Private collection

René Magritte (Lessines, 1898 – Schaerbeek, 1967)

Painter, draftsman, collagist

René Magritte painting *Attempting the
Impossible (La Tentative de l'impossible)*, 1928
Private collection

After a childhood spent in the province of Hainaut moving between Lessines, Soignies, Châtelet and Charleroi, René Magritte attended the Fine Arts Academy of Brussels where he studied alongside the painter Servranckx (with who he later worked on the creation of wallpaper motifs). His style, until then inspired by futurism and cubism, changed under the influence of the avant-garde circles and his discovery of Giorgio de Chirico's painting. With E.L.T. Mesens he founded the review *Œsophage* (1925), which had a single issue, and soon joined the little *Correspondance* group led by Paul Nougé, thereby forming the surrealist core in Belgium. He held his first solo exhibition in 1927 at Galerie l'Epoque and stayed until 1930 at Perreux-sur-Marne in the Paris suburbs, working on the association of words and images as in his famous painting The *Treachery of Images* (1929), subtitled "This is not a pipe." Although he attended the meetings of Breton's group, he nevertheless remained in its margins, sharing Nougé's position. Having returned to Brussels, he became the most representative figure of Belgian surrealism, but was not averse to throwing off his admirers and his closest friends. After the "Renoir period" and "sunlit surrealism," attempting to paint in bright colours the same subjects that question language and visual perception, in 1948 he briefly entered his ex-hilirating "vache" (cow) period, an explosion of colours through which he thumbed his nose at the Parisian public but failed to sell a single work at the exhibition in Galerie du Faubourg, throwing himself simultaneously into the production, with Marcel Mariën, of smutty tracts such as *L'Imbécile* (The imbecile), *L'Emmerdeur* (The pain in the neck) and *L'Enculeur* (The fucker), or a so-called invitation to conferences on sexuality of the Arts Seminar. Gradually relinquishing the polemical and political aspect of surrealism, in the mid 1950s Magritte turned away from Nougé and Mariën, who were beginning the publication of the review *Les Lèvres nues* (1954), Magritte immersing himself at the time in *La Carte d'après nature* and *Rhétorique,* essentially centred on his work. This would lead Mariën and Leo Dohmen to bring out the apocryphal tract *Grande baisse,* in which it was claimed that he intended to sell off his paintings, this fake tract putting a term to his relationship with Mariën. His reputation spreading beyond Belgium,

René Magritte
The Rape (Le Viol), 1937
Indian ink on paper
Collection of Verdec

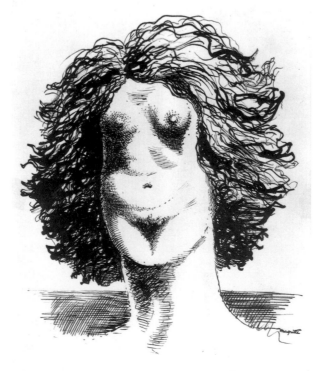

Magritte had exhibitions of varying sizes in France, England, the United States and Israel. Following Mariën's revelation, in *Le Radeau de la mémoire* (1983), of Magritte's activities as a forger and counterfeiter, charges were brought by the painter's widow, Georgette Magritte, but her case would be dismissed.

Magritte's work, that of a "visible poet," each painting generating a philosophical reflection, is among those which, like Marcel Duchamp's, have most influenced contemporary art.

Bibliog.
David Sylvester (ed.), Sarah Whitfield and Michael Raeburn, *René Magritte: Catalogue Raisonné* (London, Menil Foundation, Antwerp, Fonds Mercator, 1992 93)

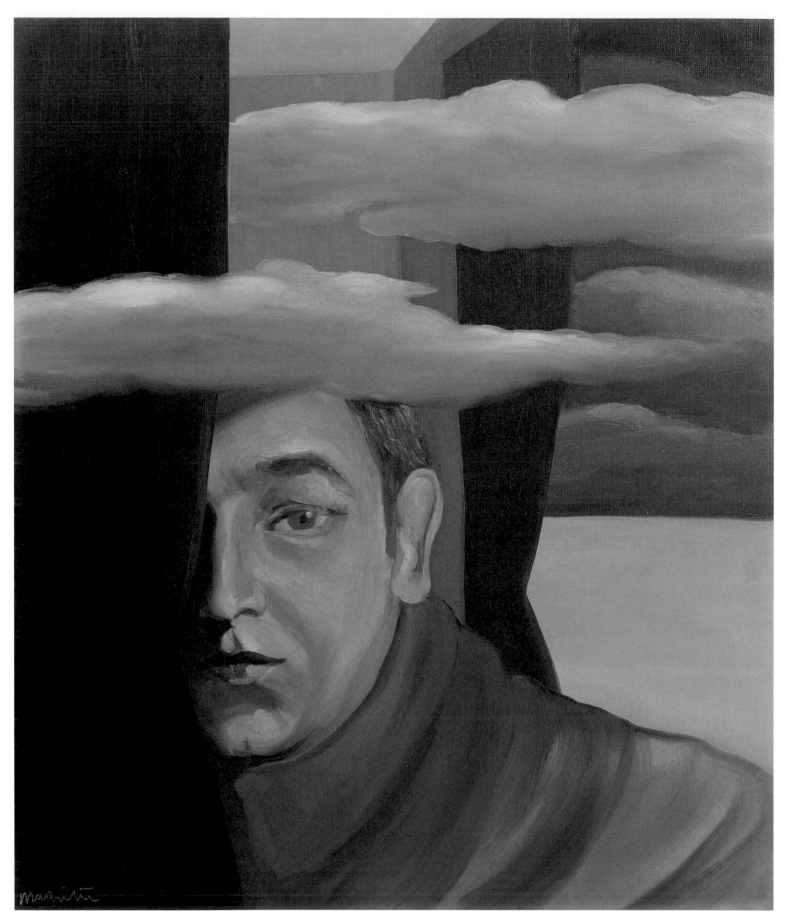

René Magritte
Portrait of Paul Max
(Portrait de Paul Max), 1926
Oil on canvas
Collection of A&N

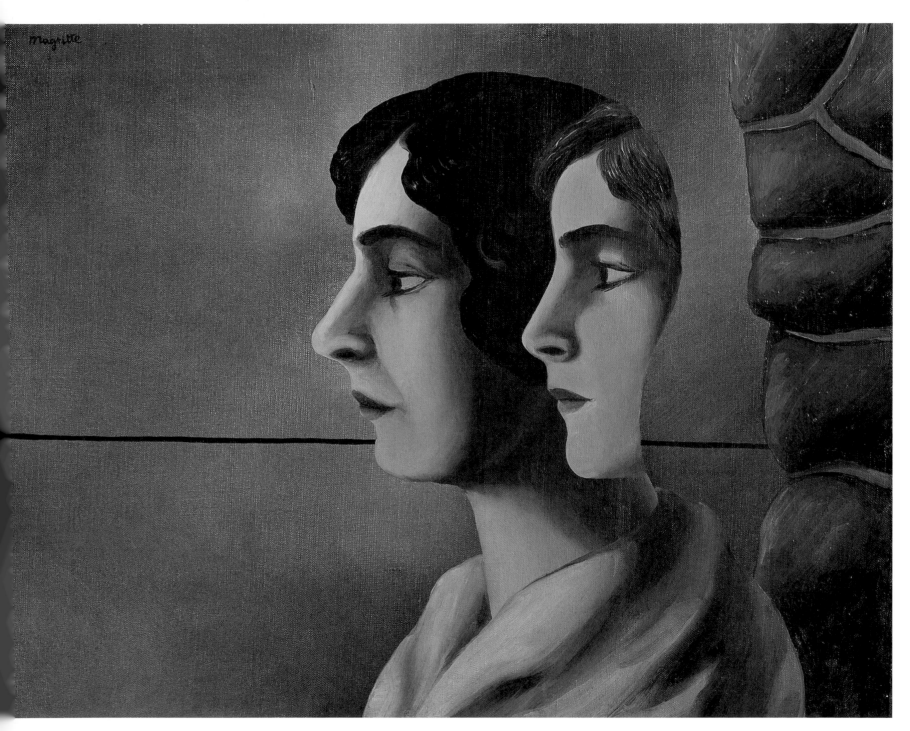

René Magritte
Faraway Looks
(Les Regards perdus), 1927-28
Oil on canvas
Private collection

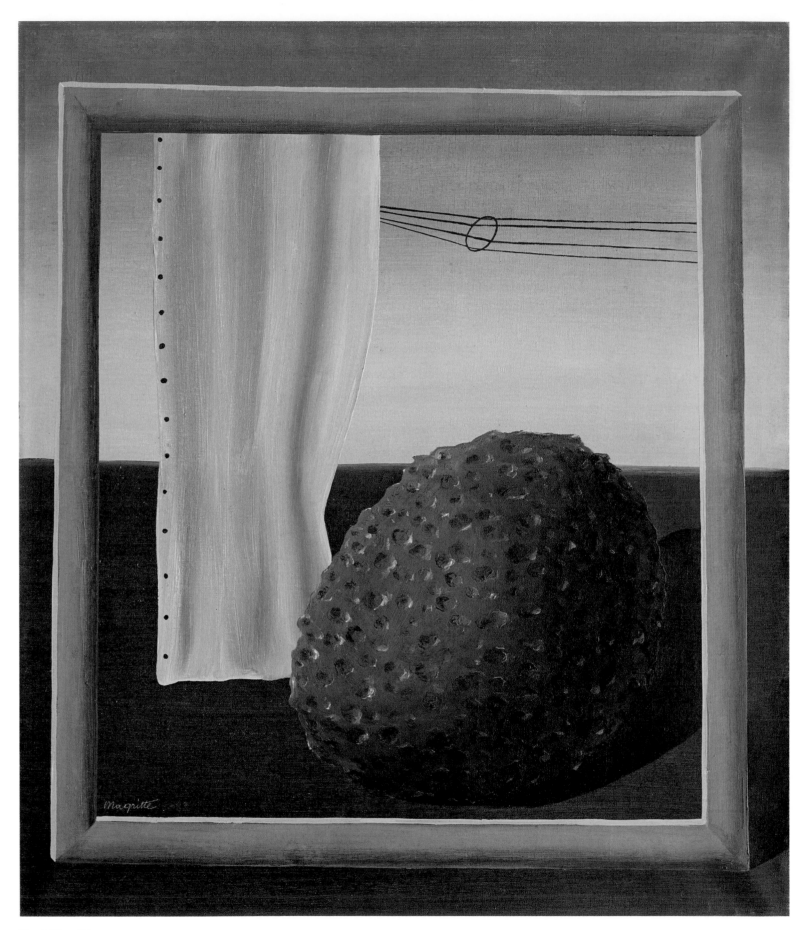

René Magritte
The Message to the Earth
(Le Message à la terre), 1926
Oil on canvas
Private collection

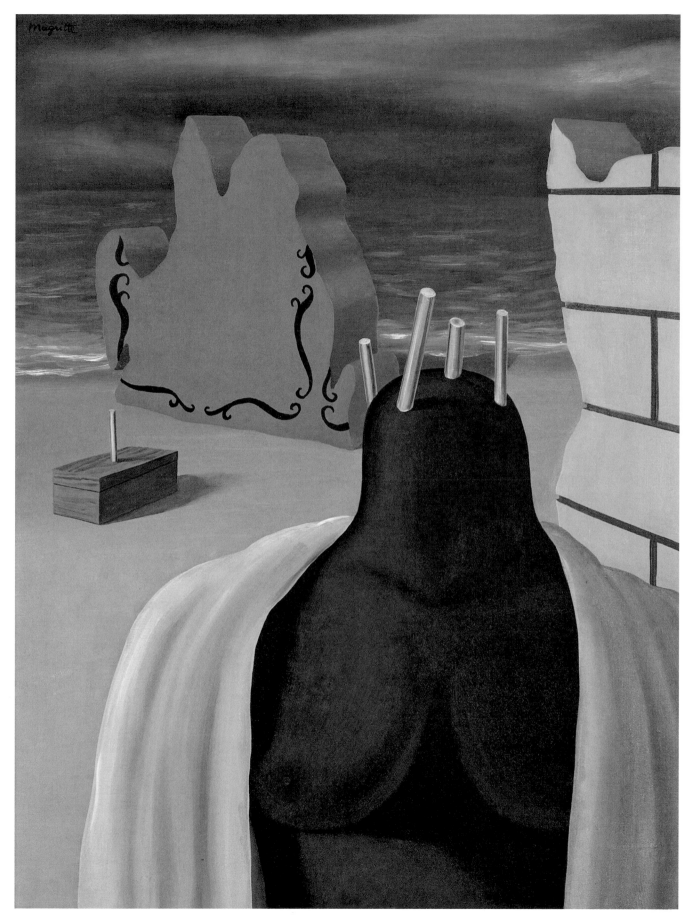

René Magritte
The Torturing of the Vestal Virgin
(Le Supplice de la vestale), 1927
Oil on canvas
Private collection

René Magritte
Draft advertisement for Belga cigarettes
(Projet de publicité pour les cigarettes Belga), 1935
Gouache on paper
Collection of the Province of Hainaut
on loan to BPS22, Charleroi

René Magritte
In Memoriam Mac Sennett, 1936
Oil on canvas
Collection of the City of La Louvière

René Magritte
The Civilizer (Le Civilisateur), 1944
Red chalk on paper
Collection of A&N

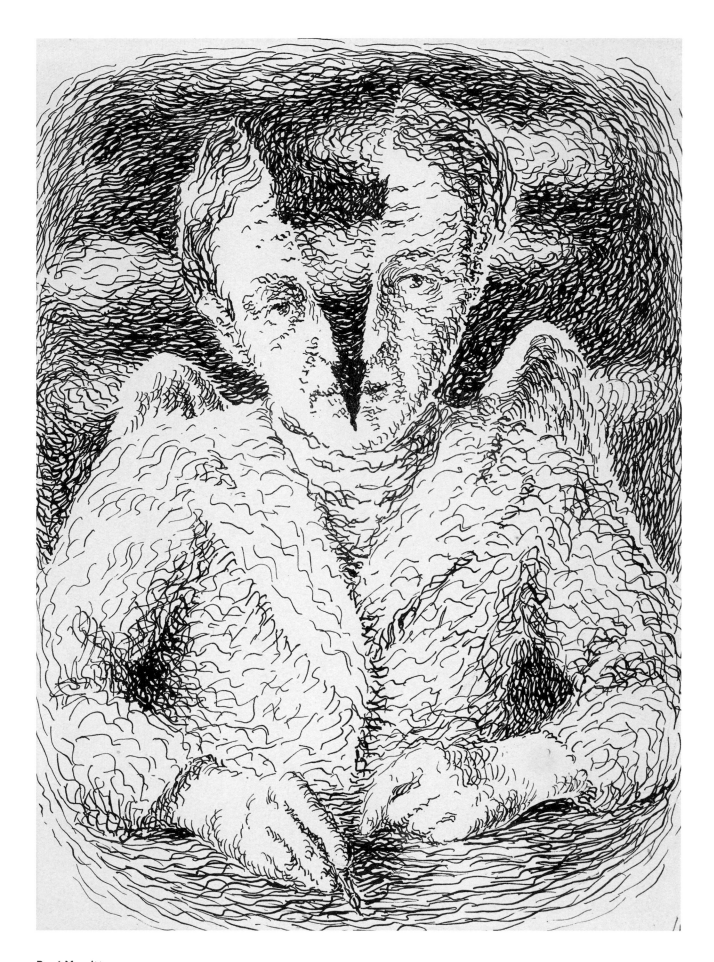

René Magritte
Illustration for *Les Chants de Maldoror*, 1945
Ink on paper
Collection of Ronny and Jessy Van de Velde, Antwerp

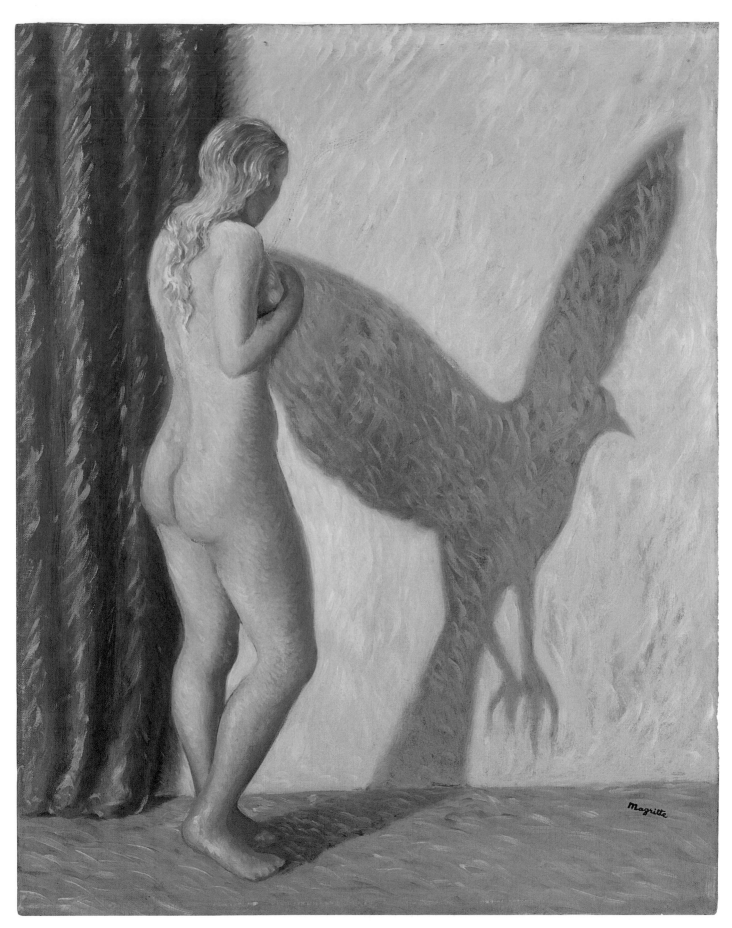

René Magritte
The Uncertainty Principle
(Le Principe d'incertitude), 1944
Oil on canvas
Private collection

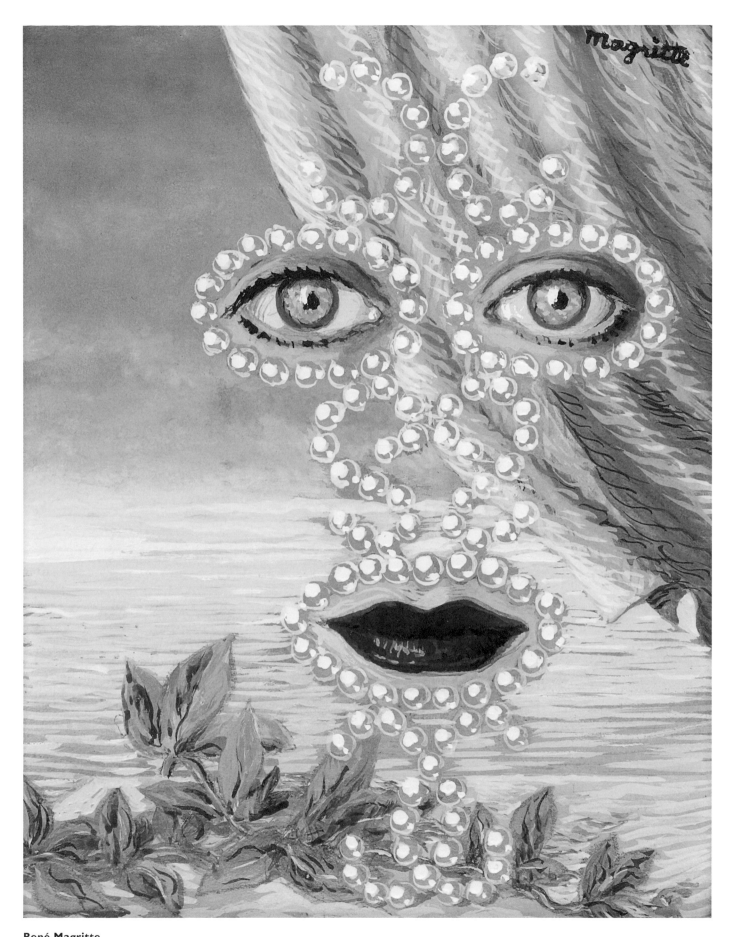

René Magritte
Sheherazade or Portrait of Rachel Baes
(Shéhérazade ou Portrait de Rachel Baes), 1947
Gouache
Collection of A&N

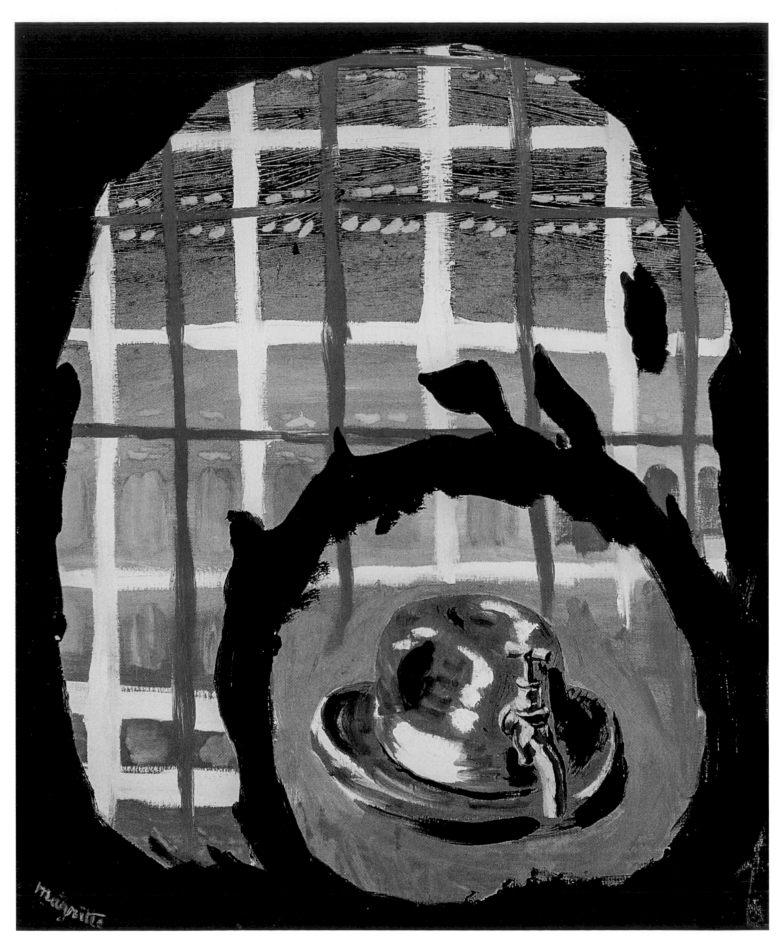

René Magritte
The Suspect (Le Suspect), 1948
Oil on canvas
Collection of CPH Bank, Tournai

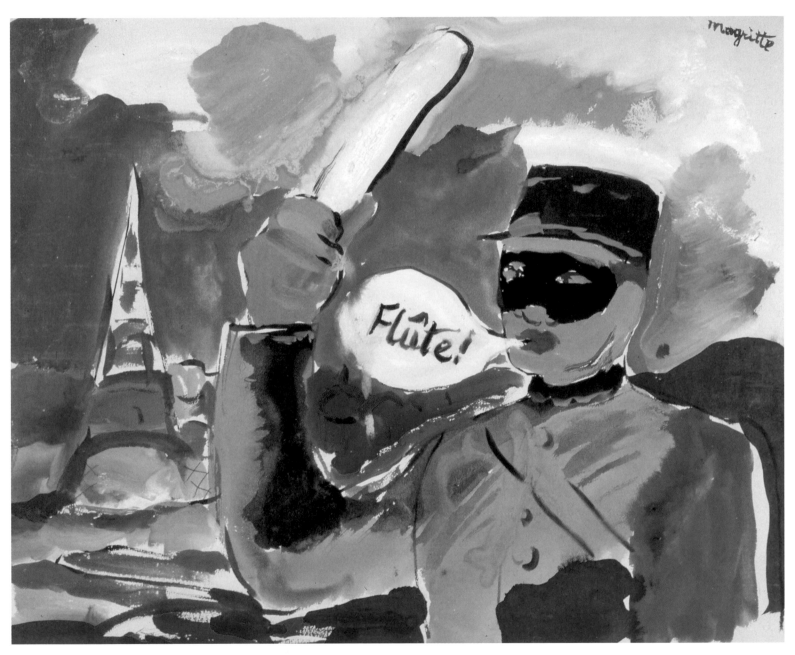

René Magritte
Drat It! (Flûte !), 1948
Gouache on paper
Collection of the Province of Hainaut
on loan to BPS22, Charleroi

René Magritte
Prince Charming (Le Prince charmant), 1948
Gouache on paper
B.K.W. Gallery, Brussels

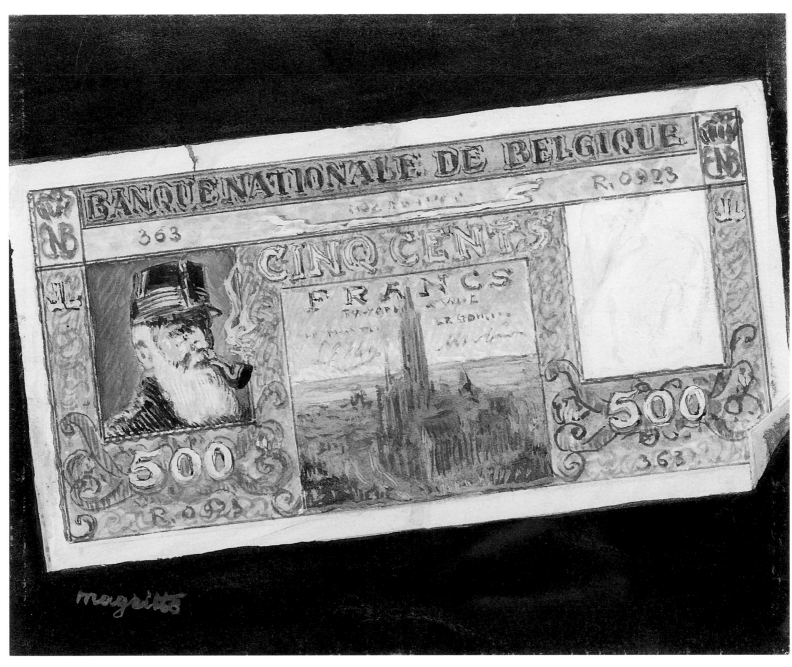

René Magritte
The Specter (Le Spectre), 1948-49
Gouache on paper
Private collection

René Magritte
The Cut-Glass Bath (Le Bain de cristal), 1949
Gouache on paper
Private collection

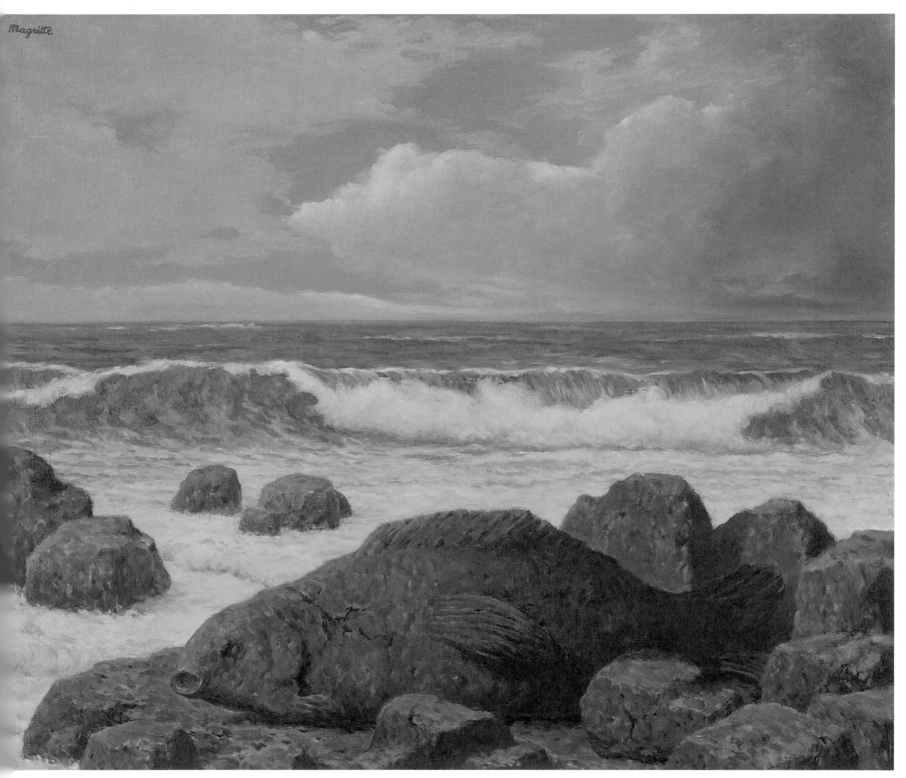

René Magritte
A Sense of Profundity
(Le Sens de la profondeur), 1950
Oil on canvas
Collection of Patty and Jay Baker

95

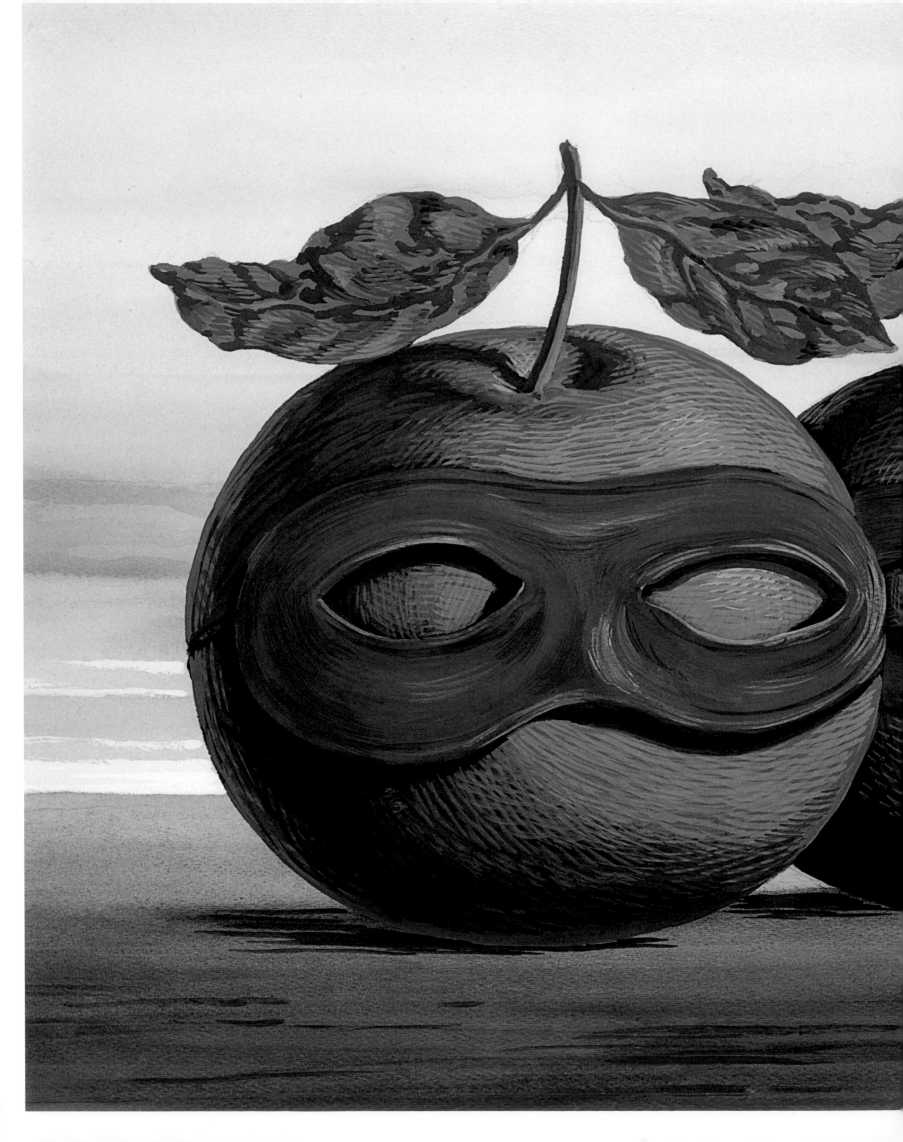

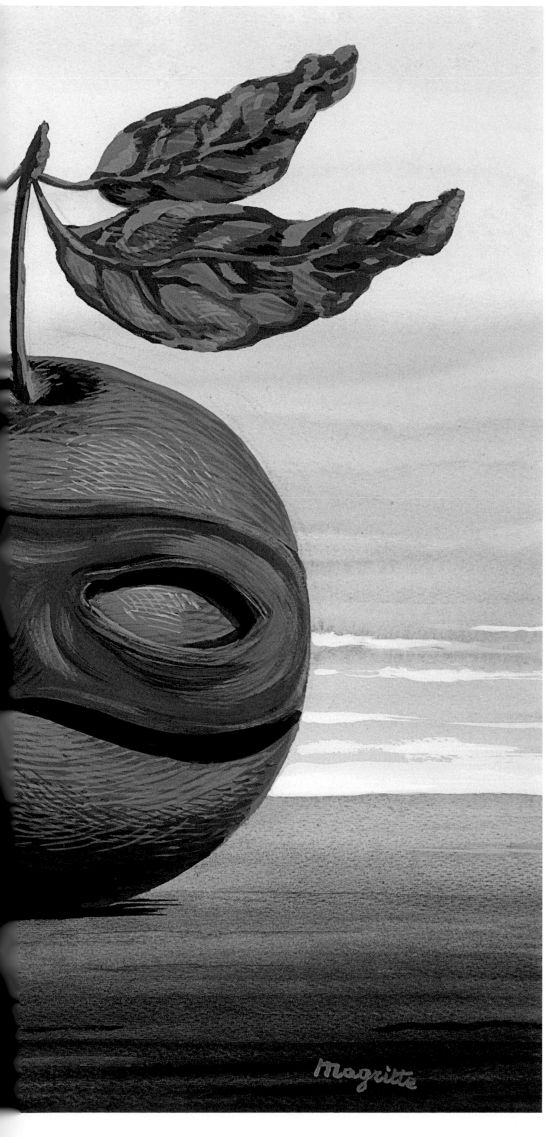

René Magritte
The I Iesitation Waltz
(La Valse Hésitation), 1955
Gouache on paper
Private collection

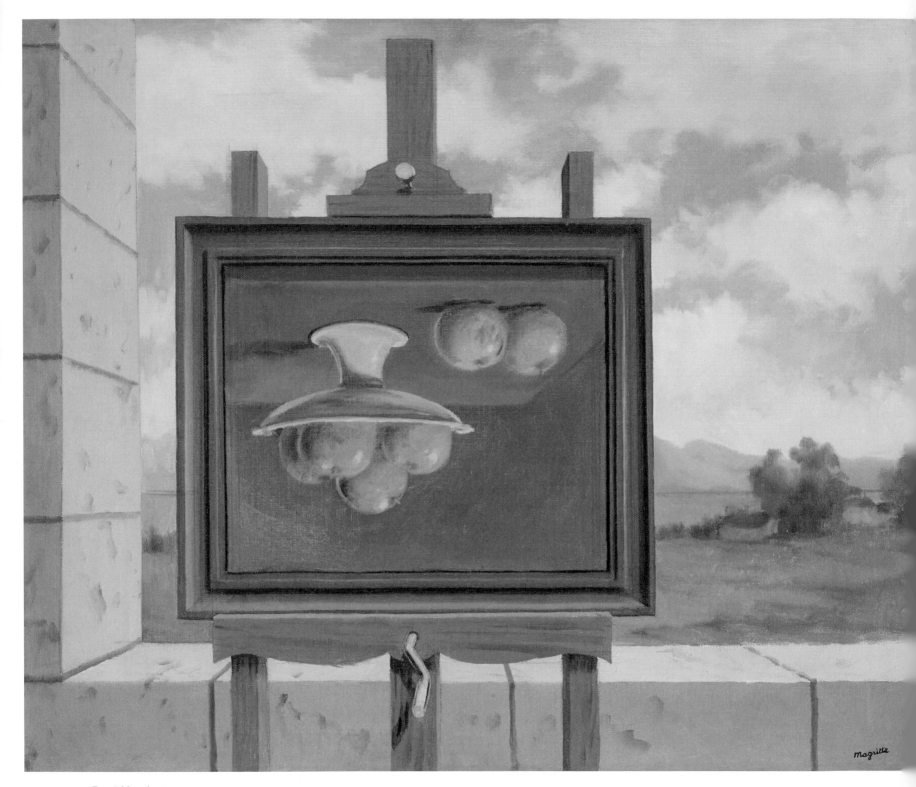

René Magritte
The Alarm Clock
(Le Réveille-matin), 1957
Oil on canvas
Private collection

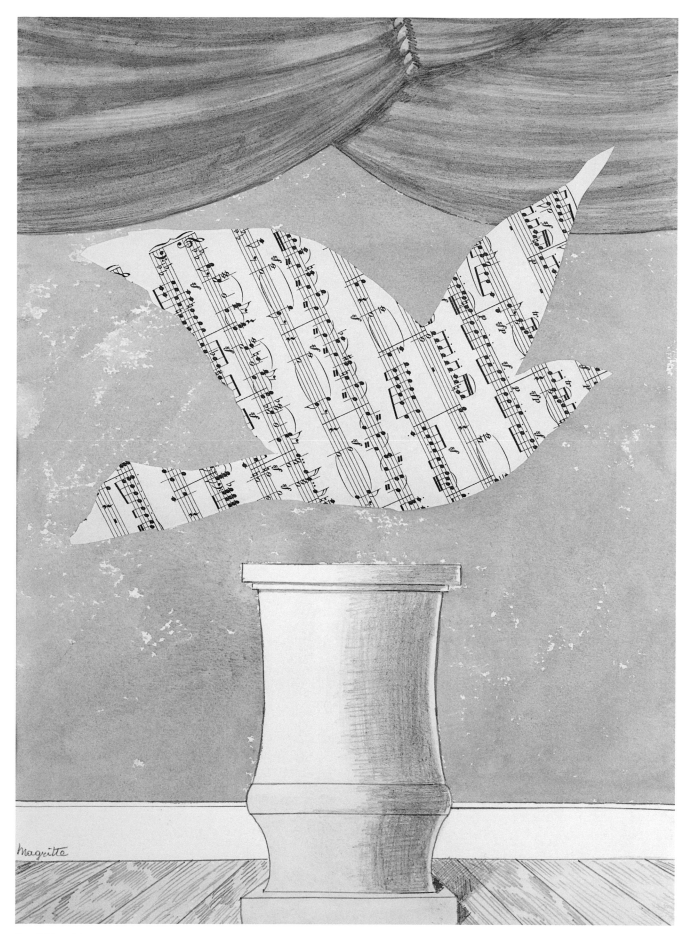

René Magritte
Dove (Colombe), 1962
Mixed media
Private collection

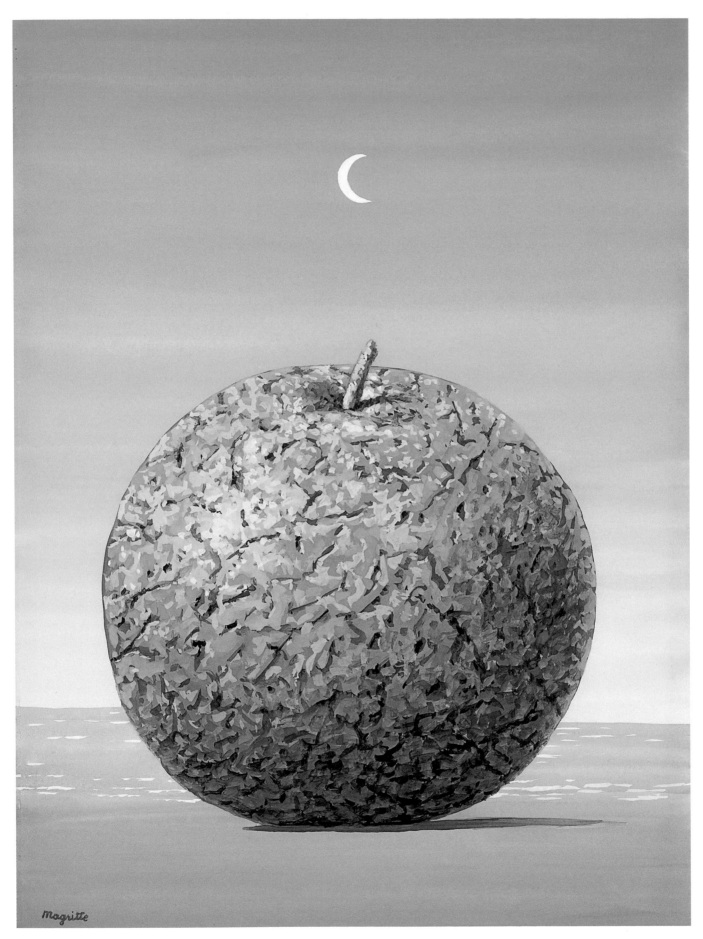

René Magritte
The Great Table (La Grande table), 1965
Gouache on paper
Private collection

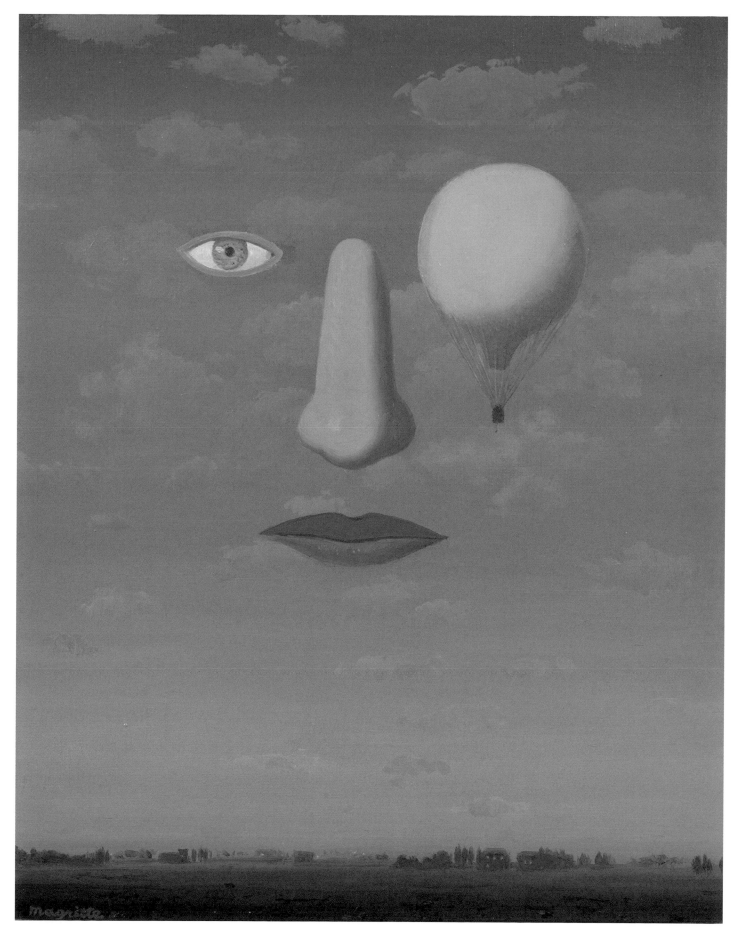

René Magritte
Good Connections (Les Belles relations), 1967
Oil on canvas
Private collection

Marcel Mariën (Antwerp, 1920 – Brussels, 1993)

Collagist, assemblagist, writer, photographer, publisher, filmmaker

Georges Thiry
Marcel Mariën, c. 1960
Museum of Photography, Charleroi –
Yellow-Now Editeur

Bibliog.
Xavier Canonne, *Marcel Mariën, le lendemain de la mort* (Brussels, Crédit Communal, 1993);
Marcel Mariën and Xavier Canonne (pref.), *L'œuvre graphique et les multiples* (Antwerp, Persona, 2002);
Xavier Canonne, *Marcel Mariën, le passager clandestin* (Antwerp, Pandora, 2013)

The enumeration of the disciplines in which Marcel Mariën was involved would suffice to describe a life not only devoted to surrealism but one that embodied it. At the age of seventeen he met René Magritte, two paintings of whose, presented in 1935 during a group exhibition at Antwerp, had impressed him. The youngest of the surrealist group, he took an active part in its activities, even initiating them. In 1938 he published his first work, *La chaise de sable,* and made his first collages, already mixing words and images. In 1937 he took part in the exhibition *Surrealist Objects and Poems* organized in London by E.L.T. Mesens and brought out his texts in the *London Bulletin.* He also published in the review *L'Invention collective* before being mobilized.

Upon his return from captivity, he founded the publishing house *L'Aiguille aimantée* and published in 1943 the first monograph devoted to Magritte. In 1946, after having participated in the *Surrealism Exhibition* of Galerie des Editions La Boétie in Brussels, he released *Les Corrections naturelles,* reconnecting with surrealism's political engagement by excluding followers and opportunists. Working at a range of jobs to earn a living – typist, sailor, home nurse, etc. – and refusing to settle down, Mariën founded in 1954 with Jane Graverol, who had become his partner, the publishing house and review *Les Lèvres nues,* which would be active until 1993, releasing among others the writings of his spiritual father, Paul Nougé. The review would also welcome the writings of the Lettrists, future Situationists, with who he would form a brief alliance. In 1959 Mariën directed *L'Imitation du cinéma,* a medium-length film whose anticlericalism created a scandal and which was banned in France. In 1962, after having distributed with his partner Leo Dohmen the tract *Grande baisse* allegedly attributed to Magritte (and in which the painter was alleged to want to sell off his paintings), he left for a long journey in the United States and then China, where he worked as a proofreader on the French edition of *La Chine en construction* (China under construction). Upon his return in 1965, Mariën devoted himself exclusively to his work as a collagist, writer, photographer and publisher, holding his first solo exhibition in 1967. In 1970 he denounced an exhibition of fake paintings by Magritte at the New Smith Gallery in Brussels and was brought to court in 1973 by Marc Eemans, whose collaborationist past he evoked in his preface to Magritte's *Writings,* a trial that Mariën won, publishing in the same breath the tract *Autant en rapporte le vent.* In 1979, he released *Figures de poupe,* fifty tales mixing humor and derision. That same year he published the indispensable *L'Activité surréaliste en Belgique 1924-1950* (Surrealist activity in Belgium 1924-50), the first exhaustive exploration of the history of surrealism envisaged by its most legitimate witness. A new scandal broke out in 1983 when he published his autobiography *Le Radeau de la mémoire*: his revelation of Magritte's work as a forger and counterfeiter led the painter's widow to press charges against him, a trial which Mariën, once again defended by Tom Gutt, won. Holding more and more exhibitions and pursuing his publishing activity, Mariën took up photography again in the 1980s, decompartmentalizing the forms of language and representation. Rejecting any aesthetic preoccupation in favor of the utmost efficiency, his work acted as a trigger of ideas, prolonging those of Magritte and Nougé.

Marcel Mariën
*The Spirit of the Staircase
(L'Esprit de l'escalier),* 1952
Black and white photograph
Private collection

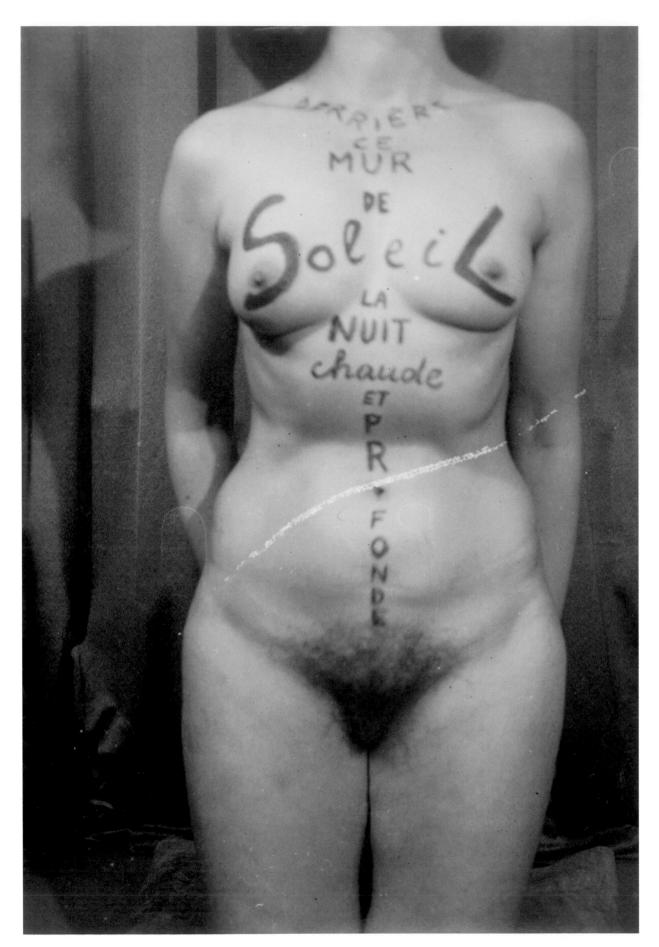

Marcel Mariën
Behind This Wall of Sun ... (Derrière ce mur de soleil…), c. 1950
Black and white photograph
Collection of the Wallonia-Brussels Federation

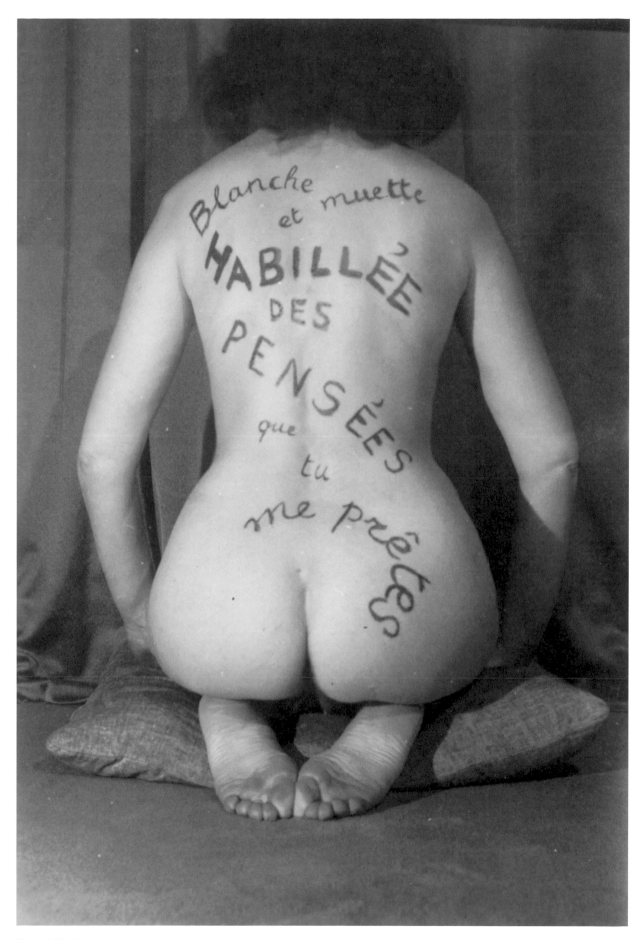

Marcel Mariën
The Whiteboard (Le Tableau blanc), 1953
Black and white photograph
Private collection

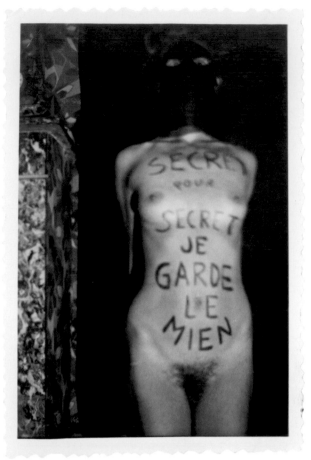

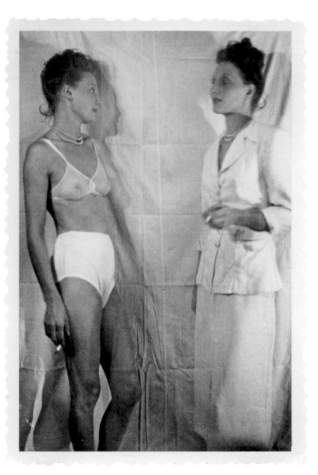

Marcel Mariën
Tell Me Yours …
(Secret pour secret…), 1949
Black and white photograph
Collection of the Wallonia-Brussels
Federation on loan to the Museum
of Photography, Charleroi

Marcel Mariën
The Astounded Mirror
(La Glace confondue), 1949
Black and white photograph
Private collection

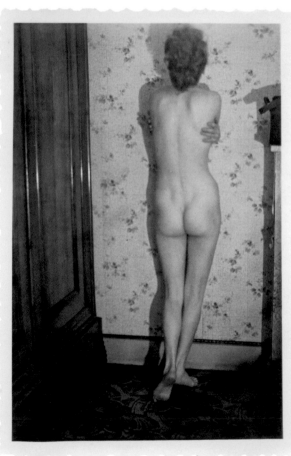

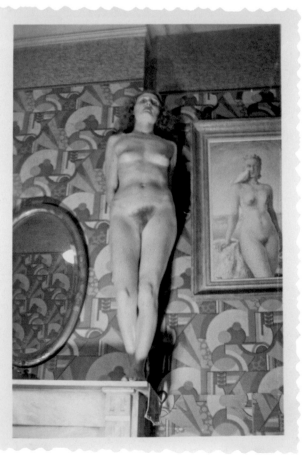

Marcel Mariën
The Florets (Les Fleurettes), 1949
Black and white photograph
Private collection

Marcel Mariën
Untitled (Sans titre), 1949
Black and white photograph
Private collection

106

Marcel Mariën
The Right of Reply (Le Droit de réponse), 1954
Collage
Private collection

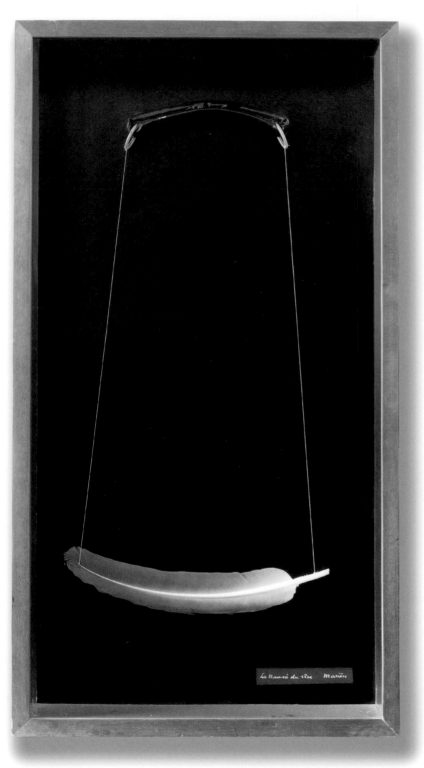

Marcel Mariën
The Crossing of the Dream
(La Traversée du rêve), 1938-45
Assemblage
Private collection

Marcel Mariën
Political Economy
(Economie politique), 1967
Assemblage
Private collection

Marcel Mariën
The Nuptial Flight
(Le Vol nuptial), 1969
Assemblage
Private collection

Marcel Mariën
The Day After Death
(Le Lendemain de la mort), 1967
Assemblage
Private collection

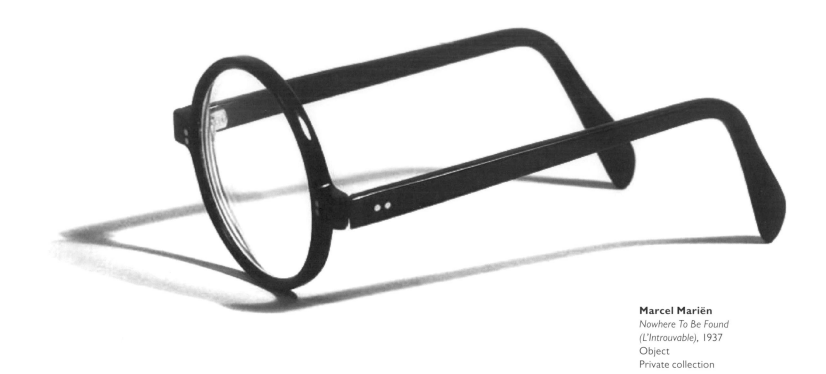

Marcel Mariën
Nowhere To Be Found
(L'Introuvable), 1937
Object
Private collection

Marcel Mariën
The Sleepers (Les Dormeuses), 1966
Collage
Collection of the Verbeke Foundation,
Kemzeke

Marcel Mariën
The Daily Mess (Le Pétrin quotidien), 1975
Assemblage
Collection privée

Marcel Mariën
*Surrealism Without the Painting
(Le Surréalisme sans la peinture)*,
1972
Assemblage
Private collection

Parler de soie mariën 9.6.75

Marcel Mariën
Parler de soie, 1975
Collage
Collection of the Province of Hainaut
on loan to BPS22, Charleroi

Marcel Mariën
*Obscenography
(Obscenographie),* 1975
Drawing and collage
Private collection

Marcel Mariën
The Carnival of Rio (Le Carnaval de Rio), 1974
Collage
Collection of the Province of Hainaut
on loan to BPS22, Charleroi

Marcel Mariën
*Crime and Reward
(Crime et récompense)*, 1975
Assemblage
Private collection

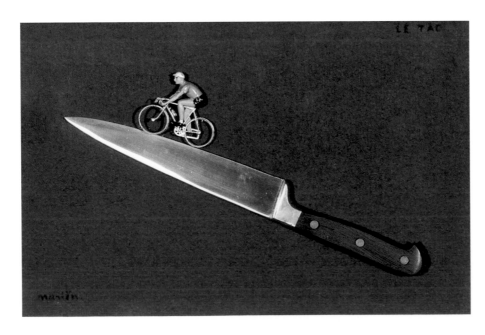

Marcel Mariën
The Tao (Le Tao), 1976
Assemblage
Collection of the Province of Hainaut
on loan to BPS22, Charleroi

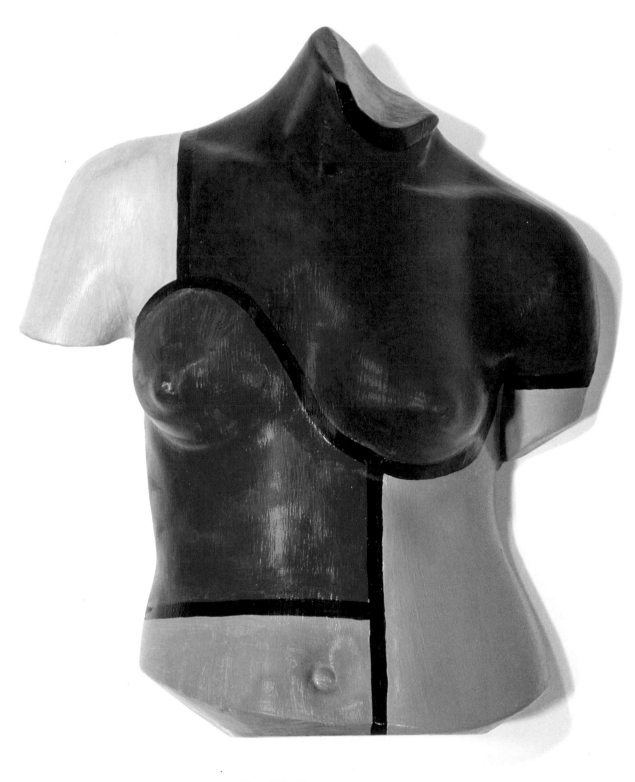

Marcel Mariën
The Venus of Amersfoort
(La Venus d'Amersfoort), 1982
Collection of the Province of Hainaut
on loan to BPS22, Charleroi

Marcel Mariën
The Suburb (La Banlieue), 1983
Black and white photograph
Private collection

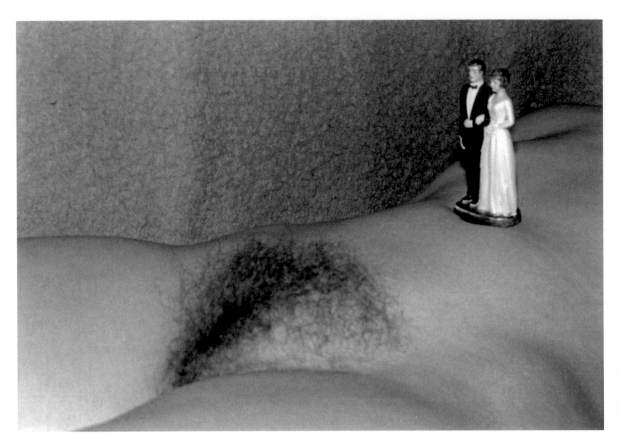

Marcel Mariën
The Wasteland
(Le Terrain vague), 1984
Black and white photograph
Private collection

Marcel Mariën
The Orient (L'Orient), 1983
Black and white photograph
Private collection

Marcel Mariën
Untitled (Sans titre), 1987
Black and white photograph
Private collection

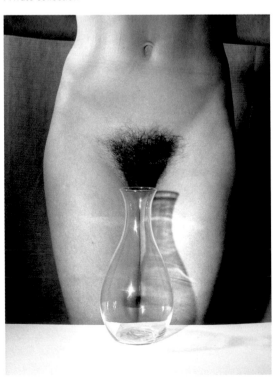

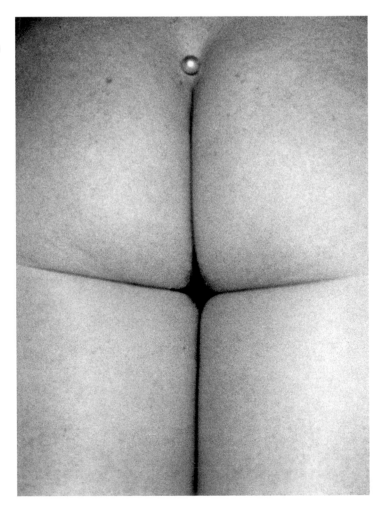

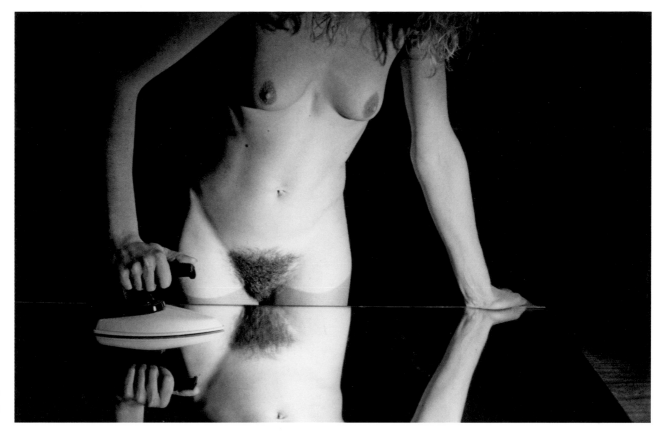

Marcel Mariën
*Degas, Dense, Design
(Degas, dense, dessein)*, 1983
Black and white photograph
Private collection

Marcel Mariën
*The Cherry Orchard
(La Cerisaie)*, 1983
Black and white photograph
Private collection

Jacques Matton (Ville-sur-Haine, 1939 – France, 1969)

Painter, draftsman, poet

After studying to become a commercial artist, Jacques Matton opened a gallery-cum-bookshop in Mons and came into contact with the small circle gathered around Achille Chavée, whose *Le Sablier d'absence* he illustrated in 1964. He then regularly took part in the activities of the Phases group and Jacques Lacomblez's review *Edda*. In 1962 he published *Les Sept vertus de la pomme de terre*. Influenced by the work of Max Ernst, he produced transfer pictures and scraped pictures while using his skills as a colorist. Matton's work was growing more refined when his life was cut short in a tragic car accident upon his return from holidays.

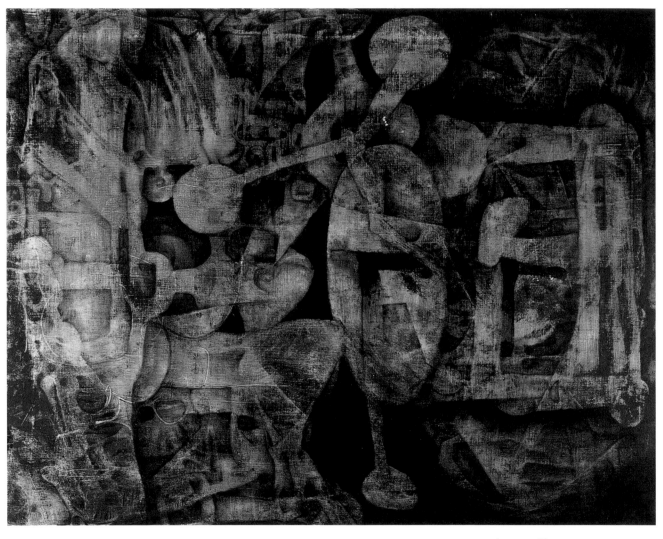

Jacques Matton
Untitled (Sans titre), 1965
Oil on canvas
Collection of the City of La Louvière

Bibliog.
Achille Chavée, "Jacques Matton"
(*Savoir et Beauté*, no. 2, La Louvière, 1962);
Phases belgiques: Courant continu
(Brussels, Crédit Communal, 1990)

Edouard-Léon-Théodore Mesens (Brussels, 1903 – 1971)

Poet, photographer, collagist; known as E.L.T. Mesens

Portrait of E.L.T. Mesens, c. 1920
Black and white photograph
Private collection

Drawn to the musical avant-garde, E.L.T. Mesens, who studied at the Brussels Conservatory, came into contact with Erik Satie and members of the Paris avant-garde such as Tristan Tzara, Francis Picabia and Man Ray. In 1925 he founded with René Magritte the review *Œsophage* and then *Marie,* before joining the small *Correspondance* group led by Paul Nougé, thereby forming the surrealist core in Belgium. Linked to the merchant Paul-Gustave Van Hecke, Mesens, besides his photographs, collages and texts, was active as a publisher and gallerist, organizing in 1928 in Brussels the first international exhibition devoted to modern photography at Galerie l'Epoque, before *Film and Photo* at Stuttgart in May 1929. After the failure of Galerie Le Centaure in 1931, he bought back 150 works by Magritte, who was bound to the gallery by contract. Head of exhibitions at the Centre for Fine Arts in Brussels, he organized two international exhibitions on the premises in 1932 and 1933 on photography and film, after being in charge of the publication of the special issue of *Variétés* (1929) and the collective book *Violette Nozières.* In 1934 he also organized the *Minotaur* exhibition at the Brussels Centre for Fine Arts. In 1938, after having curated with Roland Penrose the *International Surrealist Exhibition* in London, he became head of the London Gallery, generating the activity of a surrealist group in England where he resided until the 1960s. While the photographs and collages of the 1920s and 1930s formed the most original part of his work, bearing the influence of Man Ray and Max Ernst, the collages of the 1950s sometimes called up the work of Kurt Schwitters and revived the Dadaist spirit that marked his beginnings.

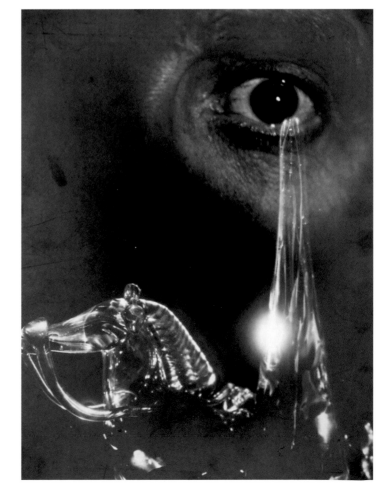

Bibliog.
Louis Scutenaire, *Mon Ami Mesens* (Brussels, Wellens-Pay, 1972);
Christiane Geurts-Krauss, *E.L.T. Mesens: L'Alchimiste méconnu du surréalisme* (Brussels, Labor, 1998)

E.L.T. Mesens
*Ulterior Motive
(Arrière-pensée),* 1926-27
Black and white photograph
Private collection

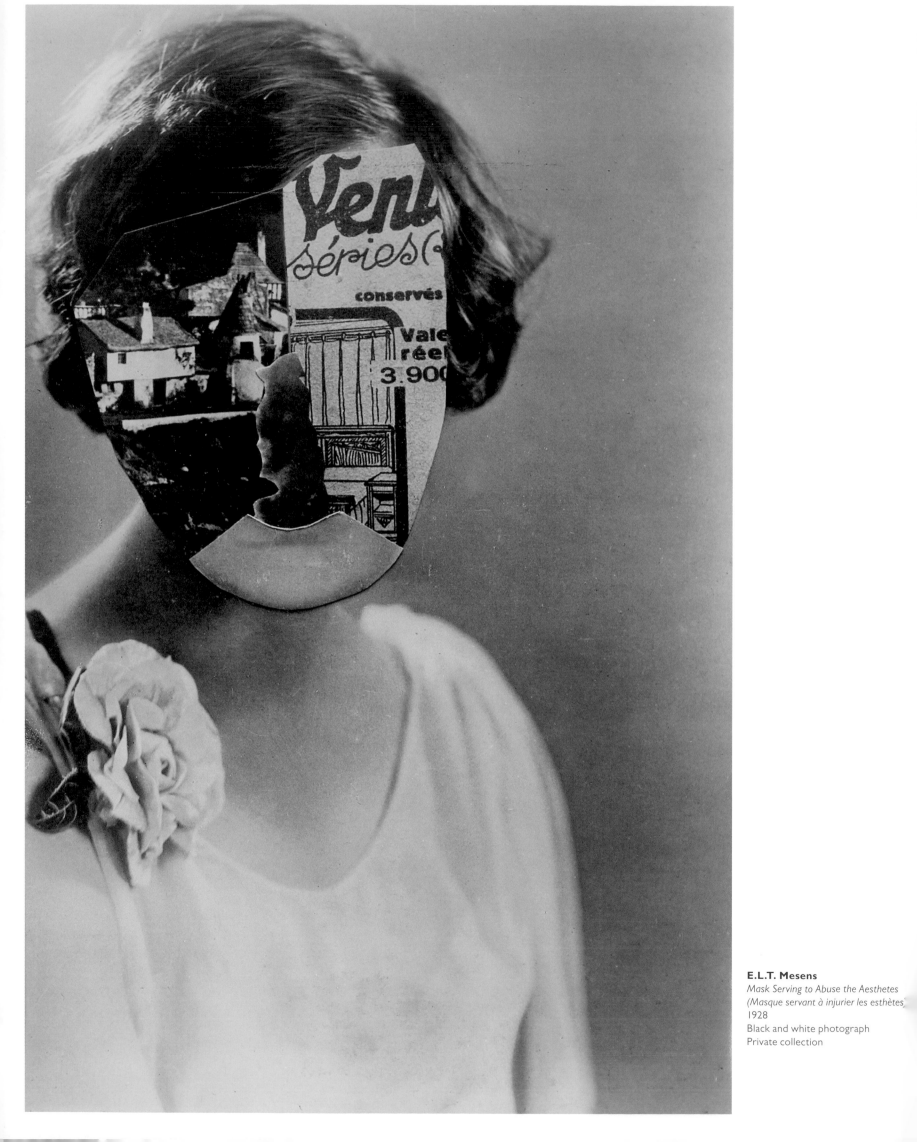

E.L.T. Mesens
Mask Serving to Abuse the Aesthetes
(Masque servant à injurier les esthètes)
1928
Black and white photograph
Private collection

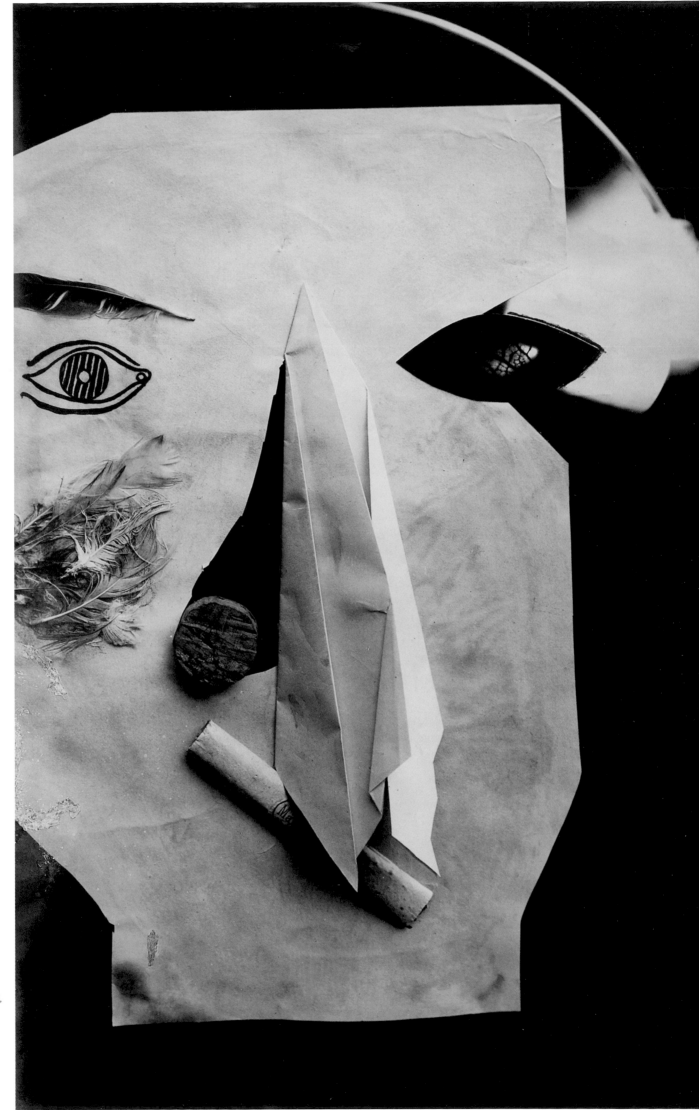

E.L.T. Mesens
*Widow's Mask for the Waltz
(Masque de veuve pour la valse),*
1928
Black and white photograph
Private collection

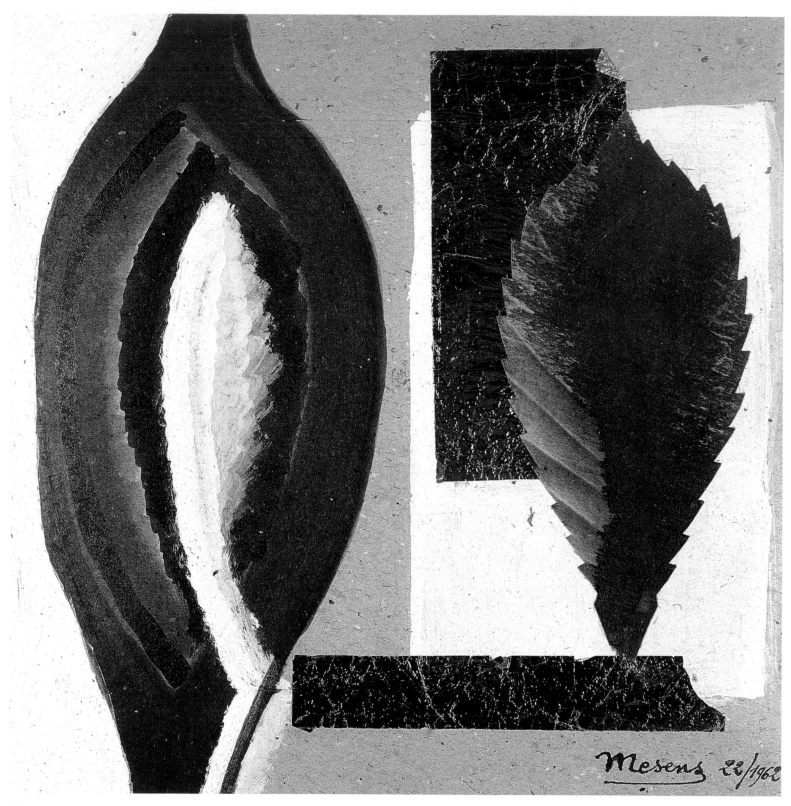

E.L.T. Mesens
Free I (Libre I), 1962
Painting and collage on cardboard
Collection of the Wallonia-Brussels Federation

124

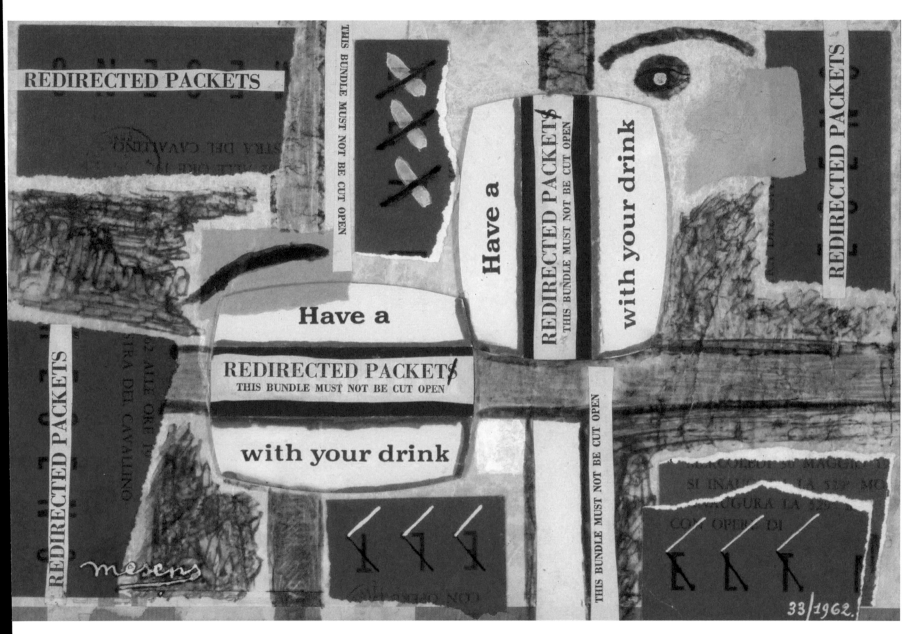

E.L.T. Mesens
Deconstruction no. 33
(Déconstruction, n° 33), 1962
Collage
Collection of the Province of Hainaut
on loan to BPS22, Charleroi

125

Paul Nougé (Brussels, 1895 – 1967)

Poet, writer

Georges Thiry
Paul Nougé, c. 1966
Museum of Photography, Charleroi –
Yellow-Now Editeur

A biochemist by training, Paul Nougé took part in the foundation of the Communist Party in Belgium and was influenced in his early years by Paul Valéry and André Baillon. In 1924, together with Marcel Lecomte and Camille Goemans, he published the *Correspondance* tracts which marked the beginning of surrealism in Belgium, simultaneously to the publication of André Breton's *Surrealist Manifesto.* He would soon rally to his cause the driving forces behind the review *Œsophage,* René Magritte and E.L.T. Mesens, and would emerge as the leading thinker of the group, giving titles to many of Magritte's paintings, whose early catalogs he prefaced. In 1929, the year when he produced the photographic series published as *Subversion of Images,* he pronounced a talk in the Salle de la Bourse in Charleroi at an event in conjunction with a concert by André Souris and an exhibition of paintings by Magritte. Published as *The Charleroi Lecture,* Nougé examined in it the relations between the arts, his analysis focusing on music in particular. Magritte illustrated his first collection of poems, *Clarisse Juranville* (1925). Despite collaborating on various publications initiated by the Paris group, Nougé clearly distanced himself from Breton in the 1930s, as regards both method and the purpose of artistic creation, although both men remained close intellectually. At odds with Magritte in the postwar period, he participated in 1954 in the foundation of Marcel Mariën's review *Les Lèvres nues.* The latter undertook the publication of his work in *Histoire de ne pas rire* (1956) and *L'Expérience continue* (1966), two volumes that reveal the profound coherence of Nougé's thought, a sharp and lucid theorist as well as an admirable poet. However, the "greatest mind of Belgian surrealism" in Francis Ponge's terms chose for anonymity and discretion, indifferent to what happened to his work and a movement to which, however, as much as Magritte, he contributed a specific tone, distinct from the other forms of surrealism.

Paul Nougé
Make-Up (Le Fard)

Paul Nougé
Women at the Mirror (Femmes au miroir)

Paul Nougé
Cut Eyelashes (Cils coupés)

Bibliog.
Olivier Smolders, *Paul Nougé: Ecriture et caractère à l'école de la ruse* (Brussels, Labor, 1995); Christine De Naeyer, *Paul Nougé et la photographie* (Brussels, Didier Devillez, 1995)

Paul Nougé
Photographs from the series *Subversion of Images (Subversion des images),* 1929
Black and white photographs
Archives et Musée de la Littérature, Brussels

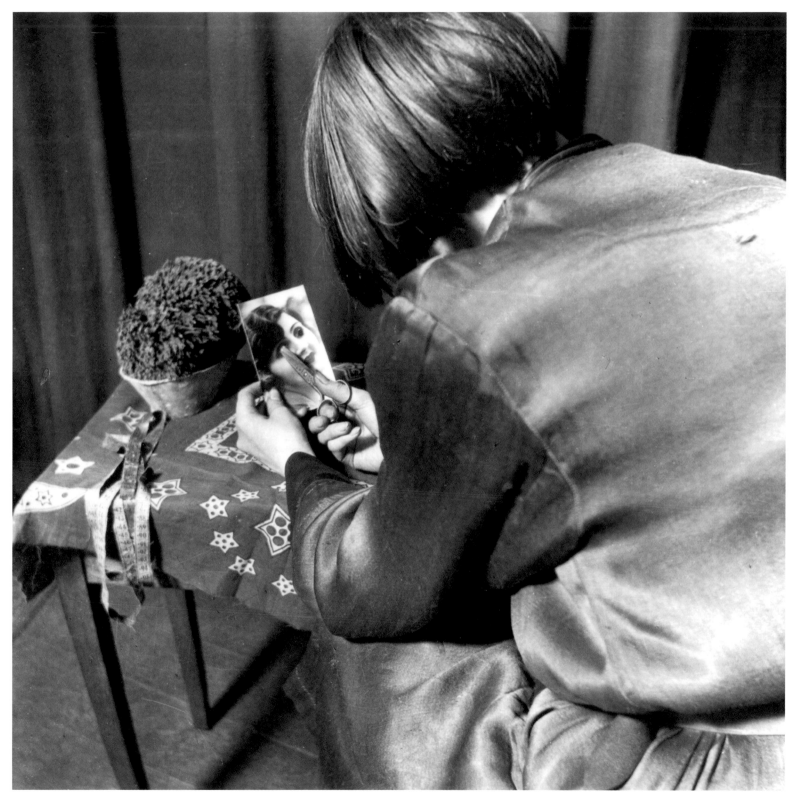

Paul Nougé
The Revenge (La Vengeance)

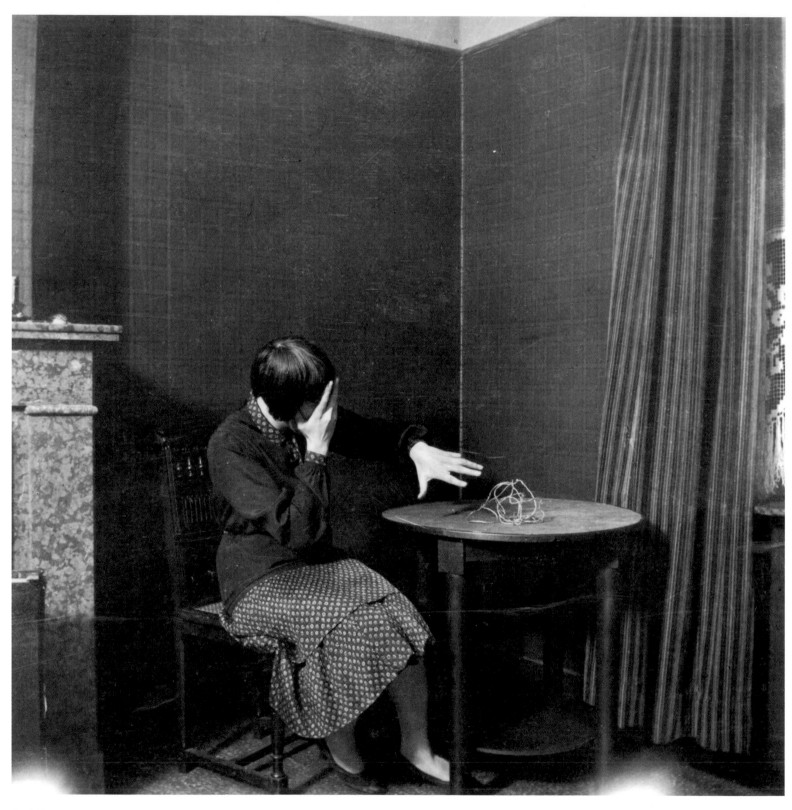

Paul Nougé
Woman Frightened by a String (Femme effrayée par une ficelle)

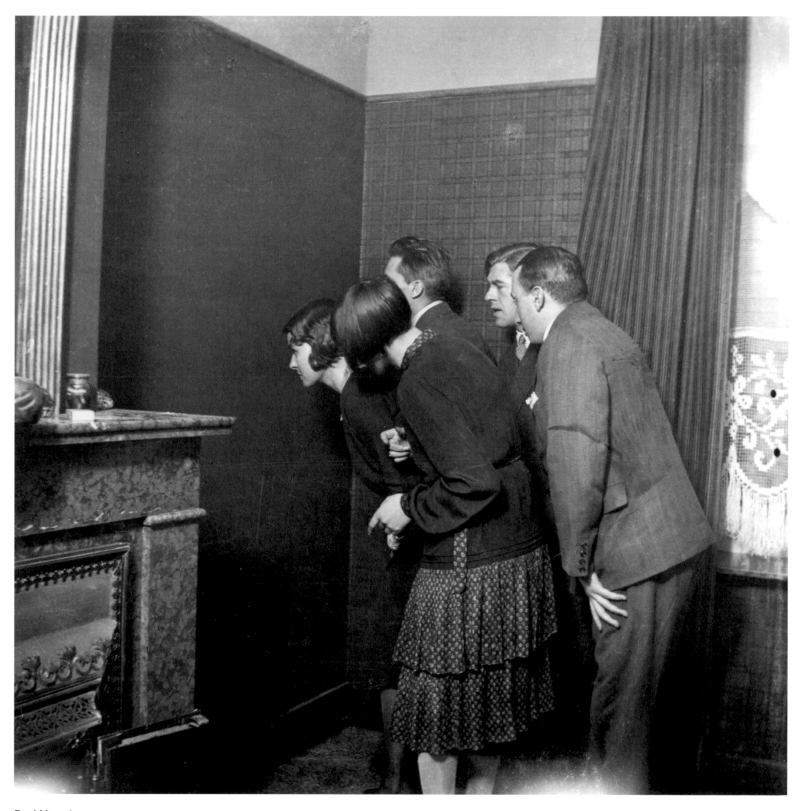

Paul Nougé
Birth of the Object (La Naissance de l'objet)

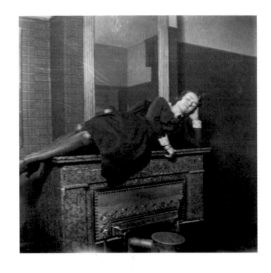
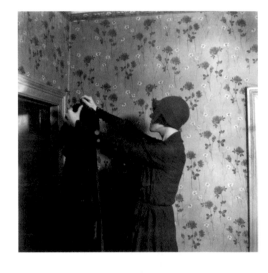
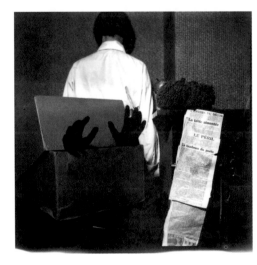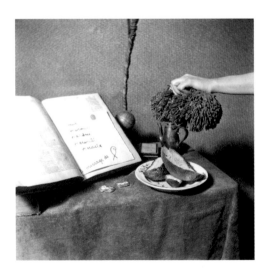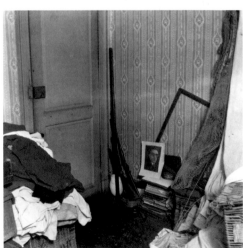

Paul Nougé
From left to right, top to bottom:
The Depths of Sleep (Les Profondeurs du sommeil)
The Reader (Le Lecteur)
Woman on the Stairs (Femme dans l'escalier)
… the Birds Are Pursuing You (… les oiseaux vous poursuivent)
Linen and Bell (Linges et cloche)
Coat Hanging on Nothing (Manteau suspendu dans le vide)
Magnetized Table, Tomb of the Poet (Table aimantée, tombeau du poète)
Whispering Wall (Mur murmure)
The Attic (Le Grenier)

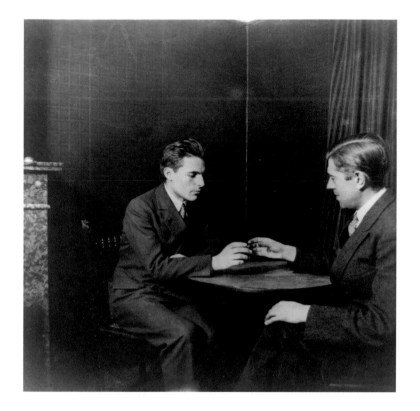

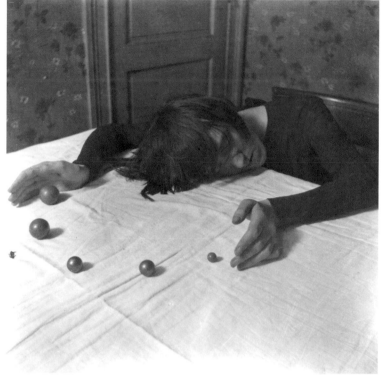

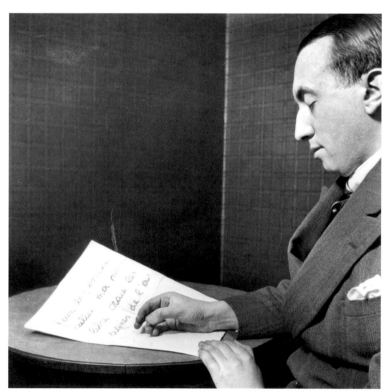

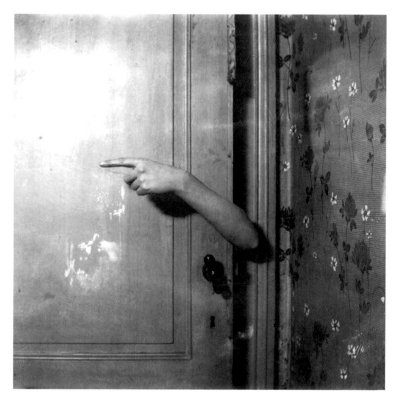

Paul Nougé
From left to right, top to bottom:
The Drinkers (Les Buveurs)
The Juggler (La Jongleuse)
The Harvest of Sleep (Les Vendanges du sommeil)
The Telling Arm (Le Bras révélateur)

Louis Scutenaire (Ollignies, 1905 – Schaerbeek, 1987)

Poet, writer

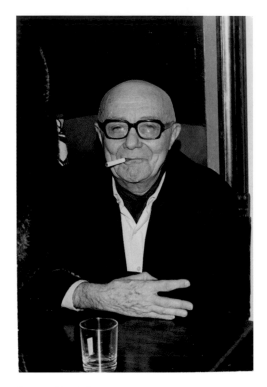

Portait of Louis Scutenaire
Private collection

In 1926, Louis Scutenaire, whose first name was still Jean, sent some of his texts to Paul Nougé: it was the start of a long friendship and close collaboration with the Brussels group, where Scutenaire befriended René Magritte. He would not only defend and praise the painter, but collected his work too. Scutenaire collaborated on the review *Distances* and on the catalog of the Magritte exhibition at Galerie l'Epoque in 1928. Magritte illustrated in 1937 Scutenaire's first collection of poems, *Les Haches de la vie*. At the same time, he began work on a novel made up of borrowings, *Les Jours dangereux, les nuits noires,* described by Mariën as "a vast collage that combines the past and the future, where the eternal snows nestle in the bottom of chasms and where the author's scissors rule as much as the most liberated style." Scutenaire refused to sign *Le Domestique zélé* (1936), the tract that excluded André Souris from the Brussels group, and participated in several reviews including *L'Invention collective* and *Le Ciel bleu.* It is Magritte who in 1939 again illustrated the cover of *Frappez au miroir!* In 1945 Gallimard published *Mes Inscriptions,* a series of aphorisms that was reissued several times. In 1947 he released *Les Vacances d'un enfant,* which evoked his childhood in a dazzling style, and that same year he released *René Magritte,* a perceptive and kind study of the painter's work. In the 1960s, he took part in the activities of Tom Gutt's group, choosing the latter as his publisher and executor. A major figure of Belgian surrealism, his collection of about one hundred works by Magritte was donated, upon the death of Irène Hamoir, his wife since 1930, to the Museum of Modern Art in Brussels. Without this collection the Magritte Museum would never have existed.

Bibliog.
Raoul Vaneigem, *Louis Scutenaire*
(Paris, Seghers, 1991);
Irène, Scut, Magritte and Co.
(Brussels, Musée d'Art Moderne, 1996)

Louis Seutenaire
Hotchpotch II (Pêle-mêle II), 1934
Collage
Collection of the Verbeke Foundation, Kemzeke

Gilbert Senecaut (Antwerp, 1925 – 1997)

Poet, collagist

Leo Dohmen
Communicating Vessels (Les Vases communicants), 1956
Portrait of Gilbert Senecaut
Black and white photograph
Collection of the Wallonia-Brussels Federation

A travelling salesman, Gilbert Senecaut met Marcel Mariën at the outbreak of World War II, who would bring out *L'Erection expérimentale* through his publishing house *L'Aiguille aimantée*. Senecaut participated in and financed the first series of *Les Lèvres nues* in which some of his collages were reproduced. In 1959 he collaborated on the film *L'Imitation du cinéma* under the pseudonym Serge Treblich and brought together a small group of surrealists in Antwerp such as Leo Dohmen and Roger Van de Wouwer. His utter discretion, which made him a minor actor, was matched only by his loyalty to the surrealist spirit.

Gilbert Senecaut
Miss Vatican, 1953
Collage
Collection of the Verbeke Foundation, Kemzeke

Bibliog.
Xavier Canonne, *Le Surréalisme en Belgique: 1924-2000* (Brussels, Fonds Mercator, 2007)

Max Servais (Etterbeek, 1904 – Brussels, 1990)

Writer, draftsman, collagist, sailor

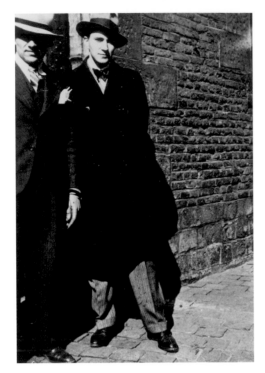

Max Servais and Fernand Dumont in Mons, 1935
Private collection

After an aborted vocation as a sailor, Max Servais entered the bank Crédit Communal de Belgique, whose art collection he helped shape. In 1929 he met Paul Nougé, who was working as a chemist in the laboratory of his uncle, Dr. Ruelens, and was in contact with the Brussels surrealist group. In 1932 he published *Le Couteau dans la plaie*, reissued in the *International Surrealist Bulletin* which he would illustrate. His friendship with Fernand Dumont brought him closer to the Hainaut group. For the first time he showed his collages at the 1935 *Surrealist Exhibition* and illustrated *Mauvais temps*, the only journal published by the Rupture group. He took part in the exhibition *The Surrealist Object* at Galerie Ratton in Paris. He also wrote several detective novels and texts for radio programs before picking up his glue and scissors again thirty years later. His brutal, direct collages bear witness to his hatred of the army and the police as well as bourgeois and clerical authority.

Max Servais
Odds and Ends (Bric à brac), c. 1934
Black and white photograph
Private collection

Bibliog.
Cinq Surréalistes de Belgique: Rachel Baes, Marcel Mariën, Max Servais, Armand Simon, Robert Willems (Brussels, Crédit Agricole, 1998)

Max Servais
The Contempt of Culture
(Le Mépris de la culture), c. 1934
Black and white photograph
Private collection

Max Servais
The Limit of a Destiny
(Limite d'une destinée), c. 1934
Black and white photograph
Private collection

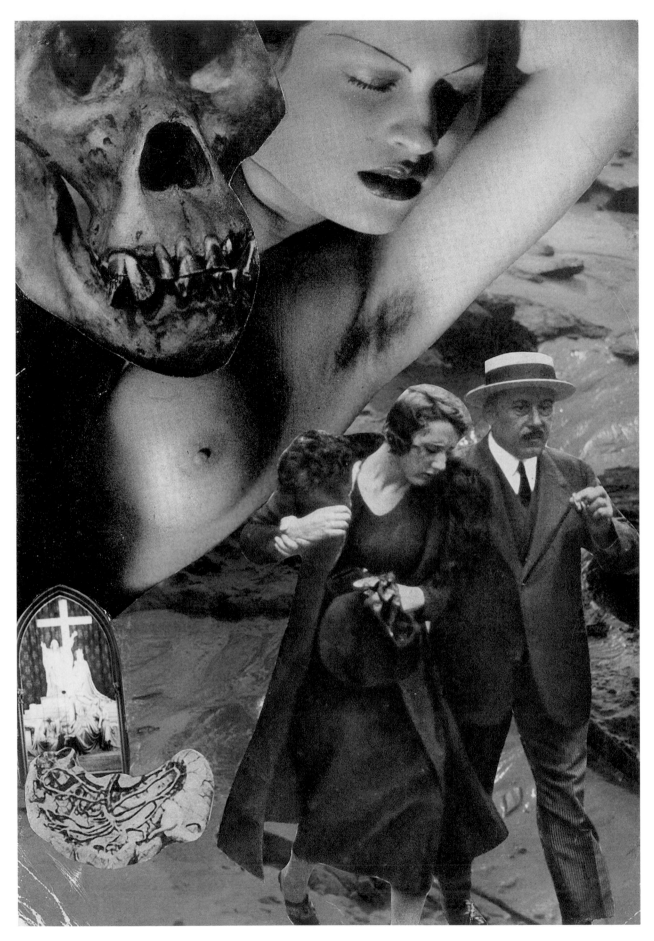

Max Servais
Violette Nozières, 1934
Collage
Private collection

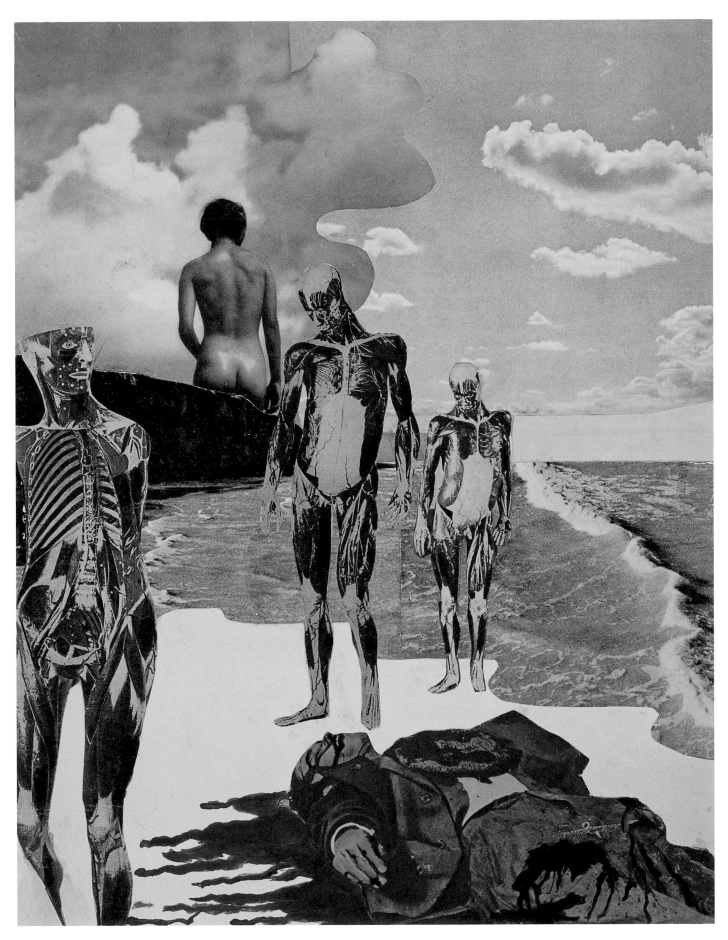

Max Servais
Equinox (Equinoxe), 1935
Collage
Private collection

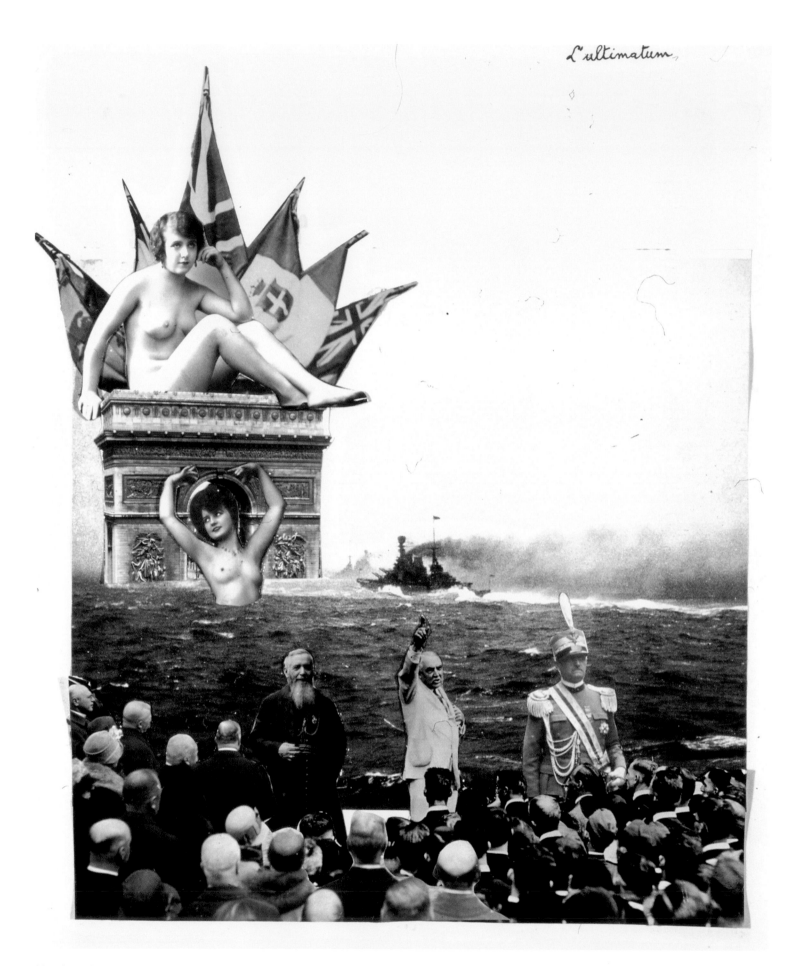

L'ultimatum

Max Servais
The Ultimatum (L'Ultimatum), 1934
Collage
Private collection

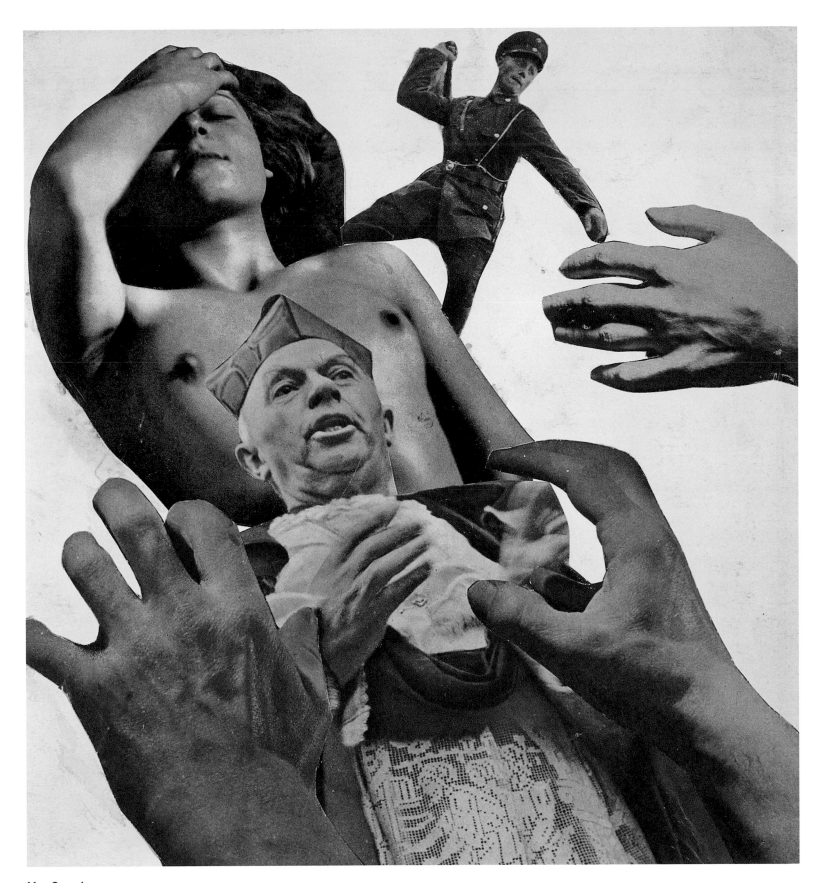

Max Servais
Hands off! or No Loving Allowed
(Bas les pattes ! ou Défense d'aimer), 1934
Collage
Private collection

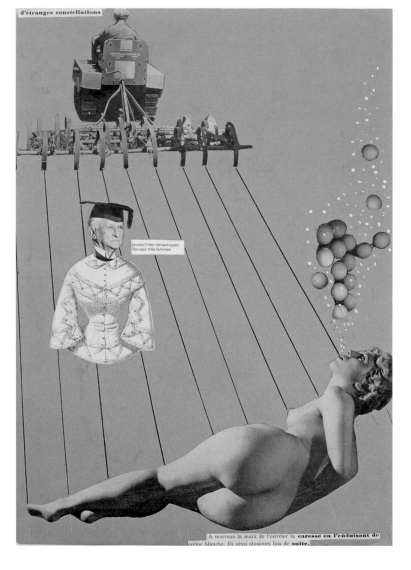

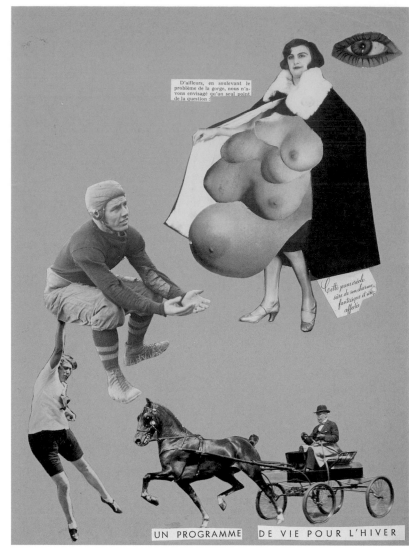

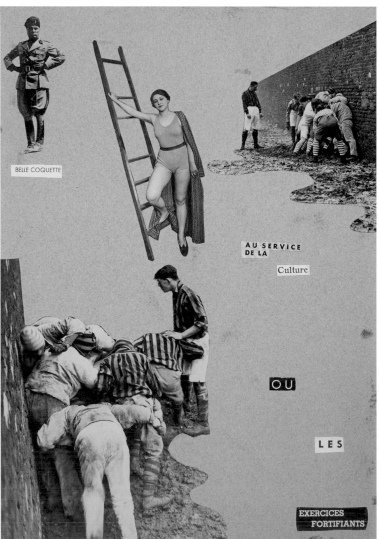

Max Servais
Untitled, Strange Constellations …
(Sans titre, D'Étranges constellations…), c. 1935
Collage
Private collection

Max Servais
Untitled, A Life Program for Winter …
(Sans titre, Un Programme de vie pour l'hiver…), c. 1935
Collage
Private collection

Max Servais
Untitled, At the Service of Culture …
(Sans titre, Au Service de la culture…), c. 1935
Collage
Private collection

Max Servais
The Dream You Waste During Your Time Here (C'est un peu de rêve que vous gaspillez sur votre passage), 1933
Collage
Private collection

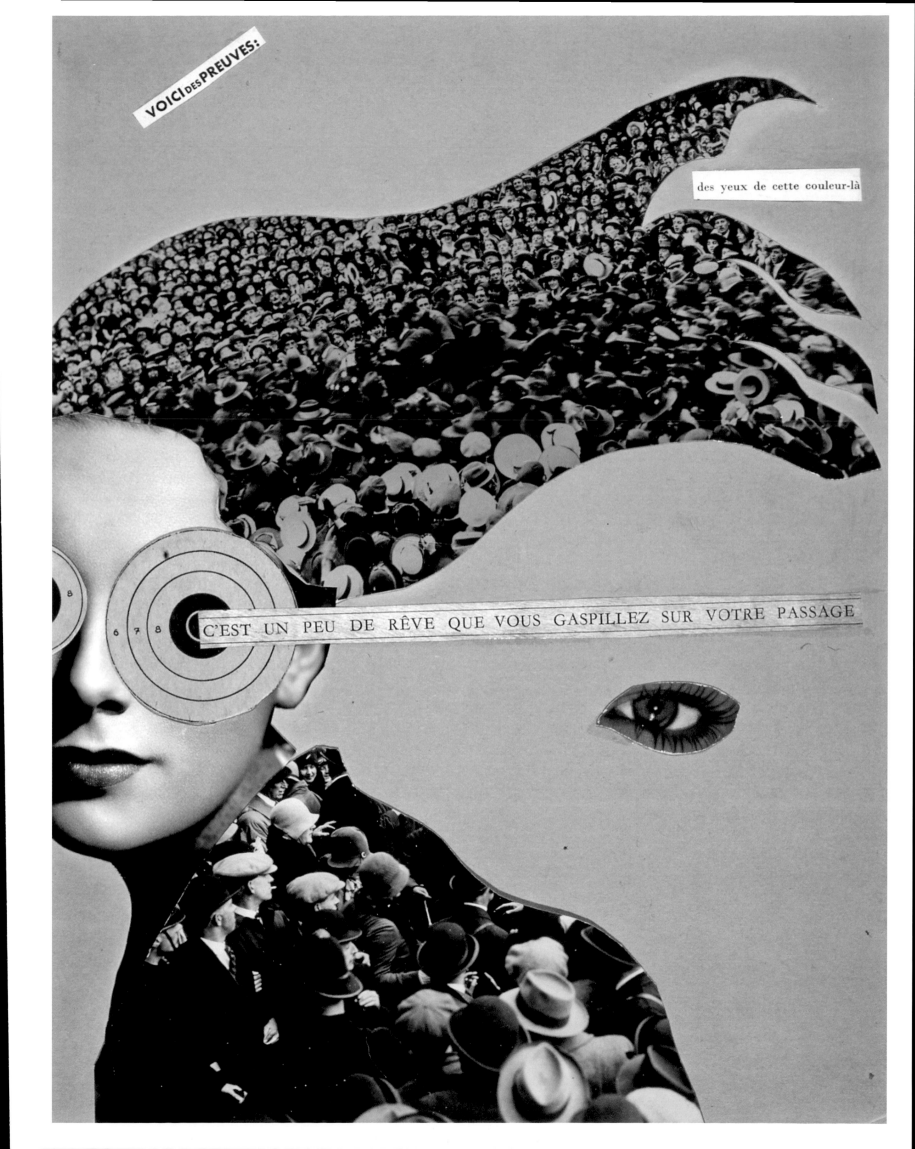

Armand Simon (Pâturages, 1906 – Frameries, 1981)

Draftsman, writer

A fellow schoolmate of Fernand Dumont and Achille Chavée's in 1921 at Mons, Armand Simon discovered in 1923 in the window of a secondhand shop an edition of *Les Chants de Maldoror* by the Comte de Lautréamont (the pseudonym of Isidore Ducasse).

He would keep trying to conceive the graphic equivalent of Lautréamont's book, abandoning the writer's pen for the draftsman's pencil. Working in secret until Dumont discovered and revealed his drawings, he joined the Rupture group in 1936 and then the Hainaut surrealist group. In 1939, believing he had reached his graphic maturity, he began to illustrate *Les Chants de Maldoror*, giving himself up to a rare and genuine exercice of automatic drawing. Simon's belief that love and death were intertwined produced in his work ever-changing figures in hostile environments. His timidity, his wariness of surrealism's political side provoked a certain isolation which earned him the nickname "the loner from Pâturages." He first showed his work at the *International Surrealism Exhibition* organized at Galerie des Editions La Boétie. His work consists of thousands of line drawings, many of which are in the Collection of the Province of Hainaut.

Armand Simon
c. 1975
Private collection

Armand Simon
Tied Down (Le Fil à la patte), 1939
Ink on paper
Private collection

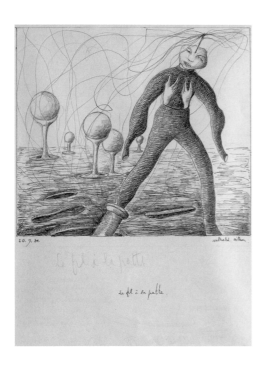

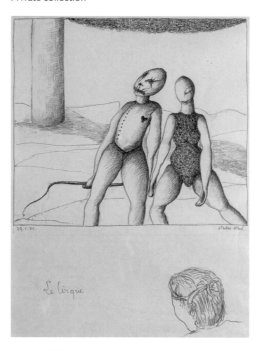

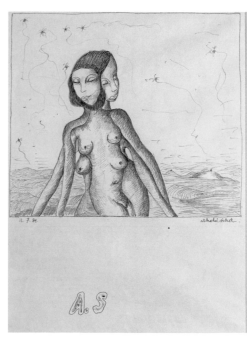

Bibliog.
Xavier Canonne, *Armand Simon: De l'autre côté du miroir* (Brussels, Les Editeurs d'Art associés, 1987); *Armand Simon: Portrait très fragmentaire d'un romancier noir* (Morlanwelz, Les Marées de la nuit, 2006)

Armand Simon
The Circus (Le Cirque), 1939
Ink on paper
Private collection

Armand Simon
Untitled (Sans titre), 1939
Ink on paper
Private collection

Armand Simon
The Domain of Madness (Domaine de folie), 1939
Ink on paper
Private collection

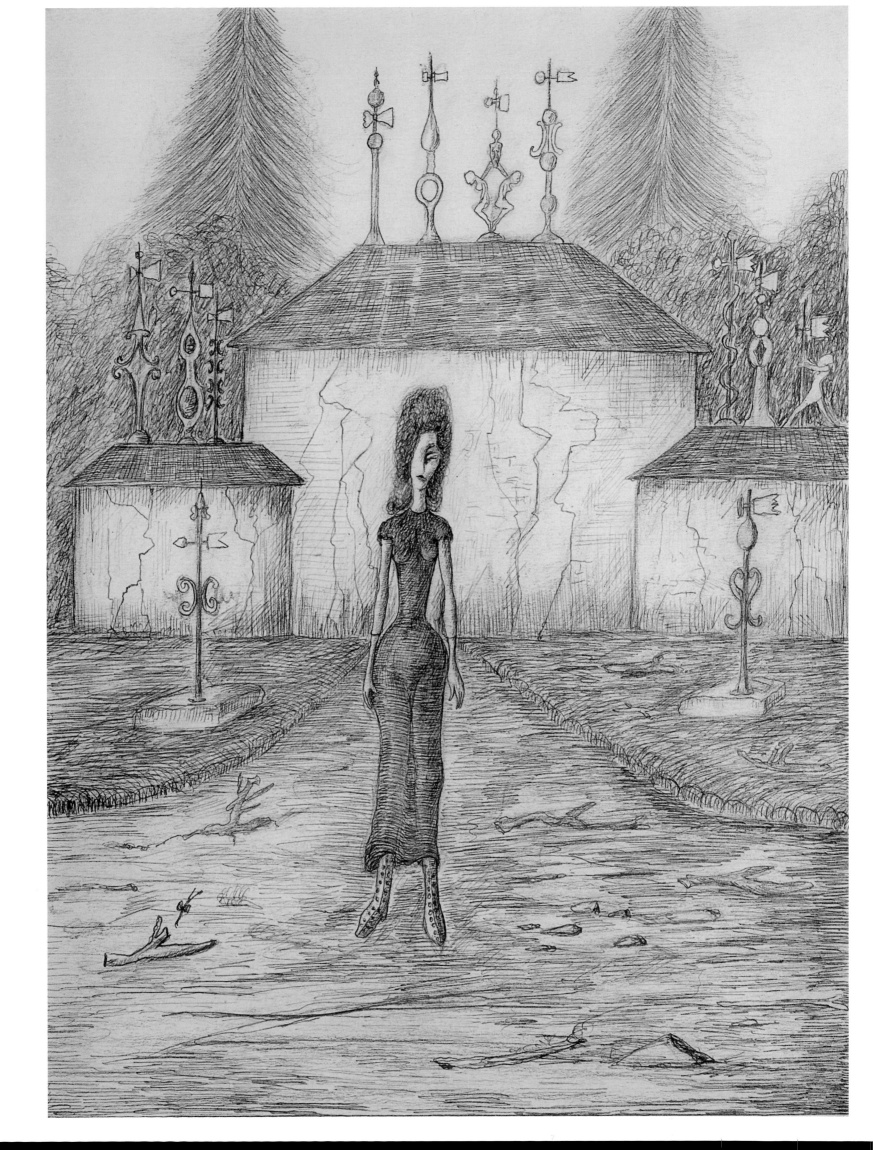

Armand Simon
Untitled (Sans titre), c. 1935
Ink on paper
Collection of the Province of Hainaut
on loan to BPS22, Charleroi

Armand Simon
The Assassins no. 4
(Les Assassins no. 4), 1943
Ink on paper
Collection of the Province of Hainaut
on loan to BPS22, Charleroi

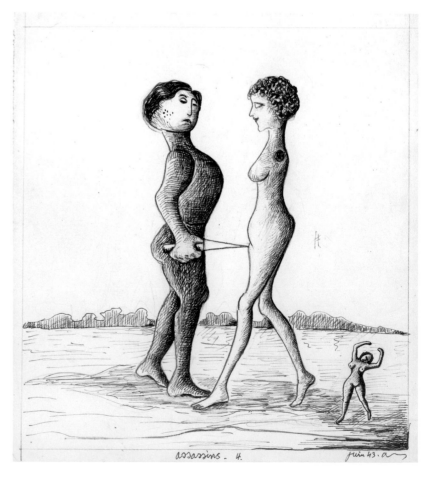

André Souris (Marchienne-au-Pont, 1899 – Paris, 1970)

Poet, musician

Roland d'Ursel
André Souris, c. 1950
Museum of Photography, Charleroi

It is at the Pro Arte concerts in Brussels in 1925 that André Souris met Paul Nougé during the performance of Arnold Schoenberg's *Pierrot Lunaire.* He then took part in the *Correspondance* tracts, joining the trio formed by Nougé, Marcel Lecomte and Camille Goemans. In 1927, he composed *Quelques Airs de Clarisse Juranville* on texts by Nougé. It is on the occasion of a chamber-music concert in the Salle de la Bourse conducted by Souris that Nougé gave his talk entitled *The Charleroi Lecture* analyzing the relations between the arts, Souris like Nougé having always defended the importance of music, which was nevertheless neglected by surrealism. He would be excluded from the group in 1936 through the tract *Le Domestique zélé,* accused of having conducted a mass in memory of Henry Le Boeuf, founder of the Centre for Fine Arts in Brussels. He directed the musical studio of the Arts Seminar from 1945 to 1947, where he introduced modern musical concepts. Having settled in Paris in the 1950s, he nevertheless maintained close relations with the Belgian surrealists, collaborating on Marcel Mariën's review *Les Lèvres nues,* and writing the score for the latter's film *L'Imitation du cinéma.*

Bibliog.
Robert Wangermée, *André Souris et le complexe d'Orphée: Entre surréalisme et musique sérielle* (Liège, Mardaga, 1995)

André Stas (Rocourt, 1949)

Collagist, writer

André Stas
Sheet of Stamps (Feuille de timbres), 1984
Collage
Private collection

It is at an exhibition of collages by Marcel Mariën in the mid 1970s that André Stas met some of the members of the Brussels group. He had his first solo exhibition in 1970 at the Yellow Now gallery in Liège, prefaced by Louis Scutenaire. He was involved in the publication of Mariën's *Les Lèvres nues* and the review *Le Vocatif,* and exhibited at Tom Gutt and Claudine Jamagne's Galerie La Marée.

Exhibiting and publishing widely (among others, aphorisms), Stas showed a lot of creativity served by a sense of humor and literary citation, transforming a range of materials, from pornographic images to ancient engravings.

André Stas
An Invitation to Travel (L'Invitation au voyage), 1981
Collage
Private collection

Bibliog.
Tom Gutt, Xavier Canonne and A. De Wasseige,
Collages 1976-2001 (Brussels, La Papeterie, 2001)

André Stas
In Memoriam Paul Eluard, 1984
Collage
Private collection

Raoul Ubac (Malmedy, 1910 – Paris, 1985)

Photographer, painter, sculptor

Georges Thiry
Raoul Ubac, c. 1950
Museum of Photography, Charleroi –
Yellow-Now Editeur

Fascinated by André Breton's *Surrealist Manifesto,* Raoul Ubac came into contact with the Paris surrealist group about 1932. His first photographs were produced under the influence of Man Ray's work and already show Ubac's interest in rocks and stones. Travelling through Dalmatia, residing in 1934 on the island of Hvar, he assembled some stones which he then photographed. His first book, *Actuation poétique,* appeared in Paris in 1935 under the pseudonym Raoul Michelet. He took part in the *Surrealist Exhibition* of October 1935 at La Louvière, and in the activities of the Brussels group without, however, cutting himself off from Breton and his friends. He then created astoundingly inventive works of great technical quality, like the *Penthésilée* series inspired by Heinrich von Kleist, but also "petrifications," solarizations of replicated wrestling female bodies. Prefaced by Paul Nougé, his exhibition at Galerie Dietrich in 1941 in Brussels constituted one of the rare surrealist activities in occupied Belgium. However, the exhibition was denounced by collaborators and shut down by the occupier. Although he participated in 1945 in the *Surrealism Exhibition* organized by Editions La Boétie, Ubac gradually distanced himself from surrealism, turning towards gouache, painting and the sculpture of stones or slates in a move towards abstraction.

Raoul Ubac
Catalog of the exhibition at Galerie
Dietrich, Brussels, 1941
Black and white photograph
Museum of Modern Art, Brussels

Bibliog.
Ubac (Liège, Musée Saint-Georges, 1981);
Ubac (Paris, Maeght, 1970);
Raoul Ubac (Paris, Galerie Bourqueret+Lebon, 1995)

Raoul Ubac
*The Struggle of Penthesilea
(Le Combat de Penthésilée),* 1937
Photograph
Collection of the Wallonia-Brussels Federation
on loan to the Museum of Photography, Charleroi

Louis Van de Spiegele (Cuesmes, 1912 – Mons, 1972)

Painter, draftsman, sculptor

A student at the Fine Arts Academy of Mons, he joined the Rupture group in 1936 and then, following in the footsteps of Achille Chavée and Fernand Dumont, the Hainaut surrealist group. He took part in *L'Invention collective,* in which two of his paintings were reproduced. A discreet personality, he was for a while Dumont's companion in misfortune in the Nazi prisons. He produced a nice pencil portrait of the latter and illustrated his posthumous book *La Liberté* (1948). He sculpted the bust of Arthur Rimbaud around who the members of the Hainaut group pose.

Marcel Lefrancq
Louis Van de Spiegele Dreaming
(Louis Van de Spiegele rêve), 1938-39
Museum of Photography, Charleroi –
Yellow-Now Editeur

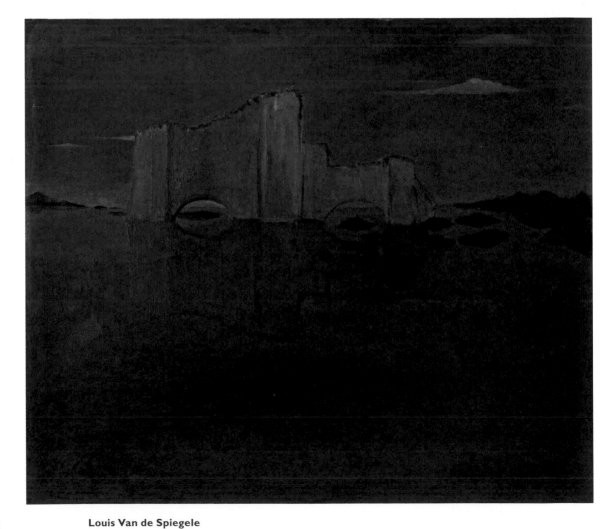

Bibliog.
Le Surréalisme à Mons et les amis bruxellois
(Mons, Musée des Beaux-Arts, 1986)

Louis Van de Spiegele
The Gaze of Silence (Le Regard du silence), 1938
Oil on canvas
Collection of the Province of Hainaut
on loan to BPS22, Charleroi

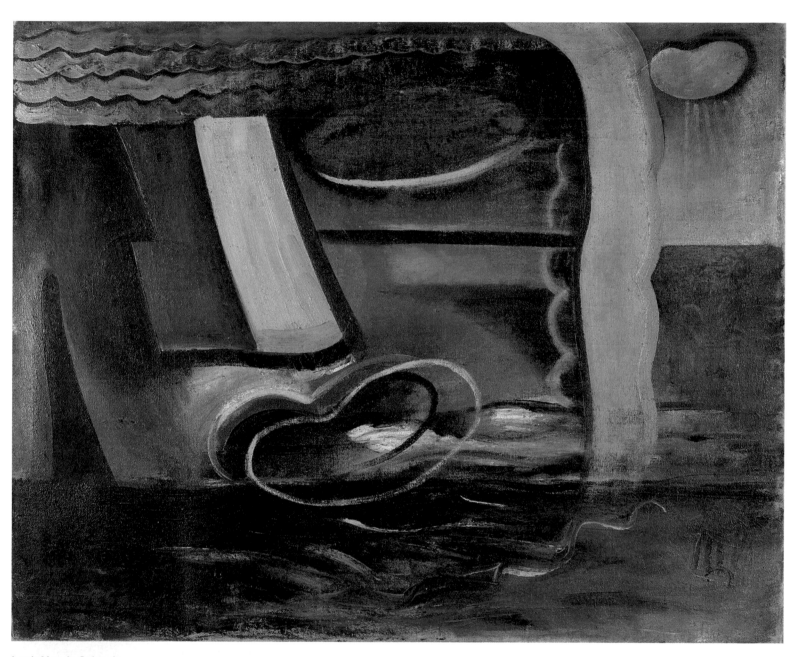

Louis Van de Spiegele
The Engulfed Cathedral (La Cathédrale engloutie), 1938
Oil on canvas
Collection of Michel Lefrancq, Mons

Roger Van de Wouwer (Hoboken, 1933 – Antwerp, 2005)

Painter, draftsman

After studying at the Fine Arts Academy of Antwerp, Van de Wouwer was noticed by his colleague Leo Dohmen. His exhibition at Galerie La Proue in May 1963 caused a scandal, his painting *Galathée* representing an antique statue fitted with a sanitary napkin, resulting in charges being brought against him. Tom Gutt and his friends defended him in the tract *Le Vent se lève*. Van de Wouwer participated in the activities of Marcel Mariën's review *Les Lèvres nues* and in several of Gutt's publications. Among others he illustrated poems by Louis Scutenaire and Irène Hamoir. Although his work consisted of shocking images, he also used alchemical words and formulas, offering the spectator riddles or suggested references rather than explicit ones.

Roger Van de Wouwer
The Call To Reason (L'Appel à la raison), 1961
Oil on canvas
Private collection

Bibliog.
Xavier Canonne, *Le Surréalisme en Belgique: 1924-2000* (Brussels, Fonds Mercator, 2007); Claude François, *A Bout portant: Un film sur Roger Van de Wouwer* (PBC Pictures et al., 2000)

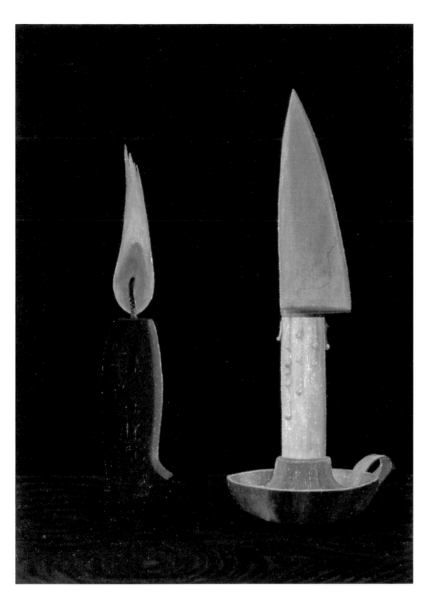

Roger Van de Wouwer
The Postulate of Euclid (Le Postulat d'Euclide), 1962
Oil on canvas
Private collection

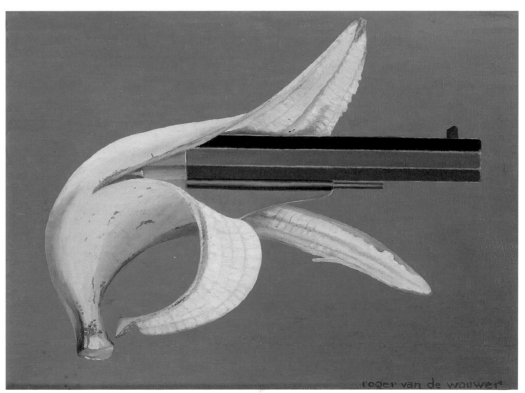

Roger Van de Wouwer
At Close Range (A bout portant), n.d.
Oil on canvas
Private collection

Roger Van de Wouwer
The Hairshirt of Tartuffe (La Haire de Tartuffe), 1961
Oil on canvas
Private collection

Roger Van de Wouwer
The Elevation (L'Élévation), 1961
Oil on canvas
Private collection

Jean Wallenborn (Brussels, 1941)

Poet, scholar

A friend of Tom Gutt's since the 1950s, Jean Wallenborn was actively involved in the activities of the small surrealist group that formed in Boitsfort about 1960, among others in the review *Après Dieu,* which appeared in 1961 and 1962. With his friend Gutt he was the initiator of various tracts, and a signatory of *Le Vent se lève* (1963), which protested the censoring of a work by Roger Van de Wouwer, and of the tract *Vous voyez avec votre nombril* (1964), which gathered the surrealists of three generations with the aim of reviving surrealist collective activity. Although he published little, Wallenborn remains the discreet memory of fifty years of surrealism in Belgium.

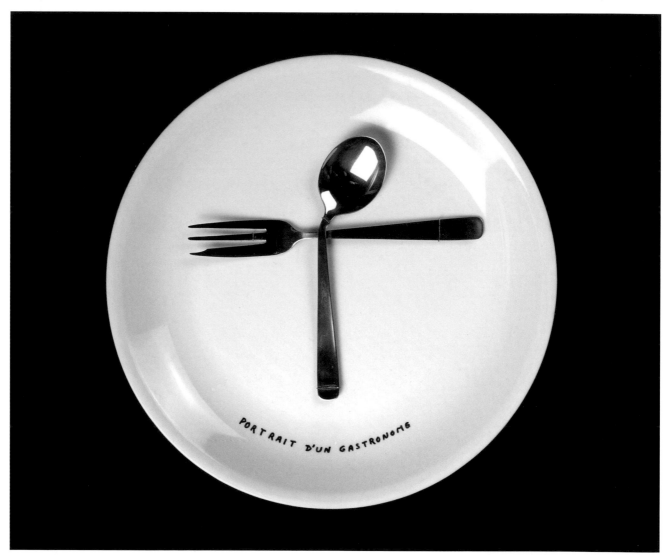

Jean Wallenborn
Portrait of a Gourmet (Portrait d'un gastronome), 1978
Assemblage
Private collection

Bibliog.
Xavier Canonne, *Le Surréalisme en Belgique: 1924-2000* (Brussels, Fonds Mercator, 2007)

Jacques Wergifosse (Liège, 1928 – 2006)

Poet; Pseudonym: Jacques Maître

It is about 1945 that Jacques Wergifosse met the Brussels surrealists and became friends with René Magritte, whose close friend he remained for a decade, the painter renewing with him the series of young admirers who, until André Bosmans, accompanied him. He took part in the adventure of "sunlit surrealism," Magritte's new way of approaching painting, and took part in the *Surrealism Exhibition* organized by Editions La Boétie. He also participated in the making and distribution of the tracts *L'Imbécile* (The imbecile), *L'Emmerdeur* (The pain in the neck) and *L'Enculeur* (The fucker). In 1946 he published *Sanglante,* his first book, illustrated by Magritte. He was also a party to and witness of the making of the paintings of the "vache" (cow) period created for the exhibition at Galerie du Faubourg in Paris in 1948, disconcerting both the general public and Magritte's admirers. Although he gradually distanced himself from the group about 1955, he continued to pay attention to its activities, participating in Tom Gutt's review *Le Vocatif,* who in 2001 would publish Jacques Wergifosse's *L'Œuvre (presque complète),* and in Marcel Mariën's publishing activities. Almost pathologically discreet, the "admirable ghost" (in the words of Tom Gutt) left behind poetry of very high quality.

Jacques Wergifosse
The Artist-Painter
(L'Artiste-peintre), c. 1945
Collage
Private collection

Bibliog.
Jacques Wergifosse, *Œuvre (presque)*
complète (Brussels, n.p., 2001);
Claude François, *La chaîne sans fin*
(Versus Production, 48 min., 2000)

Robert Willems (Ixelles, 1926 – Uccle, 2011)

Painter, draftsman, collagist

Robert Willems (with Paul Colinet)
The Boileau's Brothers, 1998
Acrylic on canvas
Collection of the Province of Hainaut
on loan to BPS22, Charleroi

The nephew of poet Paul Colinet, Robert Willems found himself naturally taking part in the activities of the Belgian surrealists who he came in contact with in 1943 already, his drawings appearing for the first time in the review *Le Ciel bleu* in 1945. In 1947, Willems took part in the *International Exhibition Surrealism* organized in Paris by André Breton and Marcel Duchamp. In 1948, he undertook the *Difficulteurs* series, featuring strange figures with bald heads and bird's noses, absorbed in activities only they understand, drawings to which his uncle Paul would sometimes add a caption. At the same time, during his stay in the Belgian Congo, he received copies of *Vendredi,* a manuscript review of which only a single issue was published and to which the members of the Brussels group contributed. Willems held his first solo exhibition in 1974, the start of a long series presenting line or color drawings that were sometimes worrying, sometimes absurd, like the work of a cruel Walt Disney.

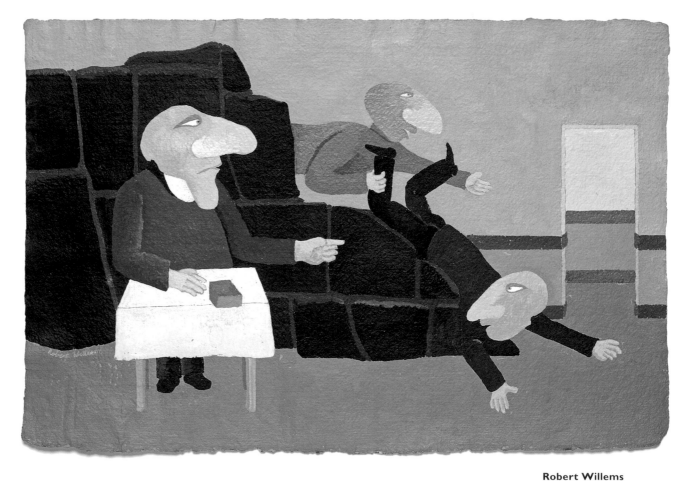

Robert Willems
*The Judgment of Heracles
(Le Jugement d'Héraclès),* 1998
Acrylic on paper
Private collection

Bibliog.
Xavier Canonne, *Le Surréalisme en Belgique:
1924-2000* (Brussels, Fonds Mercator, 2007)

Jacques Zimmermann (Hoboken, 1929)

Painter, draftsman, engraver

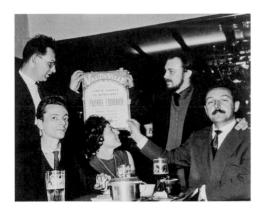

Georges Thiry
Jacques Zimmerman, Roland Giguère, Marie Carlier,
Jacques Lacomblez and Henri Ginet. Presence noted
of Remo Martini and Edouard Jaguer, 1962

A friend of Jacques Lacomblez's since the 1950s, Jaques Zimmerman participated with him in the publication of the review *Edda,* which appeared between 1958 and 1964. A gestural painter, initially influenced by the work of Hans Hartung, he wanted to create insightful jungles painted in broad strokes, detaching tense structural lines from the frame, in a tempest-tossed universe beaten by waves.

Bibliog.
Phases belgiques: Courant continu
(Brussels, Crédit communal, 1990);
Jacques Zimmermann (n.p., 2004)

Jacques Zimmermann
The Fleeing Space (L'Espace en fuite), 1973
Oil on canvas
Collection of the Province of Hainaut
on loan to BPS22, Charleroi

Select Bibliography

Rik Sauwen, *L'Esprit dada en Belgique* (PhD diss., Université Catholique de Louvain, 1969).

José Vovelle, *Le Surréalisme en Belgique* (Brussels, André De Rache, 1972).

Christian Bussy, *Anthologie du surréalisme en Belgique* (Paris, Gallimard, 1972).

Jacqueline Talmasse, *Essai de bibliographie du surréalisme littéraire en Belgique* (Liège, CSB, 1972).

Régine Van Belle, *Le théâtre dadaïste et surréaliste en Belgique* (Antwerp, Universitaire Instelling, 1973-74).

Marcel Mariën, *L'Activité surréaliste en Belgique, 1924-1950* (Brussels, Le Fil rouge – Lebeer Hossmann, 1979).

René Magritte et le surréalisme en Belgique (Brussels, Musées Royaux des Beaux-Arts, 1982).

Le Surréalisme à Mons et les amis bruxellois (Mons, Musée des Beaux-Arts, 1985).

Phases belgiques: Courant continu (Brussels, Crédit Communal de Belgique, 1990).

Surréalismes de Belgique, in *Textyles: Revue des Lettres belges de Langue française* no. 8 (Brussels, Nov. 1991).

Jean Weisberger, *Les Avant-gardes littéraires en Belgique* (Brussels, Labor, series Archives du futur, 1991).

Cinq Surréalistes de Belgique: Rachel Baes, Armand Simon, Marcel Mariën, Max Servais et Robert Willems (Brussels, Crédit Agricole, 1998).

Les Surréalistes belges, spec. issue of *Europe,* monthly literary rev. (Paris, April 2005).

Xavier Canonne, *Le surréalisme en Belgique: 1924-2000* (Brussels, Fonds Mercator; London, Thames & Hudson, 2007).

Xavier Canonne, *Le Surréalisme à La Louvière: Un abécédaire du surréalisme dans les collections de la Province de Hainaut, du Centre de la gravure et de l'Image imprimée et de la Ville de La Louvière* (Brussels, Marot, 2012).

Surrealism in Belgium no. 1 (Brussels, B.K.W. Gallery, 2014).